D1599857

*The Grass Shall Grow*

# The Grass

# Shall Grow

## Helen Post Photographs the Native American West

MICK GIDLEY

University of Nebraska Press | Lincoln

Acknowledgments for the use of copyrighted
material appear on pages 147–53, which
constitute an extension of the copyright page.

All photographs are by Helen Post (1907–79)
unless otherwise noted.

Publication of this volume was assisted by
the Virginia Faulkner Fund, established in
memory of Virginia Faulkner, editor in
chief of the University of Nebraska Press.

Library of Congress
Cataloging-in-Publication Data
Names: Gidley, M. (Mick), author.
Title: The grass shall grow:
Helen Post photographs the Native
American West / Mick Gidley.
Other titles: Helen Post photographs
the Native American West
Description: Lincoln: University of
Nebraska Press, [2020] | Includes
bibliographical references and index.
Identifiers: LCCN 2019015589
ISBN 9781496216205 (cloth: alk. paper)
ISBN 9781496219428 (pdf)
Subjects: LCSH: Post, Helen M. |
Indians of North America—West (U.S.)—
Pictorial works. | Indians of North
America—West (U.S.)—Portraits.
Classification: LCC F78.W5 G53 2020 |
DDC 978.004/9700222—dc23
LC record available at
https://lccn.loc.gov/2019015589

Designed and set in
Adobe Caslon Pro
by L. Auten.

To Ruth and Ben

# Contents

List of Figures . . . . . . . . . . . . . . . . . . . . . . . . . ix

Preface and Acknowledgments . . . . . . . . . . xiii

A Note on the Figures . . . . . . . . . . . . . . . . . xvii

Prologue . . . . . . . . . . . . . . . . . . . . . . . . . . . . . . 1

1. Introducing Helen Post . . . . . . . . . . . . . . . . . 5

2. Creating a Read-and-See Book . . . . . . . . . . . 35

3. Peopling Post's Pictures . . . . . . . . . . . . . . . . . 52

4. Photographing a New Deal
   for the Indians . . . . . . . . . . . . . . . . . . . . . . . . 83

Conclusion . . . . . . . . . . . . . . . . . . . . . . . . . . . . . 111

Notes . . . . . . . . . . . . . . . . . . . . . . . . . . . . . . . . 129

Photograph and Figure Credits . . . . . . . . . 147

Index . . . . . . . . . . . . . . . . . . . . . . . . . . . . . . . . 155

# Figures

1. Helen Post being fitted for a pair of moccasins . . . . . . . . . . . . . . . . . . . . xx

2. Cover of *As Long as the Grass Shall Grow* . . . . . . . . . . . . . . . . 2

3. Anni Albers, weaver . . . . . . . . . . . . . . . . 8

4. Unnamed welfare recipients . . . . . . . . . . . . . 9

5. Helen Post with camera . . . . . . . . . . . . . . . . 11

6. *Wastelands—Near San Juan River* . . . . . . . . 12

7. Navajo road crew at work . . . . . . . . . . . . . . . 14

8. Seneca man at Tonawanda carving a mask . . . . . . . . . . . . . . . . . . 15

9. Helen Post and Oliver La Farge . . . . . . . . . . . . 16

10. Headdresses, Crow Fair . . . . . . . . . . . . . . . . . . . 17

11. *Pictograph That Gave Name to Standing Cow Ruin* . . . . . . . . . . . . 18

12. *White House Ruins, Canyon de Chelly* . . . . . . . 19

13. *Sam Day, Jr.* . . . . . . . . . . . . . . . . . . . . . . . 20

14. *Ocotillo and Shadow* . . . . . . . . . . . . . . . . . 21

15. Navajo rug used in modern interior . . . . . . . . 22

16. A decorated deerskin . . . . . . . . . . . . . . . . . 23

17. Native American artists with
    Eleanor Roosevelt . . . . . . . . . . . . . . . . . . 24

18. Nellie Star Boy Menard
    and children . . . . . . . . . . . . . . . . . . . . . 26

19. Four contact prints of
    Post's photographs . . . . . . . . . . . . . . . . . 27

20. Cover of *Brave*
    *against the Enemy* . . . . . . . . . . . . . . . . . 28

21. San Carlos Apache woman voting . . . . . . . 30

22. *Health Education in the Field* . . . . . . . . . 32

23. Ned Bia, Navajo guide
    and interpreter . . . . . . . . . . . . . . . . . . . 34

24. *Negro Man Entering*
    *a Movie Theatre* . . . . . . . . . . . . . . . . . . 37

25. Grass, Flathead reservation . . . . . . . . . . . 39

26. Two-page spread from *As Long*
    *as the Grass Shall Grow* . . . . . . . . . . . . . 40

27. Blackfeet people, page from
    *As Long as the Grass Shall Grow* . . . . . . . . 42

28. Infant on cradle board . . . . . . . . . . . . . . 43

29. Blackfeet women looking
    out of a window . . . . . . . . . . . . . . . . . . . 44

30. Desert image from *As Long*
    *as the Grass Shall Grow* . . . . . . . . . . . . . 51

31. Fannie Makes Shines playing
    "Marie" in *Brave against the Enemy* . . . . . 54

32. "Louie Hollow Horn," leading
    character in *Brave against the Enemy* . . . . . 55

33. "Louie Hollow Horn" with
    his sick grandfather . . . . . . . . . . . . . . . . 56

34. "Louie Hollow Horn"
    asleep in the barn . . . . . . . . . . . . . . . . . . 57

35. Paul Standing Soldier and
    Andrew Knife . . . . . . . . . . . . . . . . . . . . 58

36. Buster and his grandfather,
    Yellow Kidney . . . . . . . . . . . . . . . . . . . . 60

37. Joseph Medicine Crow dancing . . . . . . . . 61

38. Joseph Medicine Crow studying . . . . . . . . 62

39. Peter Pichette, Flathead elder . . . . . . . . . 63

40. Children look at photographs . . . . . . . . . 64

41. Nora Foky washing her
    hair with yucca root soap . . . . . . . . . . . . . 66

42. Thomas Henry Sitting Eagle,
    Oglala healer . . . . . . . . . . . . . . . . . . . . . 67

43. Navajo Nightway scene . . . . . . . . . . . . . . 69

44. *John White Man Runs Him* . . . . . . . . . . . 71

45. Jicarilla store, from *As Long*
    *as the Grass Shall Grow* . . . . . . . . . . . . . 72

46. San Carlos girl and
    miniature hammock . . . . . . . . . . . . . . . . 73

47. San Carlos girl and ropes . . . . . . . . . . . . 74

48. *Johnson Holy Rock, High School*
    *Assistant, Pine Ridge* . . . . . . . . . . . . . . . 75

49. Navajo men on fence . . . . . . . . . . . . . . . 76

50. Flathead couple riding away . . . . . . . . . . 78

51. Flathead couple facing ahead . . . . . . . . . 79

52. Young Blackfeet woman . . . . . . . . . . . . . . 80

53. Young Navajo Civilian
Conservation Corps man . . . . . . . . . . . . 81

54. *Joppy Holds the Gun* . . . . . . . . . . . . . . . 82

55. The desk of the commissioner
of Indian affairs . . . . . . . . . . . . . . . . . 85

56. Stabs Down by Mistake . . . . . . . . . . . . 86

57. Meeting in Pine Ridge trading store . . . . . 87

58. Flathead girl being weighed . . . . . . . . . . 88

59. *Superintendent Ben Reifel* . . . . . . . . . . . 90

60. Robert Yellowtail,
Crow superintendent . . . . . . . . . . . . . . 91

61. Pine Ridge crafts store . . . . . . . . . . . . . 94

62. *Tom Burnsides, Silversmith* . . . . . . . . . . 96

63. Artist Andrew Tsihnahjinnie . . . . . . . . . 97

64. Flathead power-line worker . . . . . . . . . . 98

65. Mrs. Adams and her grandson . . . . . . . . 100

66. *Red Shirt Table Cooperative Herd* . . . . . . 102

67. Oglala Sioux Tribal Council . . . . . . . . . 103

68. Blackfeet house and girl . . . . . . . . . . . . 105

69. *Mr. and Mrs. Yellow Kidney,
Browning, Montana* . . . . . . . . . . . . . . 106

70. Navajo sheep . . . . . . . . . . . . . . . . . . . 108

71. Howard Gorman talks
to Navajo elders . . . . . . . . . . . . . . . . . 110

72. *Signs behind the Bar in
Birney, Montana* . . . . . . . . . . . . . . . . 113

73. Kerr Dam, at Polson on
the Flathead reservation . . . . . . . . . . . . 116

74. Kerr Dam, with workers
tending the pipes . . . . . . . . . . . . . . . . 117

75. Man and woman in a cart,
the man reading . . . . . . . . . . . . . . . . . 119

76. Jicarilla man . . . . . . . . . . . . . . . . . . . 121

77. *Mattie Last Horse at Home* . . . . . . . . . . 122

78. Mabel Burnsides, weaving . . . . . . . . . . 124

79. *Mrs. Aschi Mike Spinning* . . . . . . . . . . 125

80. *Crow Tipis* . . . . . . . . . . . . . . . . . . . . 127

*Preface and Acknowledgments*

I first came across Helen Post's work more than forty years ago, soon after I began to be interested in the ways in which Native Americans have been represented in photographs. I acquired copies of her two phototexts, *As Long as the Grass Shall Grow* (1940) and *Brave against the Enemy* (1944), and was impressed by the relative informality of their images. Despite the fact that *Brave against the Enemy* was an official publication of the U.S. Indian Office, the people in its pictures seemed at ease with the photographer. I wanted to know more but was already embarked on what turned out to be a long-term project on Edward S. Curtis, the best known of all the photographers dedicated to depicting the traditional ways of indigenous peoples. It is only during recent years that I have returned to Helen Post and learned, with some surprise, that she is still largely forgotten. Initially, I intended to devote to her just a chapter of a large-scale study of the changing photographic representation of Native Amer-

icans. But when I realized fully the wealth of imagery in the Helen Post Photography Collection at the Amon Carter Museum of American Art, Fort Worth, Texas, and how this imagery relates to aspects of the history of both Native Americans and U.S. photography, I became convinced that Post deserved her own book.

I am grateful to Post's son, Peter Modley, for donating her camera work and papers to the Amon Carter, where they are well preserved and cataloged and where many pictures are digitized for the benefit of anyone with access to the internet. Peter and his sister, Marion Schling, have kindly answered my questions, and Peter read an early draft of this book. Post worked for and knew John Collier, President Franklin Roosevelt's long-serving commissioner of Indian affairs; I am grateful to two of his grandchildren, Lucy Collier, daughter of Charles Collier; and Robin Collier, son of the photographer John Collier Jr., for sharing information with me. Staff at the Amon Carter have been unfailingly helpful. I would like to say thank you to John Rohrbach, senior curator of photographs, for hospitably taking time to comment on an earlier draft; to Devon Nowlin and Karen Barber for guiding me through many of Post's prints; to archivist Jon Frembling for genially helping me with the Helen Post Papers; to librarian Sam Duncan for assis-

tance with reference materials; and to Stefanie Ball for all her work on permissions and provision of scans. While in Texas, I was able visit the Harry Ransom Center at the University of Texas, Austin, to consult the papers of Oliver La Farge, author of the text for *As Long as the Grass Shall Grow*; I am grateful to archivist Richard Watson for his help.

I anticipate that *The Grass Shall Grow* will become but the first book to be devoted to Helen Post and that more will follow. Constraints of time, age, and funding have resulted in a book that, despite its title's reference to green space, is too redolent of my study in Leeds. I hope that future researchers will be able to make extended visits to the reservations on which Post worked in the late 1930s and early 1940s, a batch of her photographs in hand, to seek out and meet Native people with actual or inherited memories of both Post and the individuals and families she portrayed. I worked by email, and community-memory keepers who kindly helped me with identifications and other matters at Pine Ridge were Tawa Ducheneaux, archivist, Woksape Tipi Library and Archive, Oglala Lakota College, Kyle, South Dakota; and Trina Lone Hill, director, Oglala Sioux Tribal Cultural Affairs and Historic Preservation Office, Porcupine, South Dakota. On the Blackfeet Reservation, Theda New Breast, vice-chair of the Board of Blackfeet Community

College; and John Murray, tribal historic preservation officer, both of Browning, Montana, were equally helpful.

Also from long distance, archivists at a variety of institutions have been very obliging. Alex Lange and Holly Reed of the U.S. National Archives and Records Administration, Still Picture Division at College Park, Maryland, investigated the NARA's holdings of Post pictures for me. Wendy Gregory and Erin Rose of the University of Illinois Library, Urbana-Champaign, supplied a scan of a missing photograph. PDFs of rare items were provided by Peggy Tran-Le, archivist at San Francisco Museum of Modern Art; and Christa Cleeton, archivist at Seeley G. Mudd Manuscript Library, Princeton University. Michael Frost, Manuscripts and Archives, Yale University; Michelle Harvey, Archives, Museum of Modern Art, New York; and Lynn Whitfield, Texas Tech University Library, Lubbock, examined items in their holdings for me. The interlibrary loan librarians at the University of Leeds, especially Rebecca Turpin and Eddie Whitaker, have been great at locating relevant materials. I also want to express gratitude to the scholars who took time away from busy schedules to answer queries: William E. Farr, emeritus, University of Montana; Anita Herle, Cambridge University Museum of Archaeology and Anthropology; Rosalyn LaPier, University

of Montana; Katherine Morrisey, University of Arizona; Akim Reinhardt, Towson State University; Paul Rosier, Villanova University; and—a friend who recognized Post's virtues long ago—Martha Sandweiss, Princeton University. Scholar-friends who have informed my thinking more broadly about matters discussed in this book and to whom I am consciously indebted include Caroline Blinder, Goldsmith's, University of London; the late François Brunet, University of Paris Diderot; Jackie Fear-Segal, University of East Anglia; Rob Kroes, emeritus, University of Amsterdam; David Murray, emeritus, University of Nottingham; David Nye, emeritus, University of Southern Denmark; Joelle Rostkowski, director of Galerie Orenda, Paris; Eric Sandeen, emeritus, University of Wyoming; Alan Trachtenberg, emeritus, Yale University; Richard West, coeditor, *Source*; and Shamoon Zamir, New York University Abu Dhabi.

The two readers for University of Nebraska Press were perceptive, and both offered constructive criticism, to which I hope I have adequately responded. One of them offered to be identified as Miles Orvell, Temple University, Philadelphia, someone whose own work on U.S. photography has long informed my thinking. I am pleased to be published by University of Nebraska Press. Matthew Bokovoy, commissioning editor, has had faith in the book

from the start, and his advice has improved it. Heather Stauffer has kept me on track. Susan Silver's meticulous copyediting removed some inconsistencies and averted errors. I would like to express appreciation to Lindsey Auten, for the book's fine design. With Ann Baker overseeing the book's production, I knew it was in good hands; similarly, Rosemary Sekora's responsibility for publicity encourages me to believe that *The Grass Shall Grow* will, after all, find readers.

The interest of my daughter, Ruth, who also provided linguistic help, and of my son, Ben, who acted as a guide through some conceptual and computer issues, has been a considerable encouragement; the book is dedicated to them. Once again, and again inadequately, I have most of all to acknowledge the love, support, and advice of my partner and wife, Nancy.

*A Note on the Figures*

Unless otherwise indicated in the captions, all the photographs in this book were made by Helen Post. Italicization of titles in the list of figures and in the captions indicate recognized titles and are usually Post's words. Most of these Helen Post images, plus many others in the Helen M. Post Photography Collection, may be viewed in digitized form at the website of the Amon Carter Museum of American Art, Fort Worth, Texas: www.cartermuseum .org/imu/acm/#browse=enarratives.4433. Some of the illustrations here were taken from copies of Post publications in the author's collection or from works to which Post contributed. Full data on each image and on all sources is provided in the list of photographs and their sources at the end of the book.

*The Grass Shall Grow*

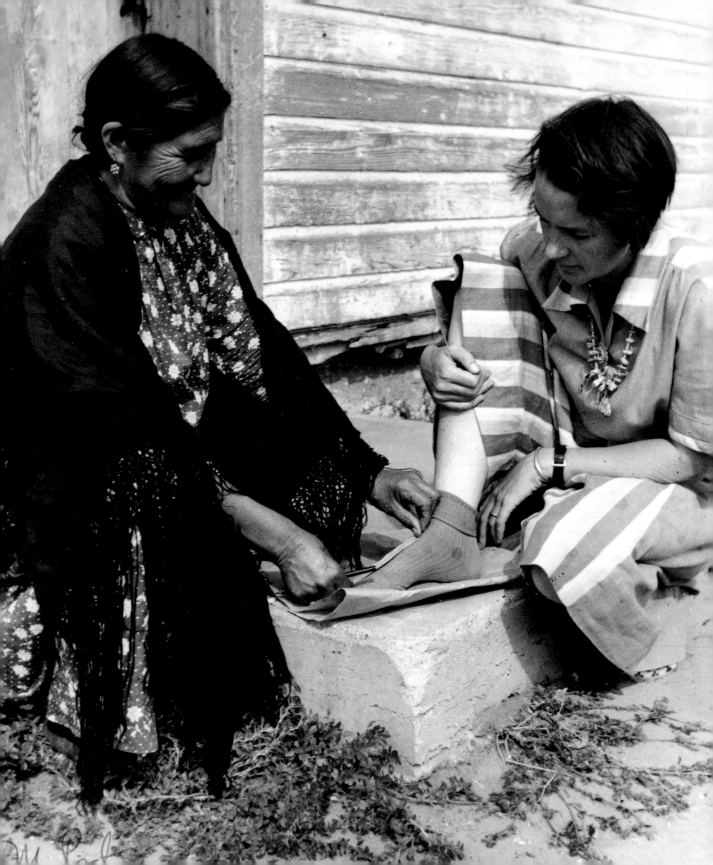

# Prologue

Helen M. Post, during a brief period of intense activity in the late 1930s and the early years of World War II, took thousands of photographs of Native Americans, some beautiful, many eye-catching, all of them informative. Working throughout the U.S. West, she built an archive of portraits, scenes of everyday life, examples of craft work, reservation landscapes, and more. She must have been pleased with what she had achieved: she held on to her files of negatives and prints, looking them over from time to time and annotating specific photographs as the years passed. But at the present time she is known—when her name achieves any recognition at all—only as the provider of photographic illustrations to *As Long as the Grass Shall Grow*, a book about "Indians Today" often credited solely to the author of its text, the novelist Oliver La Farge. *As Long as the Grass*

*Shall Grow*, published in 1940 with more than a hundred images by Post, is a fascinating factual phototext. It constituted the third volume in the Face of America series of books edited by Edwin Rosskam, a photographer and publicist very active during the second half of the Great Depression.[1]

In the United States the 1930s was an innovative period for books with photographs, especially where the images were deployed as evidence in "documentary" fashion. Publishers, designers, writers, and photographers cooperated with one another to dramatize the photographic picture book—what the Face of America series extolled as its "read-and-see techniques"—and examples were produced covering virtually every conceivable topic. By taking Native America as its subject matter, *As Long as the Grass Shall Grow* constituted a rarity among contributions to the photobook genre.[2] The cover blurb for *As Long as the Grass Shall Grow* also claimed that the book represented the latest word on its subject matter. It

1. Helen Post being fitted for a pair of moccasins by Annie Bordeaux, Rosebud Sioux Reservation, South Dakota.

I

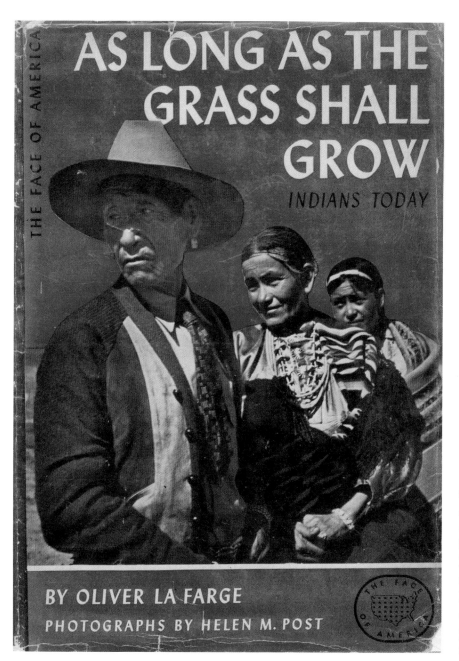

THE FACE OF AMERICA

AS LONG AS THE GRASS SHALL GROW

*INDIANS TODAY*

BY OLIVER LA FARGE

PHOTOGRAPHS BY HELEN M. POST

**2.** Cover of *As Long as the Grass Shall Grow.* The cover image depicts Aschi Mike and her family on their way to the Navajo Fair at Window Rock, Arizona, probably in 1938, the first year of the fair.

*was* up to the minute and, as such, very much a product of its epoch. But it is also a book that should be better remembered today.

Helen Post's output included photographs not only for *As Long as the Grass Shall Grow* but also for a range of other publications, most notably *Brave against the Enemy* (1944). This novel by Ann Clark, set on South Dakota's Pine Ridge Sioux Reservation and aimed primarily at younger readers, was itself a pioneering photobook: proudly bilingual, its alternate pages were printed in English and translated into Lakota by Emil Afraid of Hawk.[3] Post also made many more pictures that never featured in any publication, and a selection of these appears in print for the first time in this book. The first chapter, "Introducing Helen Post," outlines her career as a whole. Subsequent parts investigate her photography in more detail: chapter 2, "Creating a Read-and-See Book," examines *As Long as the Grass Shall Grow*; chapter 3, "Peopling Post's Pictures," focuses primarily on her approaches to individual Native people, and chapter 4, "Photographing a New Deal for the Indians," treats the way the policies of the Bureau of Indian Affairs influenced her work. In the overall course of *The Grass Shall Grow*, I identify the components of Post's vision, how her photographs represented Native peoples, and the means by which they were disseminated.

Ultimately, Post's images do not stand alone. They emerge from—and, as I suggest, they depart from—a history of photographic representation of Indians. And, while usually depicting ordinary Native people and their day-to-day activities in the home, on the land, and in social situations, some focus our attention on figures recognized at the time as influential, such as Robert Yellowtail (Crow), the first Native person to be appointed as a reservation superintendent, or the quilt maker Nellie Star Boy Menard (Rosebud Lakota). In effect, such prominent men and women help frame for us important matters—of rights and governance, art, economics, and tourism—that concerned them, usually because they were issues that affected the well-being of their entire communities. Some of these matters—including the Indian Reorganization Act of 1934, which provides the main context for chapter 4—were national in scope, while others were regional or local to specific reservations. I want to suggest, too, that Post's short photographic career both reflects and sheds light on aspects of the U.S. culture—beyond as well as within reservation boundaries—in which it took its course.

In examining Post and the particular persons and peoples she photographed in the context of the culture of the period, I must also privilege the two book-length phototexts for which she was largely responsible—partly because together they established a kind of canon of Post's photographic work. In particular, *As Long as the Grass Shall Grow*, its character shaped by

three figures then at the peak of their powers (Post, La Farge, and Rosskam), constitutes an interesting entity in its own right. It points up mainstream American attitudes toward Native peoples and offers a condensation of a singular moment in relations between Native Americans and the U.S. government. It presents data about how indigenous peoples fared during the years of its making, the era of major change permitted by the Indian Reorganization Act, itself a lauded but also contentious achievement of President Franklin D. Roosevelt's New Deal. Reading *As Long as the Grass Shall Grow* now, we are able to appreciate that it offers perspectives on the way these reforms were seen by their sponsors and supporters. We are also given at least an intimation of what such changes meant to the Native people who experienced them. *As Long as the Grass Shall Grow* therefore features strongly in the present book—especially in chapter 2.

The ease, frequent superficiality, and almost universal ubiquity of photography in our digital age may make it difficult for us to appreciate that when Post ventured onto reservations and into Native people's homes during the late 1930s and early 1940s, her visits were events. She came equipped with heavy lighting gear and several cameras, and—especially for *Brave against the Enemy*—she would often actively position individuals and groups for the best shot. She was a professional, at times a paid employee of the U.S. Indian Service, with the weight of its authority

behind her. Her photographs—no less documentary for sometimes being posed—record what appeared in front of the camera, and they often look informal, almost casual, in composition. But they also mark social and intercultural *encounters*. Post touched the lives of at least some of those she met—if only for the duration of a couple of exposures—and I regret that I am not able to demonstrate this more fully by reference to recent testimony from reservation elders or from younger folk who have inherited memories of the late 1930s and early 1940s.[4] I do show—through both analysis and contextualization of Post's photographs and by reference to her own words—that the lives of some of her Native subjects definitely touched hers.

*As Long as the Grass Shall Grow* proclaims itself a text within which Native Americans purportedly "speak" for themselves—as does *Brave against the Enemy*, if in a different manner. This is a large claim that calls for investigation, and we may decide that we do not actually "hear" indigenous voices in these works. But if the books and pamphlets to which Post contributed grant only limited access to the experience of the Native people portrayed in them, these publications—or, rather, Post's photographs in them—do give us a powerful sense of their presence. The book's conclusion, building on information provided in the preceding chapters, ventures an appraisal—mainly through readings of particular images—of Post's distinctive achievement.

# Introducing Helen Post

<div align="right">1</div>

This will introduce Mrs. Post, who is a photographer working on illustrations for a book on modern Indians. Any assistance you can give Mrs. Post in making these photographs will be greatly appreciated.

—s. d. aberle, General Superintendent,
  United Pueblos Agency

## Starting Out

Helen Margaret Post was born on May 6, 1907, into a family long settled in Montclair, New Jersey.[1] She and her younger sister, Marion—someone also destined to become a professional photographer, if for an equally short and concentrated period—enjoyed a carefree childhood, marred only by a knotty sibling rivalry that, for the remainder of their lives, never fully unraveled. The marked independence and creativity displayed by the two girls received encouragement from their father, Walter, a physician, and especially from their unconventional mother, Nan, who had conspicuously progressive views. (She later became a paid advocate for Margaret Sanger's pioneering birth control movement.) From an early age Helen convinced her parents that she had the talent and the temperament of an artist. Despite the family's straitened financial circumstances, partly caused by the separation of her mother and father after a scandalous divorce case during Helen's teen years, a trust fund established in happier times enabled her to study ceramics at Alfred University in upstate New York. During a year spent abroad in Austria, she took courses at the University of Vienna and worked as a teaching assistant near Salzburg. Through all the vicissitudes of her life, she would sustain a concern for education.

Upon graduation Post taught in Kentucky for a while before, in 1933, venturing back to Vienna, this time to learn photography as a trainee under Trude Fleischmann. Fleischmann's magnetic personality enabled her to run a successful portrait studio that doubled as a kind of salon for many members of the city's artistic community, and she and Post

may have been lovers. Post trained with a Linhof camera and in 1936 bought a secondhand one of her own that—later, along with other cameras—she would use for the remainder of her career.[2]

During the 1920s the youthful Fleischmann had courted notoriety by nude studies of dancers and made likenesses of such bestriding figures as the architect Adolph Loos, the stage and film star Tillie Losch, and the conductor Wilhelm Fürtwangler. Among those who sat for her during Post's apprenticeship were the dancer Grete Wiesenthal, sometimes accompanied by her vivacious sisters, and the young actor Hedy Kriesler, who went on to become the Hollywood legend and unrecognized inventor Hedy Lamarr. Alban Berg, the avant-garde composer, was a particularly frequent and celebrated subject, and after his sudden death Fleischmann was asked to make a posthumous portrait of him.[3]

After some months in Vienna, Post was joined by her sister, Marion Post (later Post Wolcott), who also took to photography under Fleischmann's direction, and both young women immersed themselves in the whirl of the city. Vienna, controlled by socialists, was a laboratory for progressive welfare schemes, some of them, such as the huge Karl Marx Hof working-class housing project, highly visible. Austria—since 1918 but a small remnant of the state that had once been the mighty Austro-Hungarian Empire—fizzed with ferment. Riven by profound differences between its majority conservative areas (the countryside and smaller cities) and "Red Vienna"—differences that were cultural as much as political—the nation seemed ready to boil over. Engelbert Dollfuss, the dictatorial right-wing chancellor, twice precipitated military action, with much bloodshed, against alleged "Bolsheviks," and street marches by both Nazis and socialists frequently disturbed the capital. In 1934 Austrian Nazis assassinated Dollfuss, an event that made liberal-minded citizens fear what actually happened just four years later: the Anschluss, direct military intervention and annexation by the neighboring German Third Reich.[4]

While Vienna could be frightening, it was also culturally vibrant and, partly *because* of its political upheaval, exciting. Unlike her contemporary Edith Suschitzky (later Tudor-Hart), who fled her native Vienna soon after Post arrived, Post seems not to have participated in demonstrations or photographed the strident street agitation.[5] But such events—with their waving banners and roaring crowds—were central to this moment in which Post came of age. The tenor of the times, the sense that the city's progressivism was embattled, alerted her to the potentiality of camera work that was socially engaged. The sympathy with the Left that the experience helped forge both steered her photography toward social issues and, if

less emphatically than was the case for her sister, Marion, set the compass point of her political orientation.

In 1935 Post returned to the United States and launched herself as a professional photographer in New York City, ultimately settling at 142 Lexington Avenue. In addition to taking studio portraits, mainly of children, she went outdoors, now usually with her Rolleiflex and its tripod. She photographed the soaring towers of the Rockefeller Center, the George Washington Bridge, and, further afield, factory chimneys and grain silos. She made studies of trees, of clothes on the line, of birds and flowers, and of rock formations in Maine. She documented a range of professions through individual lives—a dentist, a doctor, and Sam Lyman, a railroad engineer at the controls of his train. She produced series on such topics as a group of Peruvians determined to maintain Peruvian dance traditions in New York City, their new home.[6]

Post undertook mainly workaday commissions, some of them exhaustive, to document various progressive educational institutions, among them the newly established and experimental Black Mountain College near Asheville, North Carolina. Her work there, in 1937, included portraits of such instructors as Anni Albers, the innovative weaver, and the painter Xanti Schwawinsky, both of whom had fled their teaching posts at the Bauhaus when that prestigious German arts institution began to suffer persecution as the Nazis rose to power. She recorded, too, examples of Black Mountain seminars and studios and made landscapes out of such scenes as a group of students living out the work and land ethic of the institution by hand plowing the fields of the college farm.[7]

Post also tackled the kind of documentary photography being undertaken during this period by Arthur Rothstein, Russell Lee, and others at the federal government's Resettlement Administration under the direction of Roy E. Stryker, head of the Historical Section. The Resettlement Administration—which became the Farm Security Administration (FSA), a title that more accurately expressed the range of the agency's activities—produced photographic work that was increasingly seen as trendsetting. Stryker propounded its aims in a much-quoted formulation: "The newspicture is a single frame; ours a subject viewed in a series. The newspicture is dramatic, all subject and action. Ours shows what's in back of the action. It is a broader statement—frequently a mood, an accent, but more frequently a sketch and not infrequently a story." The FSA made and circulated "stories" of people "tractored off" their failing farms, sharecroppers eating meager meals, dispossessed "Okies" seeking shelter in migrant camps, depressed steel and coal towns, and even country folk adrift in the city.[8]

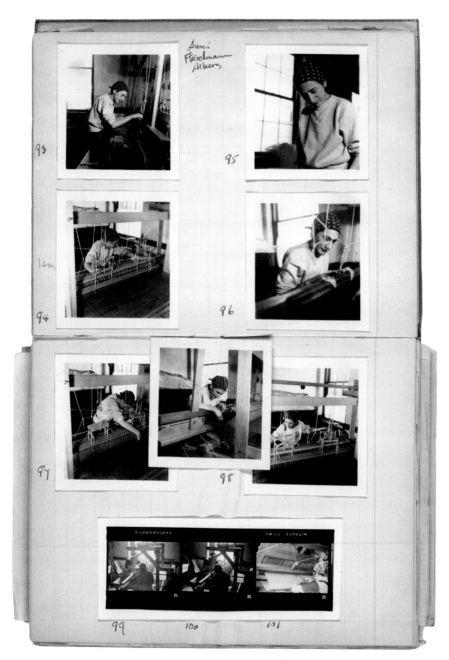

3. Anni Albers, weaver. A page from Helen Post's pasted-up and annotated sequence of contact prints made at Black Mountain College, near Asheville, North Carolina. (The use of "Fleischmann" in the handwritten annotation is a reference to Anni's maiden name. She was not related to the photographer Trude Fleischmann.)

4. Unnamed welfare recipients, West Virginia.

Post, probably while recording the educational visit to the coalfields of West Virginia by a group of senior students from Brooklyn's Lincoln High School, made a short series of striking portraits of Works Progress Administration employees and miners, both working and relaxing. But Post was clearly still learning: the two figures in *Direct Relief Client* stare discomfortingly at her camera—and she failed to record their names. These were images that might just as easily have been made by her sister, Marion, who started to work for the FSA in 1938 and subsequently remembered that her own first FSA assignment had been a trip to

document the very same West Virginia mining communities.[9]

When Trude Fleischmann arrived in New York in 1939, having fled first to England in advance of the Anschluss, she and Post worked together for a while. One of Fleischmann's contemporary portraits of Post presents the younger woman as both very professional (at ease with her photographic gear) and very feminine (its vantage point ogles her exposed crossed legs). By this time Post was married to Rudolf (Rudi) Modley, another Austrian Jewish émigré. At the time of their wedding, in late 1937, Modley—who had left Vienna in 1930—was already gaining recognition in the United States as an authority on the new field of graphic symbolism, such as pictographs, isotypes, pie charts, timeline diagrams, comparative tables, and the like, especially for use in conveying statistics but also more generally. (In later life, he would join anthropologist Margaret Mead in promoting a system of symbols as an international "visual Esperanto.")[10]

Rudi Modley was politically engaged and, like his new wife, implicitly part of what became known as the Popular Front, an informal, changing, and loose coalition of members of the Communist Party and cultural individuals and organizations opposed to fascism. Like others in the movement, he was ready to lend his varied talents to the reforming efforts of President Roosevelt's government. Modley's

day job was as an economist. In 1938 he secured a contract with the Soil Conservation Service (scs) of the U.S. Department of Agriculture, the New Deal agency established in 1935 to address the nation's ongoing catastrophic loss of arable and grazing land through drought, dust storms, and, crucially, poor farming practices. He was to assess the cost-effectiveness of actual and proposed scs projects in the West. It may be that Modley's appointment at the scs came about through the intervention of one of its founding figures, Charles W. Collier, eldest son of John Collier, Roosevelt's energetic commissioner of Indian affairs, who at this very juncture was keen for the scs to help solve problems of erosion on Indian lands, starting with the huge Navajo reservation in the Southwest.[11]

## Encountering Native America

Post decided to travel with Modley, and this led to her discovery of Native America as an ongoing subject for her camera. She was charmed by the welcome individual reservation people gave her and increasingly enthralled by the rich differences of Native cultures. At the same time she became determined to document the profound material poverty she encountered in all the reservation communities she visited. In the first years of her Indian work, she was a freelancer, but the pairing of two early images, in fact taken on the Navajo

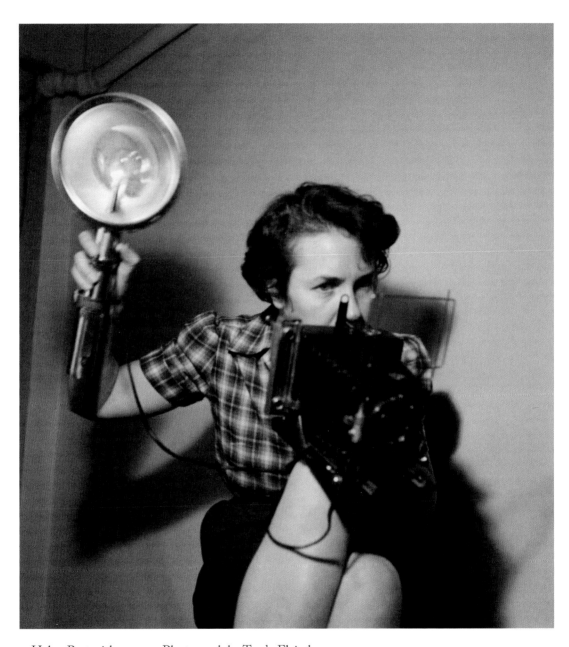

**5.** Helen Post with camera. Photograph by Trude Fleischmann.

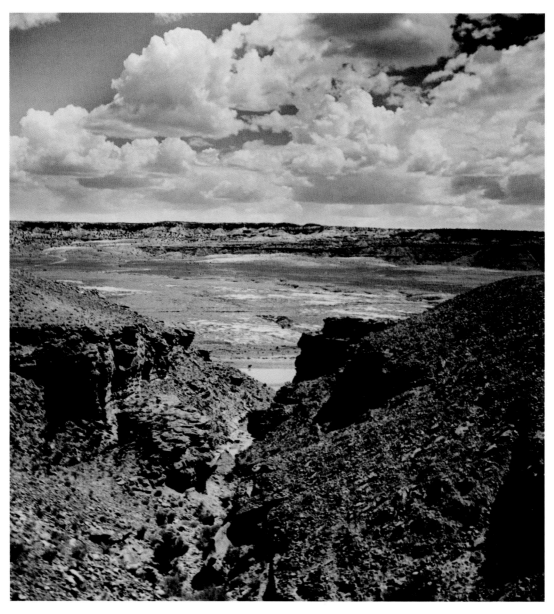

**6.** *Wastelands—Near San Juan River*, eroded Navajo territory. The original print of this image was annotated by Post: "wastelands above irrigated area near Fruitlands."

reservation, reveals their SCS context: one was aptly titled *Wastelands—Near San Juan River*, while the other, *Irrigated Land along the San Juan*, presented an example of the kind of terraced landscaping promoted by the SCS. The joint programs pursued by the SCS and the Bureau of Indian Affairs (BIA) in Navajo lands proved highly contentious, and we will later consider Post's possible role in them.

While in Navajo territory, Post appears to have worked alongside Milton (Jack) Snow, who—though trained and proficient in archaeological photography (he had been employed by the Los Angeles museum service)—was establishing himself as a photographer of SCS projects there. Snow stayed on in Navajo country for the next two decades, heading a photographic department he created for the Navajo Service, and he also photographed on the neighboring Hopi reservation. He documented all aspects of Navajo life, including many views of men and women at work. One of Snow's pictures depicts a gang of laborers securing a rocky roadside, all the men just about framed within the contour of the hillside rising behind them, as if to emphasize that they were working *with* the land. In his Navajo Service role, Snow took on Navajo assistants, some of whom became photographers in their own right. James C. Faris, in his probing book *Navajo and Photography* (1996), reproduced several of Snow's images and emphasized

Snow's personal regard for his Navajo subjects, empathy that he was able to translate into professional tact as a photographer. Post both acquired some of Snow's photographs and learned from him.[12]

Sometimes with Modley, sometimes alone, at least once with Fleischmann, Post, for the next few years, went west on several tours to photograph reservations from southern Arizona to northern Montana. Newspaper publicity items about *As Long as the Grass Shall Grow* declared that she traveled "about 10,000 miles" for its pictures. Typically, she would write ahead to prepare the way for her actual arrival, spend some weeks on each of the reservations she visited, and for accommodation would often accept the hospitality of Native families. Sometimes, when traveling alone, she slept by the roadside in her car, leaving a large hat on the dashboard to obscure the fact that she was a woman on her own. She also made occasional forays back east, photographing, for example, carvers and other craftspeople at work in the Seneca village of Tonawanda, in upstate New York.[13]

Ultimately, Post seems to have taken over four thousand Native American photographs. These depicted very many facets of reservation life: governance, work, play, prayer, education, flora and fauna, medical provision, and much else. It is not known precisely how her collaboration with Oliver La Farge on *As Long as the Grass Shall Grow* came about; possibly

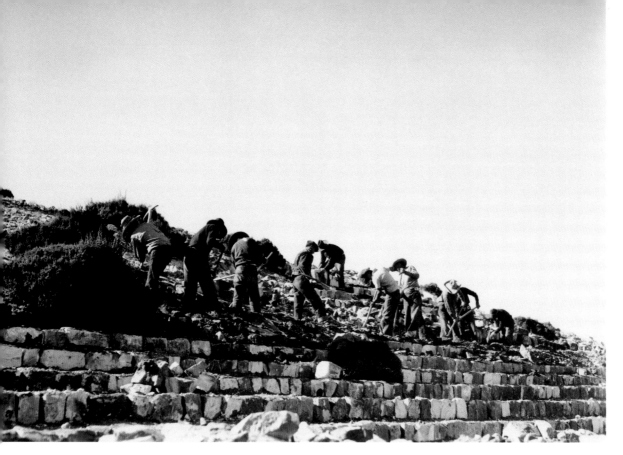

7. Navajo road crew at work. Photograph by Milton Snow.

it was through the intervention of her sister, Marion, who was a friend and FSA colleague of Edwin Rosskam, the general editor of the book's series. La Farge was responsible for the overall structure of the book's written text and, of course, for its detailed phrasing, but the concentration on particular peoples and reservations was largely determined by where in the West, up to late 1939, Post had ventured with her camera. Trude Fleischmann, in a series of artfully composed camera studies, recorded how author and photographer

together—working with prints Post had made after each of her reservation visits—selected which of Post's pictures should appear in the finished book. Rosskam took responsibility for the volume's layout and design.

*As Long as the Grass Shall Grow* constitutes a lively survey of "Indians Today"—the governance of reservations; the health, education, and welfare of the people; their economic prospects; recent reforms; and more. It sold well enough to permit, after the United States entered World War II, the planning of a new edition with

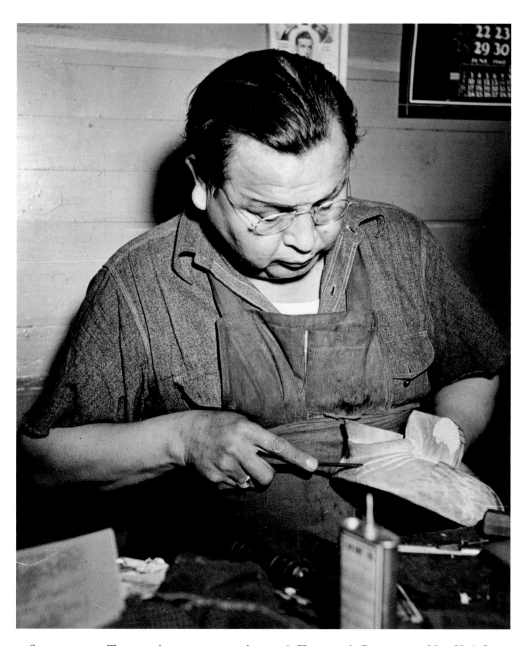

**8.** Seneca man at Tonawanda carving a wooden mask, Tonawanda Reservation, New York State.

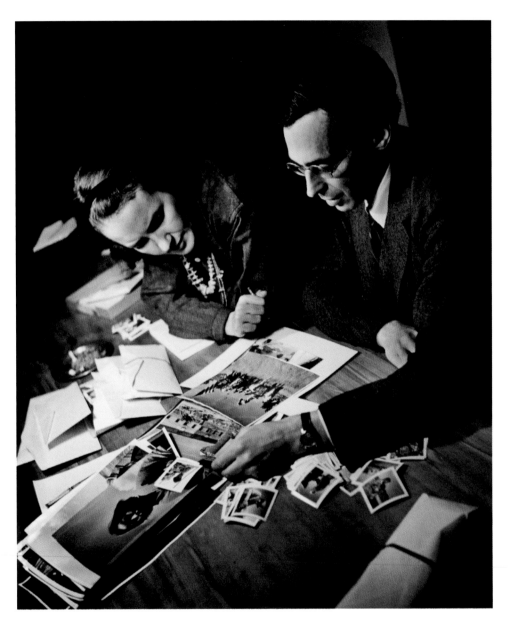

**9.** Helen Post and Oliver La Farge sorting images for *As Long as the Grass Shall Grow*. Photograph by Trude Fleischmann.

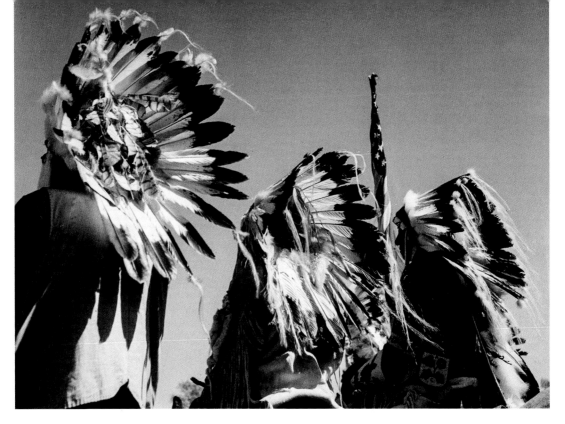

**10.** Headdresses, Crow Fair, Crow Reservation, Montana.

an extra section on the "war situation" faced by Native peoples. It found favor with such photographic friends as Jack Snow, who congratulated Post on the making of a "fine series," and it was widely reviewed, with both text and photographs eliciting warm appreciation, if not of a particularly discriminating kind. The exception was a review in the *Saturday Review of Literature*, by Margaret Bourke-White. Born in 1904 and therefore not much older than Post, Bourke-White had by 1940 already achieved fame as the star staff photographer for *Life* magazine. She became, for her time, *the* face of photojournalism. In the review she extended a welcoming hand to her younger compatriot: "Miss Post attains professional position with ease. The reader need turn only as far as page three to recognize that here is a photographer with a viewpoint of her own. The picture of the three Indians showing only the backs of heads, with a furled American flag worked unobtrusively into the composition, is both expressive and beautiful." Bourke-White listed other pictures she found impressive—among them "the small boy in the football helmet, the Indian butchering a steer, the workmen on a penstock"—and acknowledged that several more were "eloquent with motion."[14]

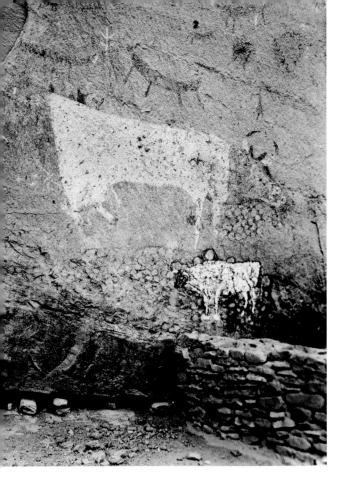

**11.** *Pictograph That Gave Name to Standing Cow Ruin*, Canyon de Chelly, Arizona.

Perhaps most significantly, Bourke-White recognized—despite the fact that "Indians are traditionally picturesque, and feathered headdresses are handsome material for photographs"—that Post had *not* succumbed to the picturesque: "Fortunately all the best pictures in the book are not those depending on these decorative accessories." Yet the review also sounded some grudging, even vaguely condescending, notes: "While Miss Post's work

at this period in her photographic development is not uniformly good, her best pictures are those of pictorial scenes, and these clearly demonstrate her ability to grasp the handling of light and shadow." "As her work progresses," Bourke-White put it, "she will undoubtedly widen her range to include a more precise selection of detail and character."[15]

It was a selection of the images Post had made for *As Long as the Grass Shall Grow* that marked—in the form of matted twenty-by-sixteen-inch exhibition prints that she produced especially—the apex of her reputation as a photographer. Under arrangements made between Post, her publisher, and the Association on American Indian Affairs, the reform organization over which Oliver La Farge presided, up to fifty of them at a time were displayed at venues throughout the United States as part of a publicity drive to sell the book. Through the months of 1940, Post's pictures were thus exhibited for short spells at Wanamaker's department store in Philadelphia, at Marshall Field in Chicago, at the San Francisco and Santa Fe Museums of Art, and in libraries and other venues throughout Indian Country, often nearby or actually on the reservations where the photographs had been taken. At one point they were planned to appear at the Los Angeles County Museum alongside the images made by the "photo-historian" Edward S. Curtis for his monumental compilation, *The*

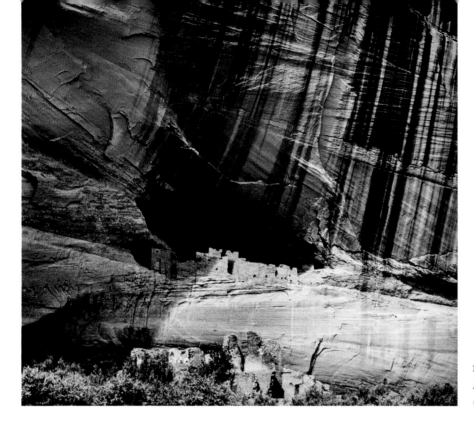

**12.** *White House Ruins, Canyon de Chelly*, Arizona.

*North American Indian* (1907–30), but instead they went to the Southwest Museum.[16]

Post's interests extended well beyond the "Indians Today" remit of *As Long as the Grass Shall Grow*. She compiled, for example, a sizable file of photographs of the nineteenth-century pictographs on the walls of the Canyon de Chelly, Arizona, at the heart of Navajo territory, as if she was making a comprehensive inventory. One of these shows domesticated cattle, two cows stippled in white on the rock face, while at least one other animal—perhaps wilder and certainly more abstract—may be seen above them. Perhaps aware of the archaeological approach adopted since about 1925 by

her contemporary Laura Gilpin, as most fully displayed in Gilpin's first book *The Pueblos: A Camera Chronicle* (1941)—the only notable "Indian" photobook of the era, one that stressed Pueblo peoples' place in, almost subjection to, their architectural and natural habitat—Post also photographed the Canyon de Chelly's various ancient Anasazi sites. In this series her shot of the White House Ruins bears a marked resemblance to Timothy O'Sullivan's well-known 1873 depiction of the same site, just one of many signs that she was immersed in the visual history of the Native American West.[17]

Post made portraits of figures already considered historic. One such depicted Sam Day

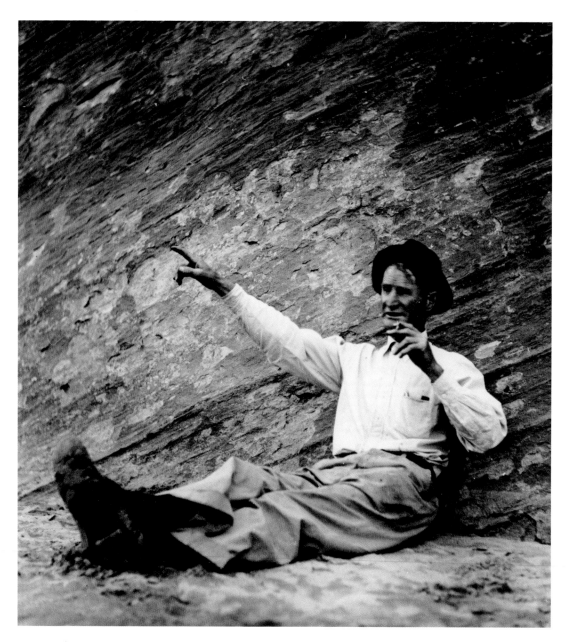

**13.** *Sam Day, Jr.*

Jr., a son of Sam Day, the prominent trader who had stores among Navajo communities at Fort Defiance and Chinle. Sam Jr. had married Kate Roanhorse, daughter of the eminent late nineteenth-century chief Manuelito, and the Day family had facilitated the Navajo work of Edward Curtis in the early years of the twentieth century. Joined by his Navajo relative Ned Bia, Day guided Post's search for "pictographic wall images." In Post's photograph of him, Day—always a flamboyant figure—appears to be holding court, and from the very earth of the canyon floor. Pointing—perhaps to a pictograph on the canyon wall above—his face slightly blurred by its own animation, he commands attention. Another historic subject was John White Man Runs Him, the elderly son of White Man Runs Him, caught in the glare of a flashgun (fig. 44). In labeling the print, perhaps years after it was made, Post seems to have mistaken the son for his father, one of the Crow warriors who had achieved renown as scouts for George Armstrong Custer when the general and his Seventh Cavalry were routed by the Lakota and Cheyenne at the Battle of the Little Bighorn in 1876.[18]

## Working for the U.S. Indian Service

By now, along with her Linhof and Rolleiflex, Post was using the Speed Graphic, with its detachable flashgun, so popular with FSA and press photographers of the 1930s. And she

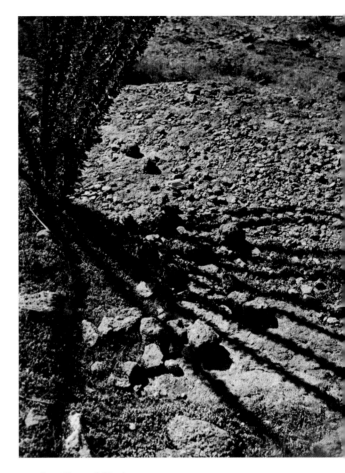

14. *Ocotillo and Shadow.*

captured many things—a Rosebud Sioux Reservation ambulance tremendously battered and broken, for instance, or a stack of tools belonging to a road crew—just because the patterns they formed made good photographs. In several of these, such as *Ocotillo and Shadow* or the untitled close-up of a shaggy horse's hooves, it is the

tendency toward abstraction that makes them visually arresting. Now and then Post managed to sell images to the Bureau of Indian Affairs, either for immediate use or to be kept on file for reproduction in BIA reports. Several, including exterior and interior views she made at Tonawanda on the Seneca reservation, appeared in the pages of *Indians at Work*, the bureau's monthly magazine during the New Deal, and late in 1940 she was officially appointed as an "educational photographer of the US Indian Service." She appears to have continued in this role for two or three years, probably through a series of short-term contracts.[19]

At the same time as her first official Indian Service appointment, the Indian Arts and Crafts Board, a New Deal agency established within the purview of the BIA, was engaged in mounting a huge exhibition of Native American art at New York's Museum of Modern Art (MOMA), and Post was seconded to work on it. She accepted the technically specialized task of photographing artifacts—masks, sculptures, medicine pipes, skins, rugs, and more. The resulting images were sometimes used as display items in their own right, alongside photographs made by Post and others "in the field," and some were circulated to the press for publicity purposes. These pictures constitute a record both of the artifacts on display and of the *way* they were displayed, which often stressed that such apparently exotic items could

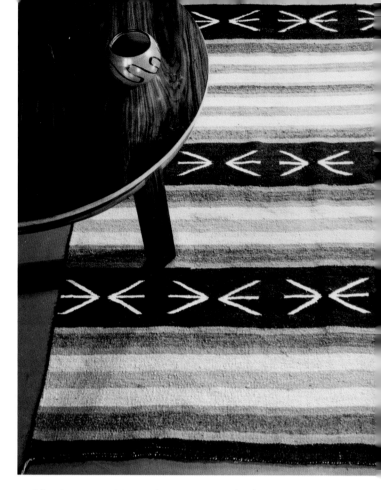

**15.** Navajo rug used in modern interior, a display at the Indian art exhibition, Museum of Modern Art, New York.

nevertheless serve as attractive features of the modern U.S. home. Many of Post's exhibition photographs—including her rendition of an albino deer skin trimmed with woodpecker feathers, an effigy made by the Karok people of the Klamath River region of northern California for ceremonial display as a sign of wealth—were reproduced in the show's major catalog, *Indian Art of the United States* (1941).

In fact, about a fifth of the book's illustrations were credited to her.[20]

The exhibition—at the time groundbreaking in its emphasis on the aesthetics of the artifacts rather than their ethnographic significance—was co-curated by René d'Harnoncourt, then manager of the Indian Arts and Crafts Board and a future MOMA director. On January 25, 1941, the First Lady, Eleanor Roosevelt, opened the show, and Post—who may also have been present—acquired a photograph of the occasion. It depicts three of the artists selected to meet Mrs. Roosevelt and receive what amounted to national commendation. They were (from left to right in the photograph) silversmith Dooley Shorty (Navajo); weaver Elsie Bonser (Pine Ridge Lakota), also skilled in porcupine quillwork and fine beading; and Nellie Star Boy Menard (Rosebud Lakota), a quilt maker especially renowned for her startling use of colors in a succession of Lakota one-star quilts.[21]

The Hopi painter Fred Kabotie, older than the others and at the pinnacle of his reputation at the time of the MOMA show, was also there, though not depicted in this particular photograph. He had been commissioned to reproduce, within MOMA, the newly excavated wall paintings at Awatobi Ruins on the Hopi reservation. His work—much of it colorful depictions of Hopi social and ceremonial life—had starred in the Hall of Indian Arts at the

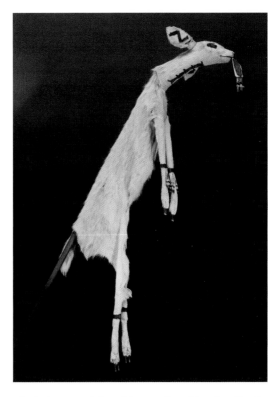

**16.** A decorated deerskin, produced by the Karok people and photographed for the Indian art exhibition at the Museum of Modern Art, New York.

new Museum of New Mexico in Santa Fe since 1930 and, as the result of a 1933 commission, thousands of visitors to the South Rim of the Grand Canyon had seen the murals he had painted in the Indian Watchtower. He would later take a leading role in the promotion of a distinctive Hopi style of silverwork and in the founding of the Hopi Cultural Center at Second Mesa at the heart of Hopi

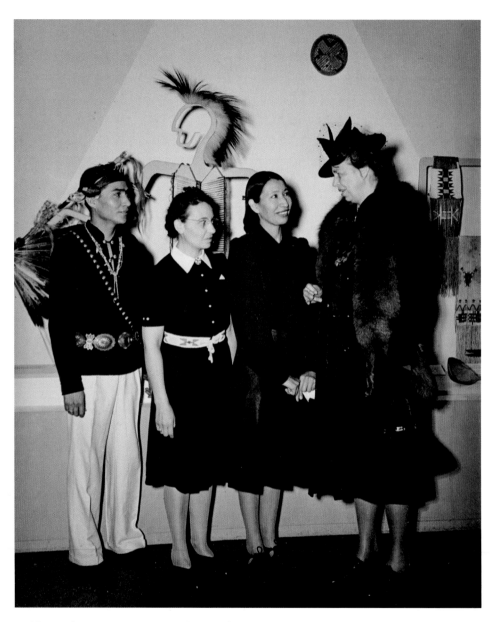

**17.** Native American artists with Eleanor Roosevelt, Museum of Modern Art, New York. Photograph by Albert Fenn.

lands. In his memoirs Kabotie remembered showing Mrs. Roosevelt his reproductions of the Awatobi murals at MOMA, "but she was a little deaf, like I am, and everywhere we went photographers were moving us around and shooting flashbulbs." "How could we talk with all that going on?" he asked. "But Mrs. Roosevelt was very kind and gracious . . . and I wished we could have gotten together for a quiet visit."[22]

Post most likely had not previously met Kabotie, and she never did get to know Dooley Shorty. By the end of the year, he had become one of the U.S. Marine Corps's famed Navajo code talkers, and after the war he went on to have a long and distinguished career in jewelry, as a maker and a teacher. But Post was probably already acquainted with Elsie Bonser, also known as Miss Red Rock, and if she didn't already know Nellie Star Boy Menard well, she soon would. A few years earlier Nellie— until her marriage she was known as Nellie Star Boy Buffalo Chief—had started the Rosebud Museum, with its Art and Craft Shop, and from this base she both helped others revive traditional crafts and promoted interest in her own work. Appointed to the Indian Arts and Crafts Board, she was selected to advise on the MOMA show and during it acted as a guide and demonstrator. Post probably acquired her print of the Eleanor Roosevelt group photograph, taken by Albert Fenn, then newly appointed as

a staff photographer for *Life*, as a gift from Nellie. For her part Mrs. Roosevelt was bowled over by what she saw in the MOMA show. She wrote in My Day, her syndicated newspaper column, "I am simply mad about the Indian exhibit."[23]

A little over a year later, at Rosebud, on the stoop of Nellie Star Boy's Art and Craft Shop, another skilled craftsperson, Annie Bordeaux, would measure Post's feet for a pair of moccasins. Post, in turn, took many photographs of Nellie—out and about, in the museum, tending her children, and costumed for powwows. In one of them, in which Nellie wears traditional dress, the Madonna-like formality of the pose is tempered—indeed, thoroughly humanized—by the seeming intrusion of the young boy. In fact, Post's time at the MOMA exhibition and at Rosebud led to a lifelong friendship with Nellie, who, in her own right, built a formidable reputation as an artist and administrator. In 1995 her lifetime of achievement led to the award of a National Heritage Fellowship by U.S. federal authorities.[24]

Probably through another Jewish refugee from Nazi-annexed Vienna, gallery owner Otto Kallir, Post was able to complement the MOMA show with a small solo exhibition of her own reservation work at Kallir's nearby Galerie St. Etienne at 46 West Fifty-Seventh Street, where her pictures were hung very close to samples of Hopi and Navajo weaving. The *New York Times*, in commending Post's

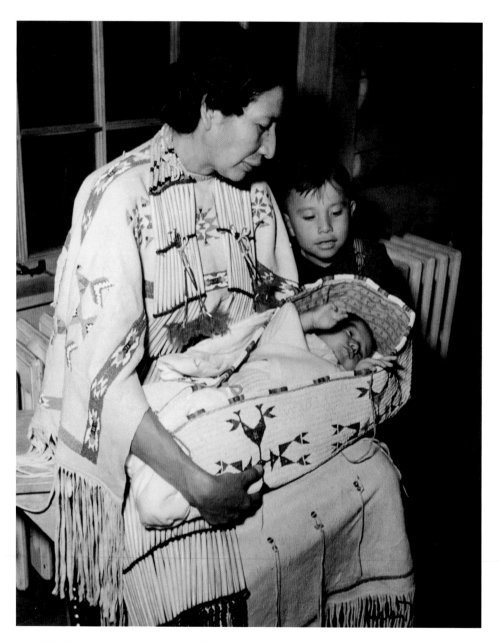

**18.** Nellie Star Boy Menard and children.

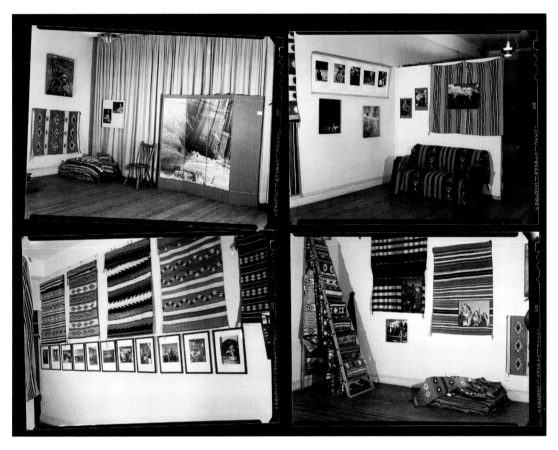

**19.** Four contact prints of Post's photographs on show with Indian textiles at Galerie St. Etienne, New York.

show, reported on February 2, 1941, that she was "about to set forth to record the life of a Sioux boy of today." This was the venture that, over the next three years, developed into the bilingual *Brave against the Enemy*, with text by Ann (Nolan) Clark, and Lakota translation by Emil Afraid of Hawk, a man who in 1930 had been to Washington DC to petition for the return of the Black Hills to his people and who frequently interpreted for white dignitaries during their visits to South Dakota's Lakota communities.[25]

*Brave against the Enemy* is a fact-based story of a young man's coming-of-age—as the sea-

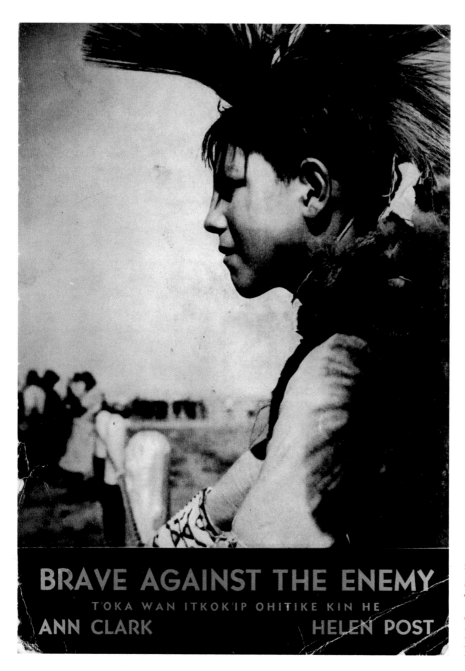

BRAVE AGAINST THE ENEMY
TOKA WAN ITKOK'IP OHITIKE KIN HE
ANN CLARK                    HELEN POST

**20.** Cover of *Brave against the Enemy*. The cover image depicts Edsel Wallace Little dressed for the Pine Ridge Fair.

sons change—in a Plains reservation community. The youngster's immediate family, his school, and the landscape are all evoked in the book's prose, but most vividly by the twenty-three pictures created by Post in her role as an Indian Service educational photographer. They were selected from many more that Post made specifically for the book, mostly at Pine Ridge but also on the adjacent Rosebud reservation, where she renewed her friendship with Nellie Star Boy Menard.

It is not known whether, when Post spent time at Pine Ridge for *Brave against the Enemy*, she interacted with her sister, Marion, who was working that summer of 1941 on FSA assignments out West. In August, for example, during Marion's sixty-day trip, she photographed— some two years later than Helen—the Crow Fair in southern Montana. On the same journey Marion actually traveled through the Dakotas and went on northward to Glacier National Park and the Blackfeet reservation. Meanwhile, also in August 1941, Helen made what were probably her final portraits at Pine Ridge, of Mattie Last Horse, posing in the traditional dress she also wore for the dedication ceremony for the new day school at the small market town of Wanblee in the northeast corner of the reservation (fig. 77). Later, in the first years of the 1940s, probably while she was facing wartime delays in the progression toward publication of *Brave against the Enemy*,

Post appears to have cooperated on a venture with Eugene Wounded Horse, someone who ordinarily made his living by driving one of the school buses on the Pine Ridge Reservation. The project, to produce illustrations for an anthology of traditional Oglala Lakota tales collected and retold by Wounded Horse, seems ultimately to have fizzled out.[26] But some of Post's other U.S. Indian Service photographs did appear in print in the 1940s and were duly credited to her.

## Further Publications

Commissioner John Collier dedicated himself and the Indian Service not only to what he saw as reform but to trumpeting the achievement of reform. Like several other federal agencies during the New Deal, the BIA proved a zealous advocate of the effectiveness of its policies, and in particular Collier believed they could be profitably adopted by other American nations with indigenous populations. In 1942 the U.S. National Indian Institute, an education and research branch of the BIA established by Collier, published *Los indios de los Estados Unidos*, the first of a series of softbound, short Spanish-language titles, the bulk of it written by Allan G. Harper, but with sections contributed by Joseph C. McCaskill and by John Collier himself. The second in the series, *La política de los Estados Unidos sobre gobiernos tribales y las empresas comunales de los indios*, was

devoted to indigenous governance and written by McCaskill in tandem with one of the earliest Native American figures permitted to exert actual influence in the Indian Office, the Salish Kootenai author D'Arcy McNickle. These books were quickly followed by others—on Indian agriculture, on reservations, and on art, the last written by René d'Harnoncourt, co-curator of the 1941 Museum of Modern Art show. The series was not hot-metal printed but produced at relatively low cost in typescript; despite the modest format of the books, they were generously illustrated by photographs, the first two with ones credited to such agencies as the Bureau of American Ethnology, the National Park Service, the scs, and the Indian Office itself. But, as stated in a prefatory note, they also included shots by "the renowned photographer, Miss Helen Post" ("la conocida fotógrafa, Miss Helen Post").[27]

A fair number of the images in these books from hands other than Post are either quite familiar (for example, Alexander Gardner's 1872 portrait of Red Cloud, the renowned Oglala leader, or stock views of Monument Valley in Navajo country) or they have a generic feel (a circle of tipis, anonymous totem poles, unnamed men in feathered headdresses). This means that Post's pictures bring to the series a look of freshness, of "today," often an informal sense of ordinary lives and the domestic round. Readers of *Los indios de los Estados*

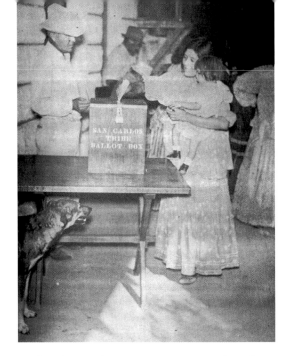

**21.** San Carlos Apache woman voting. Page from *La política de los Estados Unidos sobre gobiernos tribales y las empresas comunales de los indios*, by Joseph McCaskill and D'Arcy McNickle.

*Unidos*, for instance, soon encounter a view of laughing children running toward the camera, and *La política de los Estados Unidos* presents a San Carlos Apache woman at the ballot box, smiling, about to vote, her child held lightly on her hip.

In 1947 the Indian Service itself again published some of Post's photographs in a book: eighteen of them served as illustrations to *Weave It Yourself*, a ninety-seven-page instructional manual by Flora Dee Goforth, a lively Texan friend who had been the weaving teacher for the BIA at Pine Ridge during the time that Post was working there on *Brave*

*against the Enemy*. For several of the pictures, sequential views of the weaving process, Grace Giroux, one of Goforth's Lakota students, acted as Post's model. But most significant was Post's contribution to *The Navaho Door: An Introduction to Navaho Life* (1944) by the anthropologists Alexander and Dorothea Leighton. Along with other Navajo photographs made either by the Leightons themselves or by the U.S. Indian Service (most likely Milton Snow), these illustrations helped to turn an academic study into a semipopular guide.[28]

*The Navaho Door* is deliberately easy to read and slightly folksy in style: in their introduction the Leightons even claimed they had come on Navajo territory almost by accident but had stayed to learn more because they had found its people so intriguing. As the book's subtitle indicates, *The Navaho Door* constituted a survey of Navajo history, government, beliefs, and practices, but—given that the Leightons were also doctors trained in psychiatry—it emphasized health and well-being. Post's pictures, like the others in the book, were general illustrations— Navajo landscapes, hogans, craftspeople, school buildings—and usually unrelated to specific points in the text. But there is an exception: *Health Education in the Field*, shot in 1939, shows a group of Navajos surrounding a nurse who holds up an X-ray image of someone's tubercular chest. Since the book, according to a prefatory remark, was "meant for Indian Ser- vice workers, in the first instance," particularly health personnel, this image graphically enacts the book's purpose.[29] *The Navaho Door* quickly went through a number of printings and was read by an audience much larger than the one for which it was originally intended.

Nazism and the intensification of World War II conspired to curtail Post's Native American career. Rudi Modley signed up with the New York Guard and then with the Office of Strategic Services (precursor to the CIA). Post followed him eastward, initially to Washington DC, then back to New York City, where, for a spell, she reactivated her studio. When invited to contribute a "how-to" piece to a photographic handbook, she used the specialist byline "child photographer."[30] Helen and Rudi also labored assiduously for organizations that assisted refugees from war-torn Europe, particularly Austria, welcoming many of them into their own home. At war's end the Modleys adopted two babies, Peter and Marion Elisabeth. Because Rudi was often traveling for consultancy work, the raising of the children fell mostly to Helen.

At the same time—as her son Peter Modley later remembered—Post managed a "country property" between Sharon and Kent in western Connecticut, out along what is now known as Modley Road, and bred German Shepherds as guide dogs for blind and partially sighted people. She still took photographs—and not

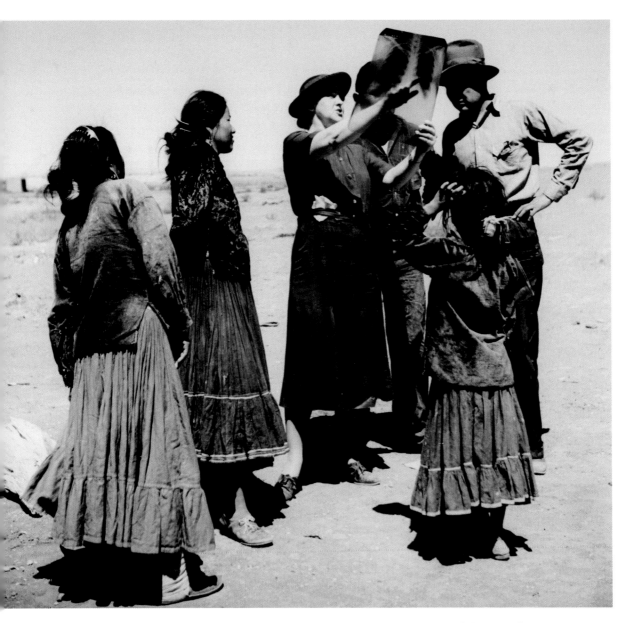

**22.** *Health Education in the Field.* Navajos viewing an X-ray. Post annotated the print, "patient in question at extreme left of group [with, on the right,] a former patient, now serving as interpreter."

just on family vacations to Gőssenberg in Austria—and in later years she tried to revive her professional career. During the early 1970s, with Rudi Modley's backing, she even had a plan to revisit reservations to photograph what was happening to the people depicted in the pictures she had made thirty years earlier. But it came to nothing, as did most of her attempts to exhibit her work anew. In 1975 she took pleasure in a local showing of her work at the Westenbrook Gallery in Sheffield, Massachusetts, and Dover Publications issued her a contract to publish a book to contain a hundred of her photographs; yet this too failed to materialize. Her undoubted pleasure in the 1970s at the revival of public interest in her sister's FSA work must have been tinged with regret at her own neglect. She was inevitably depressed after Rudi's sudden death in 1976. During her very last months, ahead of her own death from a stroke on October 22, 1979, she moved to Washington DC and appears to have suffered a severe mental breakdown.[31]

## Post's Reputation

Post was at least name-checked by Naomi Rosenblum in the expanded edition of her *A History of Women Photographers* (2000), but in this book Rosenblum mentioned neither the subject matter nor quality of Post's camera work. The dedication of Post's work to reservation life allowed one of her images—of the interior of the cooperative store run by Jicarilla people in New Mexico (fig. 45)—to be included in *Partial Recall* (1992), Lucy R. Lippard's important and widely read engagement with the photography of Native Americans, but unfortunately without commentary by either Lippard or any of the book's indigenous contributors. Barbara Babcock and Nancy Parezo incorporated photographers—including Laura Gilpin—into their groundbreaking compendium *Daughters of the Desert* (1988), but omitted Post. Ironically, though, they did use her photograph *Health Education in the Field* from *The Navaho Door*—not for its own sake but to illustrate their brief biography of Dorothea Leighton.[32]

Other single photographs by Post have been included in more probing photographic histories of particular Native peoples. *Stabs Down by Mistake Addresses the Tribal Council*, for example (fig. 56), was reproduced in William Farr's *The Reservation Blackfeet, 1882–1945* (1984) and *Ned Bia on Pick-Up Truck* appeared in James Faris's *Navajo and Photography*. Unfortunately, Faris negated his acknowledgment of Post by also including unwarranted commentary: he took a chance remark by Peter Modley about Post "tricking" Native subjects into believing that a picture had already been made, so as to secure a more "relaxed" one, as characteristic of *all* her work. In reproducing a group scene of Navajo women sitting against a log wall, in

which the figures look away as if they might have been shunning the camera, he charged that Post was *routinely* obtrusive, a claim easily countered by an examination of her archive (where this Navajo group is the *only* such picture) or, even, just a glance through either *As Long as the Grass Shall Grow* or *Brave against the Enemy*.[33] In fact, one of the very figures who for Faris appeared to look away, Ned Bia—described by Post as a "terrific guide and interpreter"—is captured with a smile in one of Post's portraits of him.

Otherwise, although some of Post's pictures are preserved in a variety of museums, including the Smithsonian Institution's National Anthropological Archives, and some have occasionally been reproduced in print—novelist Wallace Stegner, working with the editors of *Look* magazine, used several in *One Nation* (1945), itself very much a postwar book published specifically to commend the value of an ethnically diverse population—her creative output has remained virtually unknown.[34] This is a great pity. When looked at in the round, the sheer expansiveness of Post's photographic representation of Native American cultures impresses. There is nothing comparable to her vivid and varied depiction of key features of reservation life during the middle years of the twentieth century. And many of her individual images are both instructive and visually pleasing.

23. Ned Bia, Navajo guide and interpreter.

# Creating a Read-and-See Book    2

Let these facts speak for themselves, then let us look again at the people, seeing how it goes with them now.

—*As Long as the Grass Shall Grow*

## Rosskam's Designs

Edwin Rosskam was born in Germany in 1903 to American parents and first came to the United States as a near immigrant at the end of World War I. After training as a painter, spending a period roaming Polynesia, and working a spell as a news photographer, Rosskam got himself hired in 1938 by Roy Stryker, head of the photographic unit at the Farm Security Administration, primarily as the FSA "photo editor" and exhibition specialist. Rosskam was renowned for his "eye" and for his skill in the contextualization of images. He mounted *In the Image of America*, the enormously successful FSA exhibition shown in New York and Philadelphia during the months just ahead of the Japanese attack on Pearl Har-

bor that precipitated the United States' entry into World War II. This show ranged widely in subject matter and emphasized the diversity of the nation: though it mostly featured the more smiling aspects of life, it also included, for example, pictures of African American urban poverty taken by Rosskam himself. It incorporated, too, all the genres practiced by the FSA photographers, several of whom— most notably Walker Evans and Dorothea Lange—were acquiring reputations as artists in their own right.[1]

Despite the broad scope of *In the Image of America*, only one photograph of a Native American graced the exhibition. Perhaps this is not surprising, because Stryker and the FSA photographers—while enormously expanding their coverage beyond the FSA's initial remit to document only its own activities as an agricultural agency—rarely paid attention to Indians. Though the FSA photographic unit came to embrace city life as well as rural con-

cerns, eventually poking into virtually every corner of the nation, reservations were a sort of blind spot. Early in the life of the unit, in 1936, Arthur Rothstein did document Mescalero Apache housing in New Mexico, and Russell Lee, a year later, took numerous views of Native seasonal laborers at work in the blueberry fields near Little Fork, Minnesota. After the United States entered the war, other FSA figures—including, as we have seen, Post's sister, Marion—shot sequences in Indian Country, but these too stand out as oddities in the file. In an interview conducted in 1985, John Collier Jr., the FSA photographer most interested in Native life, recalled his sense of things with some bitterness: "Basically, Stryker was not interested in Indians and their problems."[2]

Sometimes Native people did appear in FSA photographs but were hidden in plain sight, as it were: the frazzled but Madonna-like "Okie" woman with her children that Dorothea Lange depicted in her celebrated *Migrant Mother* (1936), unnamed by Lange or the FSA, was later identified as Flora Owens Thompson, a Cherokee woman who, at the time of the photograph, worked as an itinerant pea picker. There seems to have been a tacit understanding that the FSA would not normally encroach on Indian Office territory, but this did not prevent the Indian Office from making some use of the FSA and its growing picture files. The first dust storms occurred in April 1934, and in

1936, at the height of the drought that led to the Dust Bowl, *Indians at Work*, the Bureau of Indian Affairs house magazine, printed a short explanation of the situation by Edwin Locke, information officer for the FSA. A few weeks later the magazine started to reproduce Dust Bowl images made by Rothstein: the frontispiece for the issue of August 15, for example, shows a cowboy and some steers *In Search of Water*, and a few pages later Rothstein's graphic presentation of a bleached cow skull lying on the cracked earth appears. In fact, FSA pictures by Rothstein, usually off-reservation views, became an infrequent feature of *Indians at Work*.[3] Given this checkered history between the two government units, it could be thought that Rosskam was going out on a limb when, at the same time as he was preparing for the *In the Image of America* show, he commissioned an entire volume devoted to "Indians Today" for his book series, itself an offshoot, if freelance, of his role at the FSA.

Rosskam brought his design and layout skills, together with his own written text, to the first two items in the series, *San Francisco: West Coast Metropolis* and *Washington: Nerve Center*, both of which were published by the Alliance Book Corporation in 1939, the first with an introduction by William Saroyan, the California story writer and playwright then at the height of his fame, the second with an introduction by Eleanor Roosevelt. In these

**24.** *Negro Man Entering a Movie Theatre by the "Colored" Entrance, Belzoni, Mississippi.*
Photograph by Marion Post Wolcott.

works—which also used predominantly his own photographs—Rosskam put into practice the belief that, as he phrased it in *Washington*, "the new unit of communication is the double-paged spread" in which word and picture complement each other.[4]

Each book in the series was designed slightly more dramatically than the last. In *San Francisco*, although the author's preface claims that "the combined medium of words and pictures . . . interpret a city," the photographs—set off by conventional neat captions in curlicued typeface—are actually just freestanding illustrations, making the volume look the very armchair "guidebook" it claims not to be.[5] In

the later additions to the series, by contrast, the pictures—with intermittent bold sans serif intertitles—often interrupt and interact with the text in a dynamic manner. The photographs, printed in different sizes and variously positioned on the page—some bleed to the edge of the page, one or two cut into others—*direct* the eye, sometimes just to move onward, but often to compare and contrast or to stop and stare.

The 1940 additions to the series, now written by figures well known enough not to need the boost of prefatory material by someone more famous, were *As Long as the Grass Shall Grow* and *Home Town*, a celebration of the U.S. small town by veteran novelist Sherwood

Anderson. *Home Town* incorporates images taken by virtually the full roster of FSA photographers, including Marion Post Wolcott, who had an especially acute eye for the indignities suffered by African Americans in the segregated South. The same may be said of *12 Million Black Voices*, the "folk history" of Black America by Richard Wright, whose powerful 1940 novel, *Native Son*, had immediately established him as the leading African American author of the era. Wright's *12 Million Black Voices*—which appeared in 1941—proved to be the final product of Rosskam's short career as a book editor.[6]

## A Documentary Book in Pictures and Words

All of these Rosskam publications were recognized as—in the newish term of the time—"documentary," produced as if from obvious firsthand evidence, such as testimony taken straight from the mouths of witnesses. *As Long as the Grass Shall Grow* went a touch further and also reproduced—during a discussion of statutes affecting Indians—both a photostat of the first page of a piece of congressional legislation introduced for the "relief of the Cherokee Nation" and the actual routing slips used to direct it during its passage through the House and Senate (57). Similarly, along with commentary on the liveliness of Indian arts and crafts, the reader finds a direct reproduction, admittedly in only black and white, of a vivid friezelike painting by one of the leading indigenous artists of the period, Ma Pe Wi (also known as Velimo Shije Herrera) of the Zia Pueblo, New Mexico.[7] It depicts a Pueblo religious ceremony: masked buffalo dancers perform in the plaza accompanied by drummers, while a woman ritualistically wafts eagle feathers (78).

*As Long as the Grass Shall Grow* is more conventionally documentary in three other ways. First, it frequently offers extended verbatim quotations from such written material as a government report on the contemporary living conditions of the Mescalero Apaches (44–45) or an eyewitness account of the means by which supposedly oil-rich Osage individuals had been tricked out of their petroleum rights and royalties (45–46). Second, it presents sketches of the lives of actual Native men and women as testimony to the competing power of social forces and the capacity of individuals to shape a new Indian identity. Later, we examine the particular case of Joseph Medicine Crow (figs. 37 and 38), who, though unnamed, is both described in words and represented in photographs (126–30).

The third and most obvious documentary feature of *As Long as the Grass Shall Grow* is, of course, its evidentiary deployment of photographs. The very first Post photograph in the book—if we do not count the cover image with its Navajo family (fig. 2)—depicts long summer

**25.** Grass, Flathead reservation, Montana.

grass, seen from low down, reaching toward a high sky.[8] Printed immediately below the photograph, the book's opening paragraph also acts as a caption to it: "When our forefathers made their treaties with the Indians, they sought for language which should convince a people utterly innocent of our legalities that these promises were binding and eternal. Let the Red Children of the Great White Father (as the white men called him) withdraw beyond a certain line, let them live in amity with their white brethren, and they should be left in peace 'As long as the rivers shall run and the grass shall grow'" (1).

On a turn of the page, the text proceeds to show that such promises were often not kept, that the first Americans were removed from guaranteed lands and ended up on hemmed-in reservations all too subject to "our legalities." The photograph on page 3, which forms a double spread with this text, shows from the rear three Plains Indians, their faces hidden behind glorious feather headdresses, one of them holding a furled U.S. flag. If read alone, the picture—the very one that Bourke-White singled out for praise (fig. 10)—could "mean" a variety of things, but in conjunction with the text opposite it seems to speak of Indians *as* Americans but as Americans with an ambiguous status.

Often sequences of pictures carry captions in bold typeface that—in words lifted directly from the longer text near them— tell the same "story" as the longer text, but in miniature. A photograph of women picking up agency rations, for example, is headed "While we last we need not die of hunger," while the next—of an empty-handed man looking away from the viewer, as if preoccupied—reads, "There is nothing for us to do at all." The third—of a behatted man in profile sitting idly on a door stoop—carries the caption "Nothing to do but wait" (37–39). Sometimes such conjunctions do more than encapsulate the larger story: they indicate relationships between abstractions. One double spread, for instance, shows on the

The union between a hydro-electric plant...

...and respect for the wisdom of the long haired old chiefs

**26.** Two-page spread from *As Long as the Grass Shall Grow*.

left a huge new river dam and on the right an elderly Native man with a walking stick being helped along by a younger companion. The caption(s), split between the two pictures, read(s), "The union between a hydro-electric plant . . . and respect for the wisdom of the long haired old chiefs" (94–95). Modernity and traditionalism, it is suggested, may coexist with ease.

Sometimes the text substitutes photographs for words. Most obviously, there is a point early on where the author writes, "The pictures describe their life better than I could; let them speak directly to you, and looking at them remember that these Blackfeet are only a generation away from the reality of that white buckskin-and-beadwork magnificence which survives at Glacier Park as a way of earning a

little extra income" (42). On the page opposite we encounter a display of three images that amplify this text: one of "white buckskin-and-beadwork magnificence" and two of present-day declension, with three bedraggled children above and an elementary latrine below.[9]

Later, after a discussion of the benefits of the Indian Reorganization Act of 1934, the text reads, "Let these facts speak for themselves, then let us look again at the people, seeing how it goes with them now, the Flathead, the Apaches, the colorful American names" (81). The words, in their slightly nudging manner, give way to pictures of Native figures in socially elevated, hitherto unfamiliar roles—a professional school teacher (82) and a skilled grading-machine driver (83). Oddly, the first image in this sequence—a Navajo baby in a cradle board—is not at all about social position or economic achievement. It seems ambiguous: insofar as we focus on the style and makeup of the board, the image draws attention to a firm Native craft tradition; but if we focus on the animated face of the infant, the picture's subject matter becomes generalized as "life," or being itself. This very ambiguity involves a double take: there is, of course, no pure being; the presence of the culturally specific cradle board tells us that this small child has already become, and happily so, Navajo.

The most radical substitution of pictures for words—to which we will return—appears at the very end of the book, in a final discussion that holds out the prospect of Native Americans participating in "our national life," of them "contributing richly to it [our national life]." The text continues, "Then the longing one young Indian expressed . . . will be realized, the dream of a race that knows it is equal to any other, and has not yet given up the fight. It is the ambition, often baffled, often discouraged, never quite lost, of the educated young progressives, of old men looking down the years from their memory of another era, it is the desire of the Indian people speaking" (133).

These are the last words of the book's text proper. A final colon after the word "speaking" sets off the photograph below it, of a Blackfeet man actually "speaking" (according to the "List of Photographs"), his arm raised almost as if pointing, seemingly looking off to the right, an action that invites us to turn the page.[10] When we do so, we find seven further images, one per page, each captioned in bold lettering with words in the first person, as if each picture—or the person depicted in it—was, indeed, "speaking." What we receive, then, is what the text proper claims as "the desire of the Indian people speaking": "We shall learn all these devices the white man has, we shall handle his tools for ourselves"; "We shall master his machinery," "His inventions"—and so on—"And . . . still . . . be . . . Indians" (134–40).

The heirs
to 3 million dollars

White buckskin-and-beadwork magnificence

The progress
which was so ardently
urged upon them

27. Blackfeet people, page from *As Long as the Grass Shall Grow*. Two of the photographs are by Helen Post; the other image (of a pipe ceremony at Glacier National Park) is by an unknown U.S. Indian Service employee.

**28.** Infant on cradle board, Red Lake Day School, Navajo reservation.

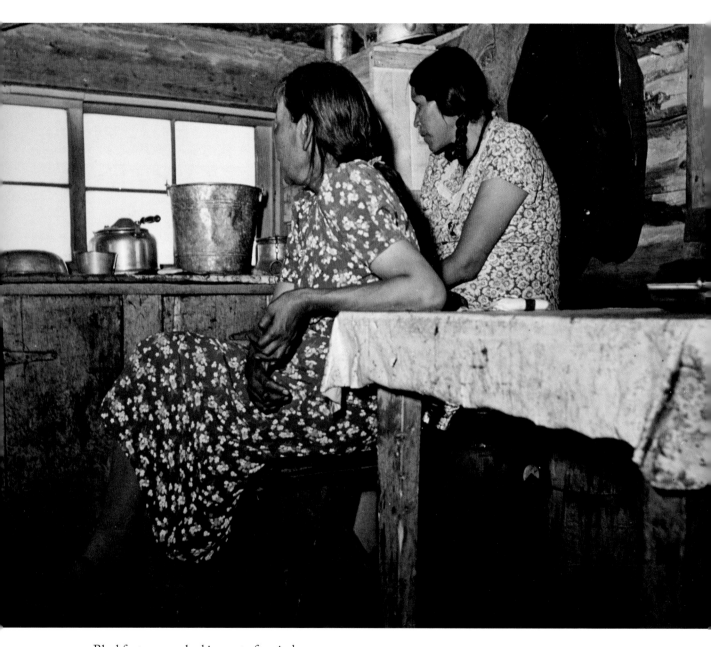

**29.** Blackfeet women looking out of a window.

As several commentators have shown, Rosskam—who in his *Washington* openly confessed that "lay-out becomes master"—often opted for a reductive parallelism between words and photographs that tended to blunt rather than enhance the pictorial power of the photographs he used. His "lay-out" or editorial work on the Richard Wright book—in which, right at the beginning of the text, he shamelessly allowed a Dorothea Lange picture of a white sharecropper to be read as black—has come in for particularly fierce criticism.[11]

Nothing in *As Long as the Grass Shall Grow* merits such strong censure, perhaps because—unlike the artists whose work was featured in the Anderson and Wright works—Post was the only photographer involved, and her connection to the book throughout its editorial and production stages meant she would have been able to protect the integrity of her photographs. (Rosskam's pasteup of the whole book shows that—except for essential enlargements and very minor crops—he left the images as they appeared in the contact prints Post had supplied.)[12] Nevertheless, some of the juxtapositions in *As Long as the Grass Shall Grow* are simplistic: early on an extensive view of buffalo scattered across a huge expanse of prairie is printed over a double page above paragraphs that begin, "It had been a good life, a roomy one" (4–5). The spread of the land is all too duly replicated, as it were, in the spread of the pages.

In one case a picture is made by its caption to act as tendentious metonym: a photograph encountered in the course of a discussion of 1923 as the "nadir of the Indians" (49–55) depicts two Blackfeet women looking out of the window of a rundown log-cabin home. We have no notion what may have attracted their attention—it *might* have been a desolate scene, but equally well it could have been their children at play. The caption above the picture, though, picks up on the textual discussion around it and, perhaps relying on the blankness of white out through the window, reads, "The end so clearly to be seen." While physically *nothing* can be seen through that window, the text and picture as a whole suggest that the women, now apparently representative of the entire American Indian people, are looking into an existential emptiness.

### La Farge's Role

Oliver Hazard Perry La Farge produced the short but artful text for *As Long as the Grass Shall Grow*—and in something of a hurry. He wrote to his brother on the last day of December 1939: "I have contracted to write a 25,000-word text for a photographic book on the Indians. It is to be a study of the realities of Indian affairs . . . , a social document, and the possibilities excite me. But the deadline is January 10, and I am about two-thirds through the first draft. So you see . . . I am rushed."

It is also likely that La Farge, no matter his excitement at the prospect of producing a newfangled "social document," had a limited appreciation of photographs and of how they might work. Certainly, despite the book's aim to educate readers away from received views of Native peoples, La Farge's surviving correspondence about it shows that his own preference in the selection of a cover image was for one depicting the all-too-usual stereotype: a Plains figure with the inevitable "feather head dress."[13]

Born in 1901, La Farge came from a distinguished family (his grandfather was the painter John La Farge, friend to Henry Adams and Henry James; his father the architect of New York City's Episcopalian cathedral, Saint John the Divine), and he benefited from a privileged education. After graduating in anthropology from Harvard, he taught at Tulane University in New Orleans, worked on ancient Mayan texts, and undertook archaeological expeditions to the U.S. Southwest and to Guatemala, all the while also turning his experiences into fiction. His novel *Laughing Boy* (1929), a tragic love story featuring Navajo protagonists, was extraordinarily successful. It scooped a Pulitzer Prize, and its highly credible descriptions of everyday Navajo life turned La Farge, overnight, into an authority on American Indians and their affairs. Reading *Laughing Boy* today, in the comparative light of fiction produced by powerful Native American writers of the

second half of the twentieth century, such as Louise Erdrich (Turtle Mountain Ojibwe) or Sherman Alexie (Spokane/Coeur d'Alene), it is not difficult to see that, as the critic Leslie Fiedler perceived as early as 1968, "writing from within the consciousness of Indians . . . [seems] an act of impersonation rather than one of identification, [giving the reader] a suspicion of having been deceived." To his credit La Farge himself, as he admitted in his autobiographical reflections, *Raw Material* (1945), was highly conscious of his limitations when fame elevated him—he "had a good name but knew nothing," he said—and set about acquiring the expertise he was presumed already to possess.[14]

By the time La Farge was commissioned to write for the Face of America series, he had not only produced more "Indian" fiction—including another Navajo novel, *The Enemy Gods* (1937)—but, with the prominent realist painter John Sloan, had organized, in 1931, what he and Sloan claimed was the very "first" exhibition of Native American artifacts as *art* rather than as the more usual ethnographic evidence. This show was a precursor to the 1941 exhibition at MOMA discussed earlier, for which Post did much of the photography. With a catalog containing essays not just by La Farge and Sloan but by such figures as the distinguished Western writer Mary Austin and the anthropologist Herbert J. Spinden, the 1931 show was

mounted—to much acclaim—at the Grand Central Galleries in Manhattan. One of the present-day Native artists to provide work for the show—a watercolor depicting an old-time buffalo hunt—was the Zia painter Ma Pe Wi, and this painting was the first to be reproduced in the catalog.[15] It should be no surprise that La Farge wrote enthusiastically, if briefly, about the development of indigenous arts, especially the employment of practicing artists as teachers at the Indian school in Santa Fe, in *As Long as the Grass Shall Grow* (66).

Crucially, La Farge had also done considerable campaigning work. He had become active in the Eastern Association on American Indian Affairs, a trust whose white members formed a political pressure group on behalf of what they saw as the best interests of Native peoples. This organization evolved into the Association on American Indian Affairs (AAIA), and—with time out for war service—La Farge served as its very active president until his death in 1963. Letters between La Farge and Günther Koppell, head of the Alliance Book Corporation, suggest that he was commissioned to produce *As Long as the Grass Shall Grow* at least in part because of his highly visible role in AAIA.[16]

It seems to have been La Farge's decision to restrict the book's detailed coverage to three culture areas of the West: the Plains, the Plateau, and the Southwest (itself the most varied of the culture areas) and, within these,

to concentrate on a limited number of what could credibly be described as "representative" peoples. Thus, the Blackfeet, Crows, and Osages represent the Plains, and the Flatheads, who live west of the Bitterroot Mountains in Montana, the Plateau. From the Southwest the main emphasis is on the Navajos and the Jicarillas, with nods, too, to the Apaches of San Carlos, Arizona, and the Pueblos of the Rio Grande in New Mexico. It was also La Farge's choice, as much as Rosskam's, to exclude material about the past—the suffering, for example, of Navajos forced to undergo their "Long Walk" into exile at Bosque Redondo, New Mexico, during the nineteenth-century Indian Wars or the vehemence of attacks on the religious freedom of Pueblo peoples during the early 1920s—to stress the general lot of "Indians today." (He did, as an exception, describe how the Osages had both benefited and suffered as a result of their oil wealth.) At the same time these decisions no doubt meshed well with the specific photographic coverage Post could provide.

## Textual Rhetoric

Sections of the text of *As Long as the Grass Shall Grow* were written in the first person—in La Farge's own voice, as it were—and stressed his close personal contact with Native American peoples. Early on, an "I" speaks to make precisely that claim: "They [Indians] were, and

still are where life remains tolerable, a singing and laughing people, quick in their humor, quick in response, masters of repartee that delights without stinging. When I look in my memory for the essence of what I have so loved in Indian camps, the summation of it, I find a tricky rhythm tapped out on a drum, a clear voice singing, and the sound of laughter" (6). Then, in accounts of the history of Indian-white relations, the "I" recurs to vouch for the veracity of points made: "But I have seen so many schools where all they had was a rail at the end of the bed on which to hang a dress" (14); "I know an Apache who, when he was a little boy, ran away from mission school" (15); "I have sat in a Navajo hogahn among a family that spoke no English, watching their eldest son die" (17). The right to speak, the authority of this "I," is based, most fundamentally, on such familiarity with Native lifeways, including formal study of them.

A second claim to authority that La Farge could address in his own voice lay in administrative experience of Indian affairs. In an account of the national struggle during the early 1920s to defeat the Bursum Bill, which had aimed to take land out of the hands of the Pueblo communities of New Mexico for the benefit of whites, La Farge first outlines the contribution of such bodies as the Eastern Association on Indian Affairs and then adds,

"Since I am now an officer of the American Association on Indian Affairs [sic], what I write may seem boasting, but I came into it late, when the greatest battles had been fought. . . . It was not my part, but of my seniors and predecessors I write" (60–61). But, of course, he *does* write of himself, if in an indirect way, in that *As Long as the Grass Shall Grow* itself constitutes another skirmish in a continuing conflict.

Also, as he so evidently embodied the AAIA, the book's text is permeated by positions promulgated by the AAIA, including the most vehement sections of the book: those outlining government policies that were ill-advised, willfully wrongheaded, or worse, such as the Allotment (or Dawes) Act of 1887. This act broke communal or tribal ownership of land, parceling it into individual allotments to allow millions of supposedly "surplus" acres to be sold off, at knockdown prices, to whites (26–30). When talking of the then present-day struggle with the enemies of the reforming Indian Reorganization Act (IRA), the text becomes particularly impassioned: "The stories I have outlined show well enough the rebirths that the reversal in Indian policy [represented by the IRA] has made possible; should the opposition [to it] prevail, all that comes crashing down. More tragic than the wrecking of programs, perhaps, will be the disillusionment, the final cruel breach of faith to prove once and

for all to the Indian that there is no use planning, no use trying, for the white man simply cannot be trusted" (132). La Farge was an earnest supporter of the IRA and had been one of the principal sponsors of a 1938 campaigning pamphlet, *The New Day for the Indians: A Survey of the Working of the Indian Reorganization Act of 1934*. In fact, although the pamphlet's preface stated that it was produced "under the editorial supervision of Professor Jay B. Nash of New York University," in much of it—the case studies especially—the hand of La Farge is evident: both generally and in specifics it actually anticipates coverage of the IRA in *As Long as the Grass Shall Grow*.[17]

The claims to authority described here are emphasized by the cover blurb to *As Long as the Grass Shall Grow*. That blurb does not mention a more nuanced claim that has been invoked since at least the time of Frank Hamilton Cushing, the late nineteenth-century anthropologist of the Zuni people of New Mexico: the authority inherent in having been accepted as a participant in indigenous ceremonial life. We see it made, for instance, in the way that Edward Curtis would express pride during his lectures and picture-opera performances at having taken a role in such events as the Hopi Snake Dance.[18] Similarly, La Farge writes about the Cloud Dance at Tewa Village on the Hopi reservation in Arizona:

It was my privilege to "work" in preparing the Cloud Dance. . . . On the last night, before the public dance appeared, we sat up all night in the kiva, the ceremonial underground chamber, making ready and rehearsing. When I came in, the place was already packed, the girls seated along one side, before them a space for dancing, in the middle the old chiefs, the rest of the floor solid with men of all ages. I sat down between the head of the auto-repair shop and a road construction foreman. The foreman gave me a cigar. The shop manager said, "Hello La Farchi, do you still think your Ford is better than a Chevy?"

For a moment I was startled, the men seemed to clash with their setting. But to them nothing was startling. . . . [They] saw no conflict between these new, external things and the ancient thing they had gathered here to do. . . .

We sang all night, building song on song, filling the place and ourselves with music as fine as any I ever hope to hear, and a delightful, uplifting happiness. It was a true approach to God. The climax song at dawn, magnificent, triumphant, thrilling, had been composed by a truck driver one morning as he drove along, seeing the first rains coming over the horizon. (124)

Notice the pronouns here: "I" becomes "we." And throughout the text pronouns are deployed with much subtlety. At the begin-

ning, when "our forefathers made their treaties with the Indians" (1), the act of identification is with whites. But soon the second person "you" appears, seemingly allowing Native people themselves to address their plight: "There was one fairly sure way out [of boarding school]. If hunger, overwork, bad air and hopelessness brought you so far down that you were clearly dying, you would usually be sent home" (17). And then, at crucial points, there is the first-person plural, marking total identification with the subjects of the book as a collectivity, a people, as in "When our children are six, the Government will take them away. If it didn't, we couldn't feed them. We have no country of our own left now" (35). But, throughout, the implied *reader* is an American, emphatically not a Native American: "The fate of the Indians depended, and depends, upon the variable conscience of the white men. It is your story as well as theirs, a fall and an upward struggle which belongs to all of us, a conflict in which the Indian pays with his life for our inattention" (68).

Clearly, the verbal text of *As Long as the Grass Shall Grow*—as all such texts must be—is a rhetorical construct. We are alerted to its most obvious rhetorical feature by the ringing words of the title—taken, as we have seen, from the oratory of treaty speeches. The phrase has a symbolic import, and La Farge granted it a material reality. One of the markers of 1923

as the "nadir of the Indians" (49) was that, due to overgrazing on the constricted reservation land, "The horses of their pride became miserable and scrawny, the dust blew. The treaties had been made for as long as the grass shall grow, and already now in many places *the grass had stopped growing*" (50). And, on the page opposite this declaration, one of Post's photographs depicts desertlike land marked by just a few horse hoofprints. Similarly, a picture of soil erosion appears later during a description of Navajo land issues: "By 1933 the condition was acute; here, too, the grass was ceasing to grow" (101). Until, again alongside a Post photograph, this time of healthy bunch grass on the Jicarilla reservation in New Mexico, La Farge can finally proclaim, as a result of *both* the implementation of sounder environmental practices and, symbolically, better government policies toward Indians, "the great fact that *the grass has started to grow again*" (110).

We should question the effectiveness of *As Long as the Grass Shall Grow* as a rhetorical construct, and, more important, we should query the truth of its claims about government actions on Indian lands—particularly whether they did, in fact, help the grass to grow. But, ahead of that, we need to appreciate better that, though largely shaped by La Farge, the book constitutes a joint product with Helen Post, a fact that has a double significance: first, her photographs animate and, by particularization,

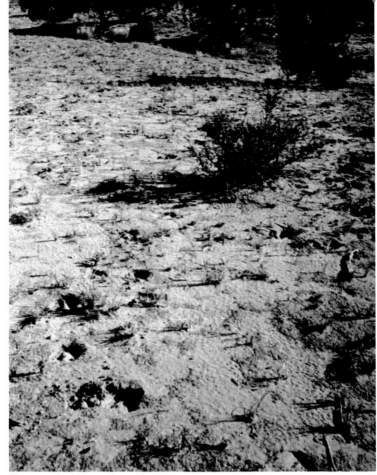

**The grass had stopped growing**

**30.** Desert image (and caption) from *As Long as the Grass Shall Grow*.

illustrate the book's words; and, second, the book's words often provide the best context for reaching an understanding of the larger meanings of a photograph, either the intention behind it or the likely reception by its first viewers. Also, we need to appreciate that, to an important extent, *As Long as the Grass Shall Grow*—like the other publications to which Post contributed, indeed like Post herself—was influenced by political decisions made in Washington.

# Peopling Post's Pictures

<div style="text-align: right">3</div>

Order No. 1418, November 25, 1939: In all cases, throughout the Indian country, any maker of pictures on tribal lands must consult beforehand the tribal officers. Limitations which they impose must scrupulously be regarded, and any charges asked by the Indians must be paid. Indians are not landscape or objects, but human beings with their privacies and dignities as such; and Indian places, though bearing no outward sign, may be as sacred in the Indian mind as any religious sanctuary in the white world.

—HAROLD L. ICKES, Secretary of the Interior

## Post, Mostly at Pine Ridge

Roosevelt's long-serving commissioner of Indian affairs, John Collier, summed up one of Post's field trips: "There among the Sioux, she saw the distress of poverty but she felt the happiness of the spirit. . . . They [the Indians] made these two months seem like a period of heightened intensity in her own humanly rich life." Collier retouched Post's experience with a near-mystical sheen: "It seemed to [her] . . .

that happiness welled from an ancient spring and flowed into a field of the future and that the field was glowing and rustling with corn and bloom." Even if Collier exaggerated here, Post's surviving papers do attest that she had a truly serious and abiding concern for both particular Native persons and the history, as lived, of the first Americans as a group. She and La Farge even had a plan, later abandoned, to hold an "auction" for "collectors" of the manuscript of *As Long as the Grass Shall Grow*, together with the photographs and other materials gathered in the course of its compilation. The money raised was to be "for the benefit of the Indians." She kept clippings, accumulated over many years, and she made extensive notes, sometimes handwritten, often typed and filed, on numerous Native subjects, including the "forgotten Indians of New York," all kinds of crafts, and such "patriot chiefs" as Geronimo and Sitting Bull.[1]

With the peoples Post actually worked alongside she had extended contact; unlike

several of the photographic artists with whom she might be compared, she didn't just arrive at the agency, shoot her film, and leave. Indeed, she built relationships with certain individuals, including the Rosebud quilter Nellie Star Boy Menard, that outlasted her photographic assignments in Indian Country. Peter Modley remembered that during road-trip vacations to points West in the 1950s and early 1960s, Post would take him and his sister to visit Menard and other friends she had made during her years as a professional photographer.[2]

In her photographic heyday, the development of relationships was most obviously demonstrated in the case of the Ann Clark book *Brave against the Enemy*, where—to meet the demands of the fact-based fictional narrative—it was necessary to follow the same Lakota "characters" through various incidents over time. As Post herself recalled, "The task of guiding a group of characters out of a similar life situation, to re-enact a fiction story, so that all the little details are correct, as well as to reproduce the main action of the story, gave me plenty of opportunity to exercise my conviction that photographs speak a forceful and realistic language. If this language of action photography of children, for children, pleases children, we can be sure it is successful."[3]

The text and photographs of *Brave against the Enemy* were structured to tell "a story of three generations—of the day before yesterday, of yesterday and of tomorrow," as undergone by the family of Louie Hollow Horn, a teenager. The "day before yesterday," as remembered primarily by Louie's grandfather, Black Buffalo, was an era of bravery against enemy warriors, of horse capture and buffalo hunting. "Yesterday," as recalled by Louie's father, Joe Hollow Horn, and his friends, consisted of cattle herding on unfenced range, a pattern of life brought to a halt for most reservation Lakota people by the breakup of their land into smaller allotted farms, economic depression, and drought. Many no longer owned any cattle or even a single horse. "Tomorrow"—at least for Louie, educated in a new vocational Indian school—would mean a mixed-grain and cattle ranch, starting with just one traded cow and the school's gift of a calf.

The "three generations"—each with their stories, and with the stories of those close to them, particularly Marie, Louie's beautiful mother, played by Fannie Makes Shines—also live in a present: a year of changing seasons in which they enjoy the rodeo, drive their wheezing car to Nebraska for potato picking at a white-owned farm, hunt quail, fell and haul timber, survive a blizzard, experience social and ceremonial dances, receive help from a healer, and, in the case of Black Buffalo, refuse a hospital bed.[4] And while each generation has its own identity, they ultimately make one "story," most emphatically when Louie, emulating his

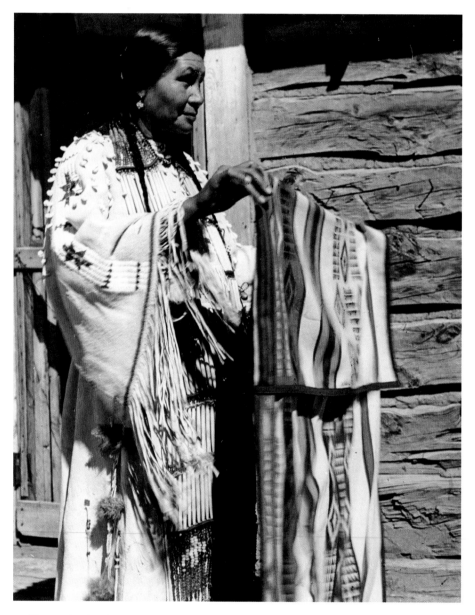

**31.** Fannie Makes Shines playing "Marie," a major character in *Brave against the Enemy* (This particular image does not appear in the original book.)

**32.** "Louie Hollow Horn," the leading character in *Brave against the Enemy*, acted by Edsel Wallace Little, in winter.

dying grandfather, embarks on a vision quest that will determine his way of life as an adult; and, crucially, his vision sets him beyond the constraints of inherited traditions. The true enemy is fear itself, and Louie is, and will be, brave against this enemy. He determines to become an independent rancher.

Given this structure, the actors were paid to spend a considerable amount of time on the project. There was extended interaction. We see Louie, usually close-up, doing a host of things, from gathering straw in summer to tending the animals in winter. In one key episode he talks intimately, over a medicine pipe, with his grandfather, Black Buffalo. In another Louie has to sleep among the straw in a barn, his calf standing in the straw near his head, looking on. The resultant picture—in which the use of flash turns the darkness of the night into visibility—shows him cooperating to do just that. The picture's vantage point—above the boy and on a level with the calf—emphasizes his abject situation, as does the overbright light of the flash.

Louie was played in the book's photographs by the fifteen-year-old real-life Edsel Wallace

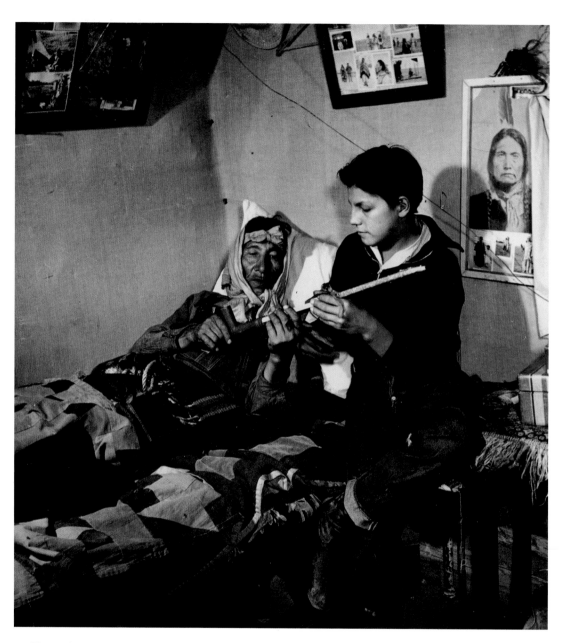

**33.** "Louie Hollow Horn" with his sick grandfather.

**34.** "Louie Hollow Horn" asleep in the barn.

Little, chosen by Post after she made a profile portrait of him, later used as the book's cover image (fig. 20), in which, as she put it, "the costume . . . [was] his very own, which he was wearing in a real celebration, with no idea either that he was being photographed, or was going to be offered the job of posing for pictures that would illustrate a new school book for the . . . children he represents." Edsel—perhaps spurred on by his experience of acting with Post—later achieved fame as the Hollywood Indian star Eddie Little Sky and often appeared in the movie frame as the third Indian man from the right, whether Apache, Pawnee, or Paiute. But in at least two films he portrayed leaders of his own Lakota people: Red Cloud in *Revolt at Fort Laramie* (1957)—though he had to suffer defeat in battle, something never suffered by the historical Red Cloud—and the fictional Black Eagle in *A Man Called Horse* (1970). *A Man Called Horse* ultimately seems exploitative—especially in its sensationalizing of the Sun Dance, performed by the white actor Richard Harris. But at the

**35.** "Black Buffalo"
(Paul Standing
Soldier) and his son
(Andrew Knife) in
a scene for *Brave
against the Enemy*.

time of its release, the makers of *A Man Called Horse* claimed it portrayed Indians in a positive manner, and they did make a feature of shooting its dialogue in Lakota. Later Little Sky returned to Pine Ridge as superintendent of its parks and in that capacity testified to the 1991 U.S. Senate Committee on Indian Affairs on behalf of the proposal (as yet still unrealized) for a national park and memorial to the Native victims of the 1890 "battle" at Wounded Knee, when the U.S. Seventh Cavalry massacred more than 250 Lakota people, predominantly women and children.[5]

Perhaps the most extreme example of cooperation between subject and photographer is revealed in another image from *Brave against the Enemy*: of the elderly Black Buffalo, played by Paul Standing Soldier, "frozen" and actually

looking very cold—even inert—after suppos-edly being rescued from a blizzard by his son, acted by Andrew Knife, who, still whitened by snow, tends him. Narratively, the picture may not be entirely convincing, but it manifestly required a committed performance from its actors. While the players in this "story" were essentially reenacting scenes familiar to them, from their own—mostly everyday—experience, the intimate pictures for *Brave against the Enemy* were all directed and posed. Many oth-ers of Post's images—where the subjects were not paid and mostly not posed—testify to her closeness to her Native subjects. Typically, she would not give directions, or even talk much, but would discreetly observe until the right moment came. She claimed that she always asked people for their individual permission to photograph.[6]

## Photographic Practices

"Navaho Lives," the most compelling chap-ter of *The Navaho Door*, the Leightons' study of Navajos, consists of the histories of three people, mostly as they themselves recalled them. The structure of *As Long as the Grass Shall Grow*, as we have seen, also includes mininarratives involving the same person or persons. A Blackfeet figure who appears in the first image of people in the book, Buster, seen looking up to his grandfather, Yellow Kidney of the Two Medicine Community at Brown-

ing, Montana—Post so identified him on the verso of exhibition prints she made—reappears several times (7, 11, 18, and 19). He is viewed, literally, from a number of angles. We follow him. We see him attending to his grandfather, playing, and learning. We have a sense of get-ting to know him. Similarly, toward the end of *As Long as the Grass Shall Grow*, the young man identified in the book's "List of Photo-graphs" (143–44) as "Crow Indian student at work on his allotment" (126) appears a number of times: first, "with his grandparents" (127); then "at his studies" (128); and, finally, "danc-ing" (129)—with extraordinary vigor, his stature exaggerated by the low camera angle—at the Crow Fair powwow. Post identified him as Joseph Medicine Crow.[7]

La Farge admitted that he did "not know this man's early story," noting only that "his grandparents go back to the old, free days of the unvanquished tribe," while "his parents come of the long, slow, downward years" (128). In later life, as if expanding on La Farge's text, Joseph (Joe) Medicine Crow, who was born in 1913, would stress his ancestry and claim that—through his well-documented exploits as a U.S. soldier in World War II—he was the Crow's "last traditional war chief." Joe's direct ancestor, Medicine Crow, had been a confi-dante to the leading Crow chief of the time, Plenty Coups; the grandfather who raised him was the prominent leader Yellowtail; and his

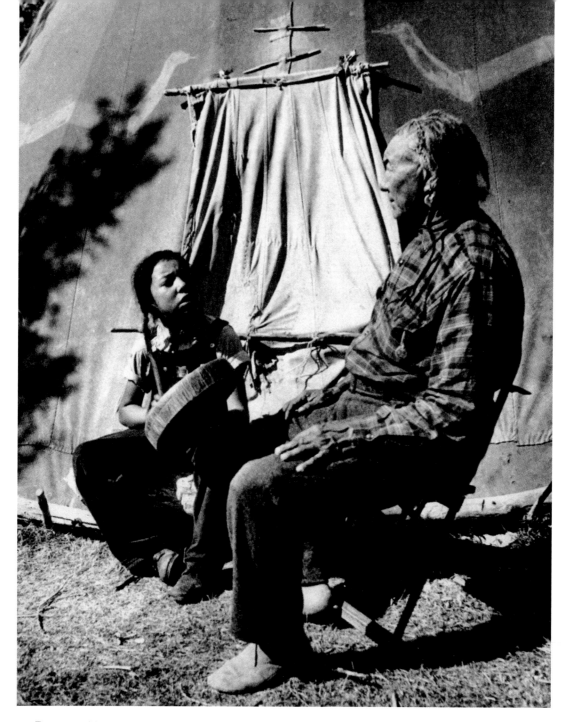

**36.** Buster and his grandfather, Yellow Kidney, an illustration from *As Long as the Grass Shall Grow*.

stepfather, John White Man Runs Him—also, as we have seen, photographed by Post—happened to be the son of the celebrated scout for Custer. The key thing for La Farge was that Joe Medicine Crow's pictures "show him well enough": they registered his close relationship to traditional elders; the way he worked "his land with modern equipment"; danced "in the ancient way"; and "steadily, even here at home," "with book and typewriter," prepared "himself for the PhD in anthropology which [would] soon be his" (130).

Joe Medicine Crow was the first Crow to earn a master's degree, in 1939, but war service prevented him from completing his promised PhD. Nevertheless, upon his return from Germany, he rapidly became the official tribal historian and also worked on Crow lands and other Plains reservations as a real estate appraiser for the Indian Office. Always, but mainly after his formal retirement in 1982, Joe Medicine Crow collected oral histories, gave many talks at the Little Bighorn Battlefield National Park, and wrote the script for the annual reenactment of the battle mounted at Hardin, Montana. He also authored books on Crow history and culture for younger readers; was cited as an authority by respected white students of Crow history, such as Frederick Hoxie; and appeared in several documentary films about Native Americans. He achieved much fame; received the coveted Presidential

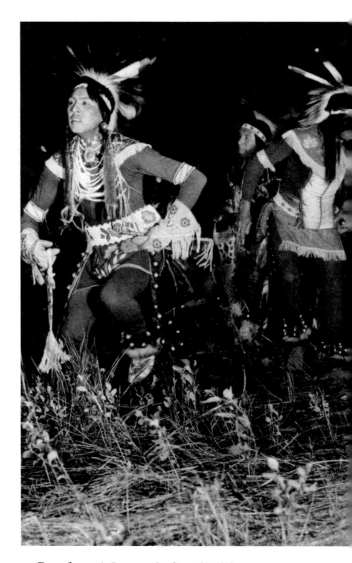

**37.** Page from *As Long as the Grass Shall Grow*, depicting Joseph Medicine Crow (*left*) dancing.

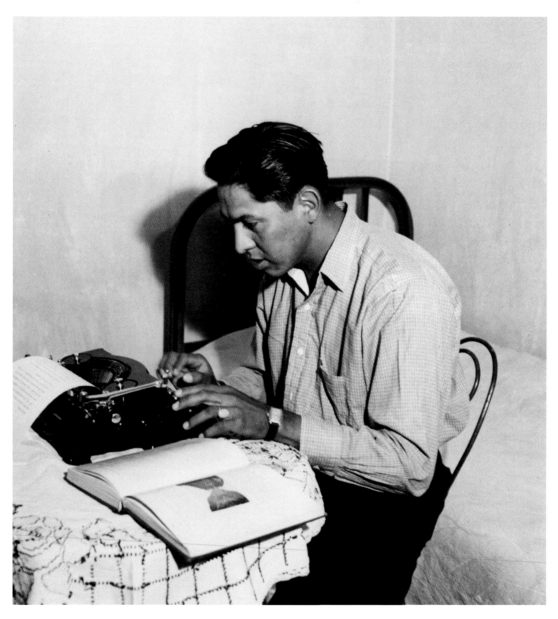

**38.** Joseph Medicine Crow studying. (In *As Long as the Grass Shall Grow* this image was printed with Joseph facing to the right.)

Medal of Freedom, in person, from President Barack Obama in 2008; and died at the great age of 102 in 2016.[8]

The relationship between Post as a photographer and those who posed for her was mostly reciprocal. She took care to dress in the manner she thought her hosts considered appropriate for a (white) woman. She gave practical help to people when she could. The Flathead elder Peter Pichette, contending with deteriorating eyesight—Post did one portrait of him using his braille typewriter—was fearful that he would not be able to complete his oral history of his people. Post's best likeness of him—taken with flash in the evening as he sits on the ground outside, probably as he was about to address others—makes us register that he has a problem with his eyes but leaves his dignity intact. At Post's urging, Pichette typed a letter to Oliver La Farge: "Helen Post . . . was here at my home two or three days ago and sure we had a [long] interview [on] this and that and through our conversation . . . she learned that I have been writing out the history of the tribe . . . that is their customs and legends and tales and Helen Post told me that you are sure interested in such." "She told me to write to you," he added, "and told me you are liable to give me a hand and assistance in taking up this work." (La Farge took a while to respond—he had been rendered inactive for a time by hospitalization—but when he did so,

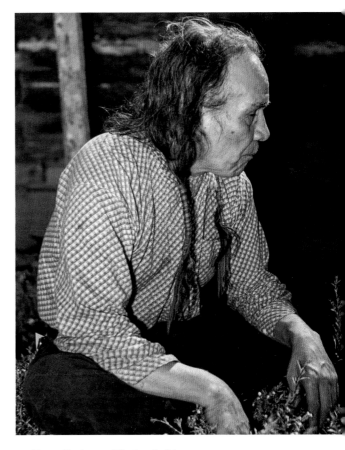

39. Peter Pichette, Flathead elder.

he asked for details of Pichette's needs and promised to help.)[9]

Post used her pictures as what might now be termed "icebreakers." At one point she appears to have written to John Collier, asking him "about the chance of traveling exhibition—in a Navajo community, staying a few days in each Day School neighborhood. Photos only, made

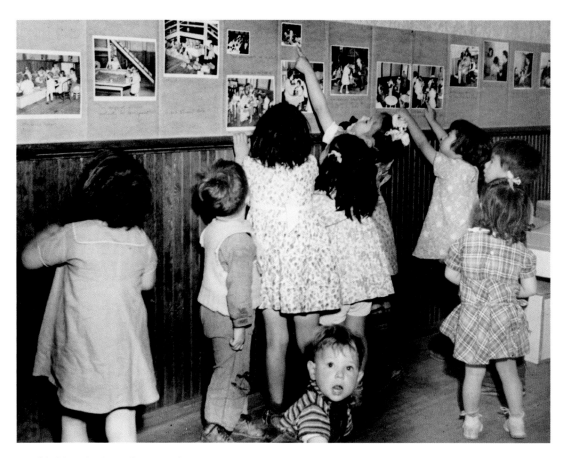

**40.** Children look at photographs.

so we could visit with the older people who . . . talk less English." She would put on displays of her photographs at the agency so that local people could see what she was doing in pictures of their own lives. In a photograph almost certainly taken at a Pine Ridge Reservation elementary school, small children—perhaps in a language-acquisition session—point and gaze at pictures of children, probably themselves, stuck to boards on the wall. Although most of the people who appeared in the photographs reproduced in *As Long as the Grass Shall Grow* were not identified by name— and *could* consequently be considered as mere representative types—they were known, and usually feature in Post's own files, as named

and sometimes quite fully rounded individuals. Peter Modley marveled at his mother's familiarity with those who sat for her:

> What is extraordinary about this work is neither her composition or technical skill, both of which were very good, but the intimacy of the photos, which reflects the amazing access the Indians gave to this strange woman. The images reach into Indian life, recording scenes in which it is hard to imagine a photographer was present, let alone a woman photographer: the blood of a freshly killed buffalo is collected in a Coke bottle by elders who will use it in a ceremony; a tribal council meets in overalls, all sitting on the counter of the trading post; an old medicine man in the archetypal felt hat instructs his grandson in his art; a young Navajo woman washes her beautiful hair in a basin outdoors; a muscular young Indian in rough cowboy attire bites the ear of a lassoed horse to divert it from the branding iron.[10]

Each of the images Modley evokes here exists, and some of them are even more remarkable when seen in the context of others taken at the same time. That of the Navajo woman—titled by Post on an exhibition print as *Nora in Native Dress Washing Hair*—is part of a detailed sequence of quiet studies of Navajo female spheres, including *Young Girl and Three Women in Native Dress, Doing Laundry* and *Woman in Native Dress with Treadle Sewing Machine and*

*Young Boy*. During such encounters—perhaps possible only to a woman photographer—Post achieved acceptance to the degree that her bulky camera was ignored or forgotten.

As we noted, La Farge used his presence—indeed his participation—during a Pueblo religious ritual to press and validate his expertise in Indian matters. By contrast, Post in the main—and definitely with regard to what she permitted to be published—stayed at a distance from such ceremonies. This may have been partly because the publications she was involved in were, broadly speaking, more concerned with "today," with the economic, everyday, social, and governmental aspects of Native American life, than with traditional or spiritual matters. Whatever its cause, her reticence ultimately testifies to deeper understanding and respect on her part. When, for at least two images, she photographed a Blackfeet man sitting atop a high snowy hill with a medicine pipe—presumably turning this revered object toward each of the four directions as part of the man's devotions—the camera does not intrude too closely.[11]

The finest of Post's apparently ceremonial studies of Thomas Henry Sitting Eagle, a prominent Lakota elder who in his youth had traveled with Buffalo Bill's Wild West show, also seems deferential (although in this case a close-up): the slightly upward vantage point that she adopted grants him command

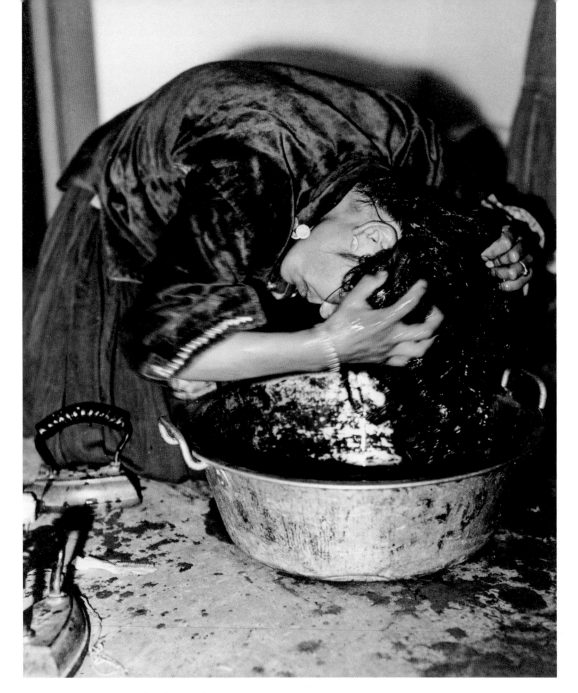

**41.** Nora Foky washing her hair with yucca root soap at Kayenta Day School on the Navajo reservation.

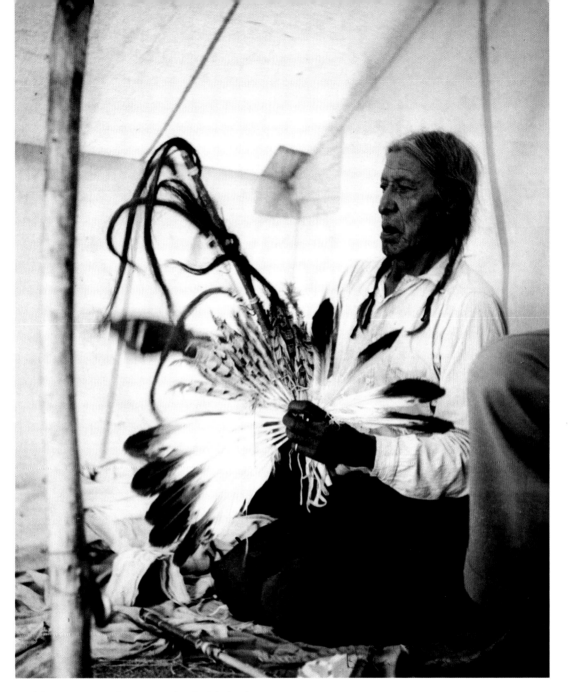

**42.** Thomas Henry Sitting Eagle, Oglala healer.

of the space above and around him. The picture—rendering what we take to be the inner intensity of Sitting Eagle's experience at this moment—was actually made at his invitation: on the back of a print in her files, Post wrote out the title, "Hunka Wand," and added a note: "Oglala Sioux medicine man in his tent, explains request that the wand be photographed so young Sioux will inherit some of the tribe's ceremonial history." Post complied with his request, taking a series of exposures of Sitting Eagle manipulating the wands into Hunka "pipes," to one of which horse tails were tied, to the other eagle feathers. Sitting Eagle was demonstrating, though not actually performing, an introductory part of the foster-parent chant, or Hunkalawanpi, essentially a ceremony to implant in the initiate—usually a child recovering from sickness—the virtues of hospitality, generosity, honesty, and fairness.[12]

And in the one ceremonial image to appear in *As Long as the Grass Shall Grow*, of the Navajo fire rite, usually called the Nightway, we notice that the highlighted dancing figures cannot be clearly discerned; our eyes go instead to the massive and dramatic shadows thrown up by the heaped bonfire onto the canyon walls behind them. With a sense of awe, we register the devotion of the participants. On the other hand, the scale of the shadows indicates that intense artificial lighting was employed to get this picture. In fact, to make

it Post did not intrude on a sacred occasion at all. The "ceremony" was not actually the final, culminating portion of a proper nine-day Nightway but a special event arranged by Navajo leaders for the entertainment of visitors to the first of what became the annual Navajo Fair. An exhibition-size print of one of the images in the sequence carries a caption in Post's hand: "Navajo medicine man Pete Price photographed at Window Rock . . . leading a demonstration section of the ceremonial for photographers and friends attending the tribal fair. Chee Dodge, Tribal Councilman, was present in his best form. He walked, as the Navajo walk, in great dignity."[13]

Judging by the contents of Post's archive, *all* the pictures that might be considered as depicting ceremonies were made at such public events. Unlike so many non-Native photographers—including, especially, anthropologists—she never "stole the secrets" of her subjects. Even the seemingly ceremonial depiction of Thomas Henry Sitting Eagle was made, obviously in public, at the Rosebud Fair. Post's images of the masked riders of the Lakota Horse Dance—traditionally very much a sacred ritual, one that the spiritual leader Black Elk, for example, sponsored to announce his visionary status—were shot at the Pine Ridge Fair. And those that she made of the Rabbit Dance, in any case a more social than religious event, came from the Rosebud Fair.

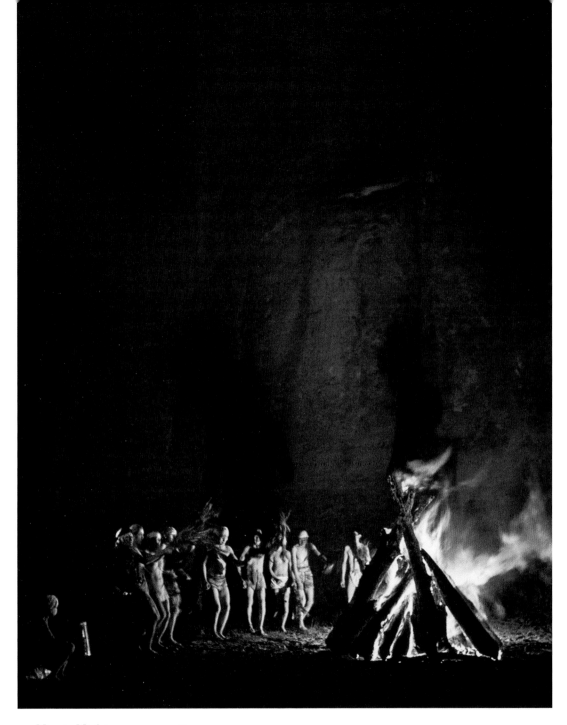

**43.** Navajo Nightway scene, 1938.

In restricting herself so, Post was adhering to what was seen as best practice at the time. Milton Snow, for example, in his "how-to" essay on photographing Indians for the handbook *1001 Ways to Improve Your Photographs* (1943), implored his readers never to be intrusive but to take advantage of such events as the Gallup Intertribal Indian Ceremonials or, indeed, an event definitely attended by Post herself, the Navajo Tribal Fair.[14]

## Flash Pictures

As we have observed, a notable number of Post's photographs show the use of flash. In the history of documentary photography, recourse to a flashgun has had a mixed reception. Its use as early as the 1880s by the Danish-born reformer Jacob A. Riis, for example, has evoked both approval and denigration. Many of Riis's pictures of New York slum conditions and criminal haunts had—and have—a direct force, what Riis himself called "the power of fact"—"the mightiest lever of this or any day," he said—and a key element of their power *is* the starkness of lighting: everything has been exposed. On the other hand, such typical and famous images as "Mullen's Alley, Cherry Hill" (ca. 1888), which Riis reproduced in *How the Other Half Lives* (1890), have also been seen as voyeuristic, their gangland subjects caught at a distance, separated from the viewer, who peers in on their literally dead-end lives. They are,

indeed, like the tenement poor in so many of his other images, "the *other* half."[15]

At the very time Post was at work, Dorothea Lange praised the use of flash by fellow Farm Security Administration photographer Russell Lee because in his hands it was a technique that went beyond the mere recording of data to reveal something of *how* the image was made—"You know, it's the fact of revealing the facts, not just putting them down," she said. But James Agee and Walker Evans believed that Margaret Bourke-White's flash usage in *You Have Seen Their Faces* (1937), the book on poor southern tenant farmers she produced with Erskine Caldwell, was exploitative. William Stott, in agreement, phrased it this way in his important history of 1930s documentaries: "She would freeze a facial expression (and the viewer's blood) with a livid flash three feet from her subject." James Faris, in the course of his damaging, if exaggerated, deconstruction of Laura Gilpin's supposed closeness to her Navajo subjects, was particularly damning about Gilpin's attempts to capture the Nightway, partly *because* of her recourse to flash.[16]

Post used flashbulbs for night scenes and—usually a technical requirement in her day—for interior shots. But, while the occasional face may appear a touch too whitened or the shadows behind a figure too ominous, there is rarely any intimation that the people in her pictures have, in any way, been intruded on.

Post's photographs—whether taken by flash or not—usually, in fact, exhibit a sense of respect for their subjects. This is best appreciated by a glance at specific images, the first two of which were made with flash. The picture of John White Man Runs Him was taken inside the store at the Crow Agency in southern Montana. The old man sits elevated on the counter and—while his daughter, caught alongside him, softens his appearance (she half turns away)—his direct look, however rheumy, is all but confrontational.[17] The shadows behind him (and her) made by the use of flash actually accentuate his presence. Given the old man's fame as the heir to someone who witnessed both Custer in his pomp and the triumph of the Lakota and Cheyenne at the Little Bighorn, this presence brings with it some historical weight.

Another interior store photograph, this one depicting the Jicarilla cooperative enterprise at Dulce, New Mexico—and headed "Their store shows a steady profit" when deployed in *As Long as the Grass Shall Grow*—seems to work particularly well. In it two Jicarilla men across the counter eye the store clerk, who in turn attends to his accounting procedures. The use of flash, we realize, has made the facial features of each of the three figures—and even those of a further man, behind the two customers—clearly visible, but without glare. The "surprising illumination" granted by the flashbulb, to use

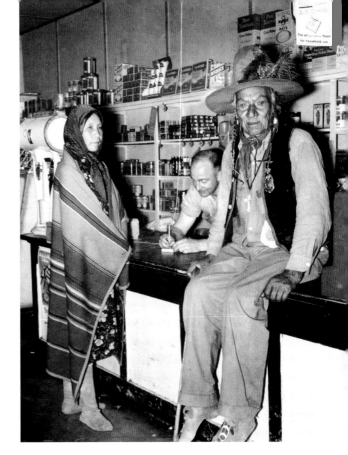

44. *John White Man Runs Him*, Crow reservation.

Kate Flint's phrase, is that everyone is at ease with what he and the others are doing.[18] The incident is seen very close, as if we are immediate onlookers or even involved in the ongoing transaction. Indeed, for the viewer, the image invites interaction; it is, itself, transactional.

## Portraits

At the San Carlos Apache reservation in Arizona, Post made a number of exposures—a sequence, an embryonic story—of a child playing with her doll under a brush-covered

**Their store shows a steady profit**

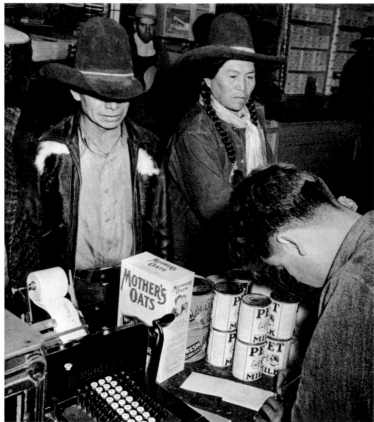

**45.** Jicarilla store (and caption), from a page in *As Long as the Grass Shall Grow*.

awning. The pictures are informative, providing knowledge of San Carlos housing, the need for shelter from the fierce sun that beats down outside the arbor, and—in the clutter to be seen—that this place serves as the home of a working farmer. The pictures intimate, too, that the homestead is far from others and that the child is accustomed to playing on her own.

With respect to this last observation, the vantage points taken in two of the photographs are particularly involving. In the first our eyes tend to follow the line from the left made by one of the ropes sloping toward the girl and her doll's miniature hammock. In the second the ropes of the hammock and those dangling vertically from a beam above (as if for an invisible child's

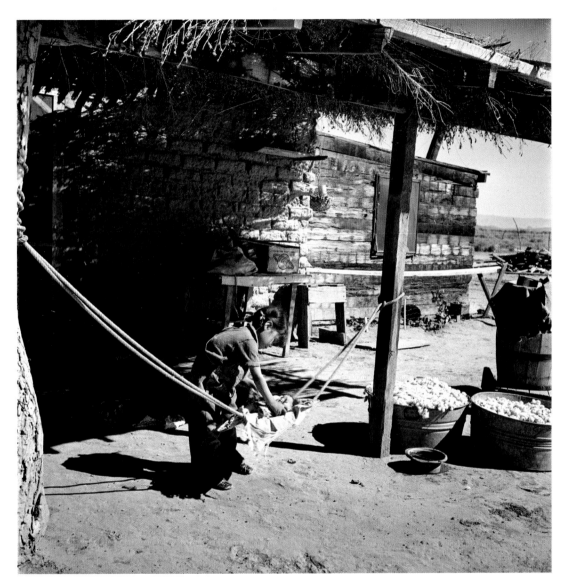

**46.** San Carlos girl and miniature hammock.

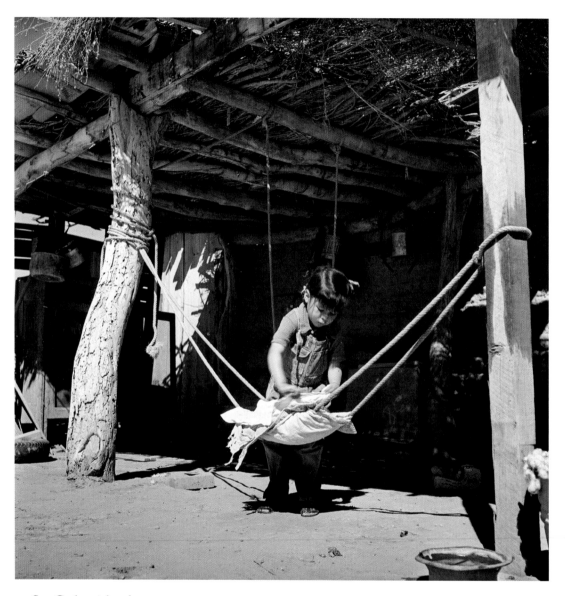

**47.** San Carlos girl and ropes.

**48.** *Johnson Holy Rock, High School Assistant, Pine Ridge.*

swing) meet *at* the girl, centering her in our sight. She registers, of course, as only a child, but in her very lightness there is being.

In a portrait taken in 1941, Post captured Johnson Holy Rock with shelves of books in the agency library at Pine Ridge. Over the shelves is a sign that acts as a caption within the picture frame: "Stories about Our Native Americans." The way Holy Rock holds several volumes in his hands indicates his ease and identification with the "stories" they tell. And he stands to one side, as if offering others—and the viewer—access to these books, some of their titles legible to the eye. Given the pride shown here, it is not surprising that Johnson Holy Rock—who joined the U.S. Army (for the duration of World War II) soon after this picture was taken—later became a leader on the Pine Ridge Reservation and served a term as the Oglala tribal president there. In 1972, during unrest at the corrupt and dictatorial rule of tribal chair Richard (Dick) Wilson, unrest that a little later erupted in the famous American Indian Movement occupation of Wounded Knee, Holy Rock was one of the elders who attempted, unsuccessfully, to impeach Wilson.[19]

*Navajo Fence Sitters* presents from the rear a group of anonymous men watching something, probably a rodeo event. In the sense that tourists frequently took pictures of Navajo men from behind—because easier to snap than if they had to face up to a whole group—this

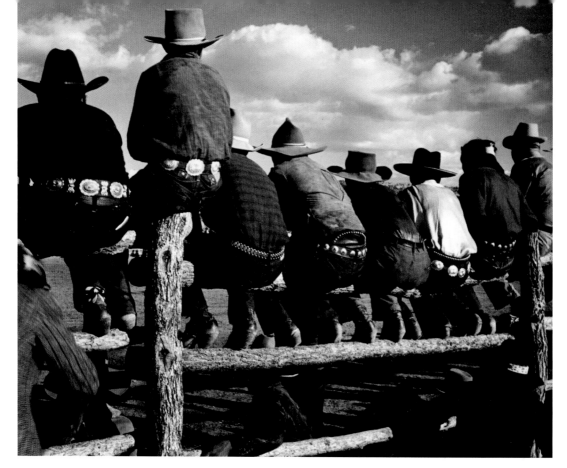

**49.** Navajo men on fence.

photograph has a touch of the stereotypical about it that is countered by its intensity. The men's hats may be askew, their shirts may be dusty or stained with sweat, and their trousers and boot heels may be worn, but they also sport a weight of silver: our attention is drawn to the silver work mounted on almost all of their belts, different in each case, yet equally in each case a display of affluence. In exhibition-quality prints especially, we register the photograph's deep texture, how it catches almost preternaturally the gleam and glint of embossed metal against duller cloth and leather. The image was made at roughly the same time that a man named Grey Moustache declined to let the anthropologist John Adair take his photograph: "No, I won't let you do that. I don't have any of my turquoise or silver on. People will see it and say, 'Why, that Navajo doesn't have anything at all.' I would feel as naked as a chicken with all its feathers plucked out."[20] In the case of Post's fence sitters, we

don't see their faces, but we certainly have to acknowledge their portable wealth.

Two other images verge on the stereotypical—yet do not fall into it. The first depicts two mounted riders, their backs toward the viewer, heading away. In *As Long as the Grass Shall Grow* this photograph functions to communicate the likely feelings—indignant but tired resignation—of the Native people in it (a Flathead couple, according to the book's "List of Photographs"). Its composition also brings to mind earlier famous riding-away images by Curtis and Joseph Kossuth Dixon whose very titles, such as, respectively, *The Vanishing Race* (1904) and *Sunset of a Dying Race* (1909), labor their larger symbolic import. But if we are tempted to read Post's picture as similarly doom-laden, the presence of the telegraph poles should hinder us. If Curtis's subjects were vanishing—"riding into the darkness of an unknown future," as he put it—Post's couple, by contrast, travel toward uplands beside a paved road lined with telegraph poles. And if we glance at any of the other four or five images Post took of the same couple (but didn't publish), we find that in these the pair ride toward us or, at ease, actually confront us, while in one the male figure smiles unabashedly.[21] The landscape around this couple may be changing, their future—whether we see them as individuals or as generic Native people—*may* be threatened, but they are unperturbed,

and we have to acknowledge that they know where they are headed.

The other image that skirts the stereotypical does so in a manner more common in 1930s documentary. By the latter part of the decade, the use of photographs to "expose" the living conditions of the poor in the United States—especially sharecroppers, migrant workers, and Dust Bowl refugees—had become common. Given that many Native American communities were more stricken by poverty than *any* other communities anywhere else in the United States, it was probably inevitable that *As Long as the Grass Shall Grow* would follow suit, at least in part. The text describes the effects of landlessness, for example, which on several reservations had resulted in starvation (32–34), and these descriptions are accompanied by photographs without any immediately surrounding text; they are presented in their own right, as it were, as if they needed no words. In one, a young woman, her back to a chinked log wall (itself a sign of rural poverty), simply looks out—or, whether *she* looks out or not, *we* encounter her eyes. In these eyes—as in her facial expression as a whole—there's an element of distress. (The interpretation of body language, especially between people of different cultures, always entails risk.) In the book's "List of Photographs," this image is described as "A generation of hunger—Blackfeet girl in Browning," so we tend to view her *as* hungry,

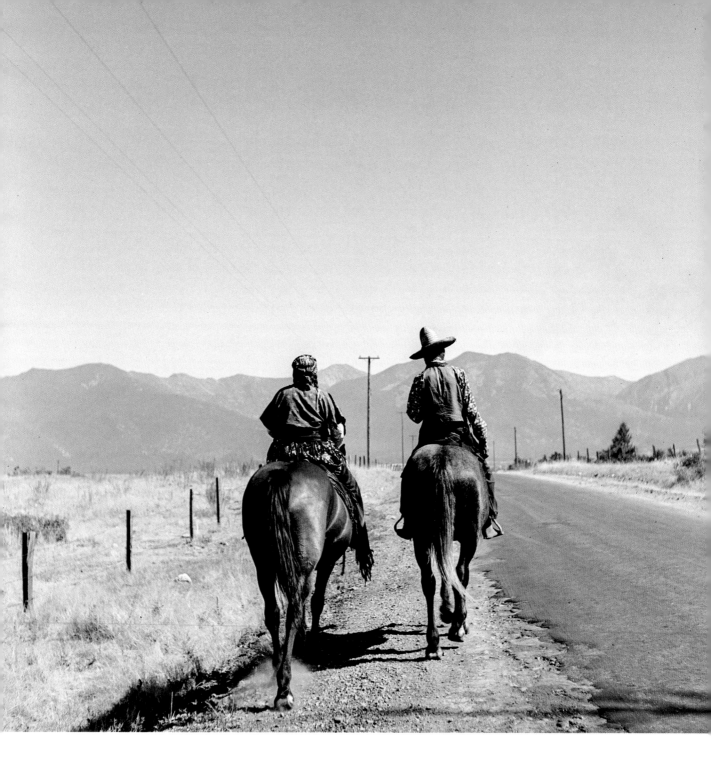

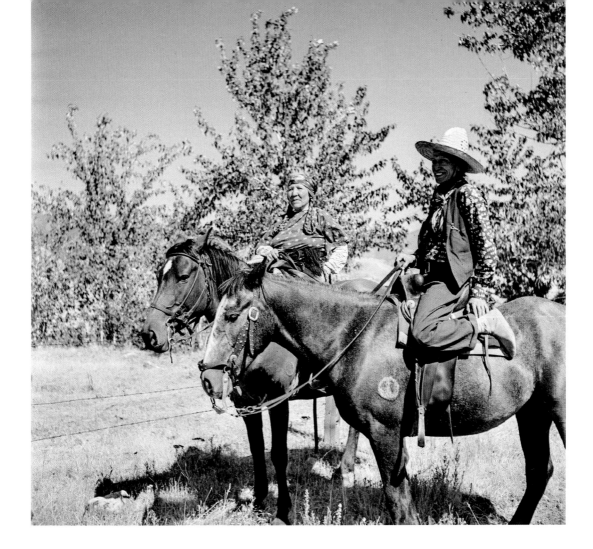

as having been damaged by a lifetime of depri-
vation. At the same time, while her features
stand out, the lighting is relatively gentle. She
is not *just* a picture of hunger. She is not abject.
She retains her dignity: she has put on what
was probably her best and prettiest dress for

**50.** (*opposite*) Flathead couple riding away.

**51.** (*above*) Flathead couple facing ahead.

the photograph, and her hands are in a sewing
basket, as if she was interrupted in her work.
Her humanity—alongside her poverty—is
registered, and respected.

Generally, Post's portraits, especially of
named individuals, are revelatory—and, as I
have been suggesting, they are usually pre-
sented with much tact. The gentle assistance
given to an elderly Flathead chief—identified

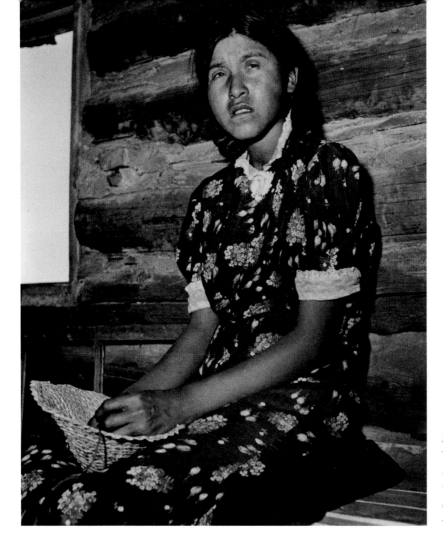

**52.** Young Blackfeet woman. (In *As Long as the Grass Shall Grow* this image was slightly cropped to bring the woman closer.)

as Koostatah in *As Long as the Grass Grow*'s "List of Photographs"—becomes the central observation of the image: the helper raises his arm slightly to take the old chief's grip (fig. 26, image on right). Similarly, in the view of the Blackfeet boy, Buster, with his grandfather, Yellow Kidney, the low vantage point of Post's camera catches the boy's upward gaze, thus intimating that for him this time together with the elder constitutes a learning experience (fig. 36). Yellow Kidney—who had been the subject for several of the most well-known portraits by Curtis earlier in the twentieth century and now again in his seventies—was a revered figure who frequently took a stand on behalf of "full-bloods" and

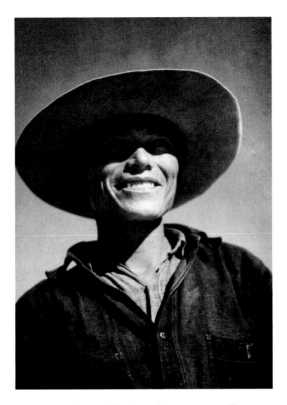

**53.** Young Navajo Civilian Conservation Corps man from *As Long as the Grass Shall Grow.*

Blackfeet Sun Dance traditions learned from his grandfather, and in the early 1990s led a successful delegation to the Field Museum in Chicago, seeking the repatriation of Blackfeet religious artifacts. Buster, in turn, passed down his Sun Dance medicine bundles to his own immediate descendants.[22]

Most of the few close-up portraits in *As Long as the Grass Shall Grow*—from this first one of Buster to the final one of a young, open-faced Navajo man, his features candidly lit up by a smile—show people at ease with Post's camera. Just occasionally, as in the portrait of the Blackfeet elder Joppy Holds the Gun, who wears sunglasses, there is an inhibitory factor—though in this case the shades, like the particular way Joppy has tilted his broad-brimmed hat, also signify his individuality. And Joppy—or Japy, as some authorities spell it—*was* a prominent character in the community. The Blackfeet/Métis historian Rosalyn LaPier has noted that he was steeped in the myths and rituals of his people; in a sense those dark spectacles communicate that there is a lot hidden behind them.[23] Post's subjects in *As Long as the Grass Shall Grow* appear to have offered themselves to the camera in just as uninhibited a way as those who followed her directions to pose for *Brave against the Enemy.* As viewers of the people in all these portraits—including those who appeared in neither book—we feel the power of their presence.

traditional Blackfeet values. Just a few years after Post's time on the reservation, in a series of interviews with Claude Schaeffer, he was able to supply firsthand information on eagle catching, painted tipis, old-style snowshoes, and a host of other topics. For Buster, who had been abandoned as a child by his parents, the relationship with Yellow Kidney *was* formative: until his death in 2000 he carried on

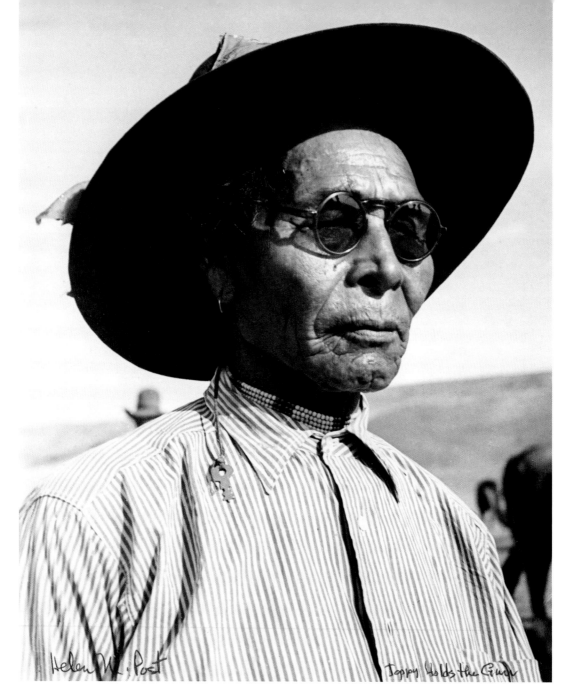

**54.** *Joppy Holds the Gun.*

# Photographing a New Deal for the Indians

<div style="text-align: right;">4</div>

Photographs have been accorded a place among the tools of our national government. They speak a democratic language, understood and appreciated by a widely diversified audience.

—HELEN POST

## Government Views

When Post entered each reservation—whether as a freelancer or as an Indian Service employee—she did so with letters of introduction from the top, sometimes written by the commissioner himself.[1] The need for photographers to have such letters was the established practice then; it did not mean that Post, clearly trusted by John Collier, had necessarily to follow his orders or rigidly pursue a BIA line. Nevertheless, she was not as independently responsible for her images as I have so far presented her: she had an employer or patron she needed to please, and, inevitably,

her photographs did often record government policy—indeed, could be said to represent it.

Oliver La Farge, for his part, admitted in his autobiographical *Raw Material* that, despite the rivalry between his organization and Collier's Indian Defense Association, when Collier became commissioner he had called La Farge in, asked his help, and won him over. Collier possessed charisma and a powerful will: La Farge was so won over that, after the 1934 passage of the Indian Reorganization Act (IRA), which purported to promote tribal self-government, he accepted Collier's invitation to work with the Hopi people in the writing of a Hopi constitution. Given that the Hopis had a viable and long-established system of government of their own, this was not an easy task, but, by keeping as much as possible to the spirit of traditional Hopi rule, La Farge was able to produce something acceptable. Col-

lier's telegram announced the result: "Hopis adopted constitution six hundred fifty one for and one hundred four against constituting more than fifty percent of electorate stop hearty congratulations to you for this outstanding success." (The Hopi voting figures also reveal that only a small proportion of the two thousand–plus electorate actually voted, and by the time Collier came to write his autobiography, *From Every Zenith*, published in 1963, he had to admit that, though La Farge "could not have done better," the constitution did not fully represent Hopi wishes and had, indeed, "never worked.")[2]

*As Long as the Grass Shall Grow* inevitably reflected the situation in which its makers found themselves. One of the three images in the book not attributed to Post is a study by Edwin Rosskam of Collier's desk. The desk top is untidy with papers that the book's text says amount to a "Mississippi of detail" (64–65). La Farge recounted in *Raw Material* how he had been invited to spend a few days in the actual office of an earlier commissioner, Charles Rhoads, an experience that had made him realize the enormity of the BIA's remit: "It all goes over the Commissioner's desk." *As Long as the Grass Shall Grow* also reproduces, as we have seen, facsimiles of legislative documents. The inclusion of such items, especially the desk photograph, introduces to the book a top-down perspective. Facing outward from that cluttered desk, we must wonder how things looked from the *government*'s point of view.[3]

The IRA was another glittering piece in the expanding mosaic of progressive legislation offered to the nation—often with support from believers in a Popular Front—as a New Deal. Collier, even though the act as finally passed didn't go quite as far as he wanted, promoted it and did his utmost to execute it. Crucially, the IRA brought to an end the ruinously destructive allotment policy of the 1887 Dawes Act, which had broken traditional communal responsibility for both territory and affairs by splitting reservation land and individualizing its ownership into small allotments. On the other hand, though proposed as empowering indigenous populations, the IRA was top-down law making: no Native people participated in its formulation. Several historians active in recent years, not all of them Native, have gone as far as to define the IRA not as liberating but as "neo-colonialist," a means of imposing "indirect rule" from Washington in a manner analogous to the operation of British colonialism during the height of the British Empire.[4]

The IRA was a multifaceted and, in part, contradictory piece of legislation: its preamble announced its facilitation of the conservation and development of land, the formation of Indian businesses, the provision of credit, "certain rights of home rule," and, among "other purposes," the extension of vocational

**55.** The desk of the commissioner of Indian affairs, Washington DC. Photograph by Edwin Rosskam.

education. It allowed for the allocation of specific federal funds for the attainment of its objectives and reached much further into the governance, status, and well-being of Native populations than can be enumerated here.[5] In turn, *As Long as the Grass Shall Grow*, in its treatment of the act, did more than summarize its provisions and workings: like *The New Day for the Indians*, the 1938 pamphlet sponsored by La Farge, for the most part it positively endorsed them.

An important feature of the IRA was its insistence on a much higher degree of Native self-determination than had characterized any previous legislation. The section on government allowed for new tribal constitutions and tribal councils, and these were not to be one-size-fits-all but adjusted, if not tailor-made, for

each people, according to their varied locations and cultures. The act allowed for each federally recognized tribe within the United States to vote on whether or not it wished to adopt the IRA itself. (And while, as we have seen, the Hopis accepted it, as did the Blackfeet, Jicarilla, Flathead, and Pine Ridge Oglala peoples, a number of nations, including those of the Navajo and the Crow, rejected it.) *As Long as the Grass Shall Grow* outlines this governmental information (especially 68–83).

The book photographically represents the constitutional aspects of the IRA most directly in *Stabs Down by Mistake Addresses the Tribal Council.* Stabs Down, a steadfast participant in the Sun Dance and other ceremonies from the early 1900s onward, was such a prominent figure within the Blackfeet community that he had also achieved some recognition beyond it. Adolf Hungry Wolf, when compiling the four-volume set of *Blackfoot Papers* (2006), included numerous pictures of him. Most notably, in the teen years of the twentieth century, the pictorialist photographer Roland Reed had chosen him to evoke the Blackfeet past in a series of images shot in Glacier National Park, adjacent to the reservation: in one, Stabs Down, atop a rocky outcrop, feathered lance in hand, stands as if forever on watch. In Post's picture an older Stabs Down, among fellow council members, bends forward attentively, the spread fingers of his right hand almost a blur as he speaks, as

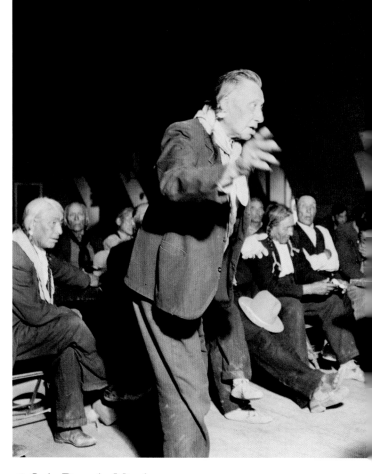

56. Stabs Down by Mistake.

if it were an extension of his open mouth. A traditionalist—in a note Post referred to him as a "full-blood come to express [his] side of the story"—Stabs Down nevertheless participates in the "progressive" process of democratic decision making, his very performance validating the IRA.[6]

Although they did not get into *As Long as the Grass Shall Grow*, Post made several images of Native people actually voting—one, of Crows, by the raising of hands, the others

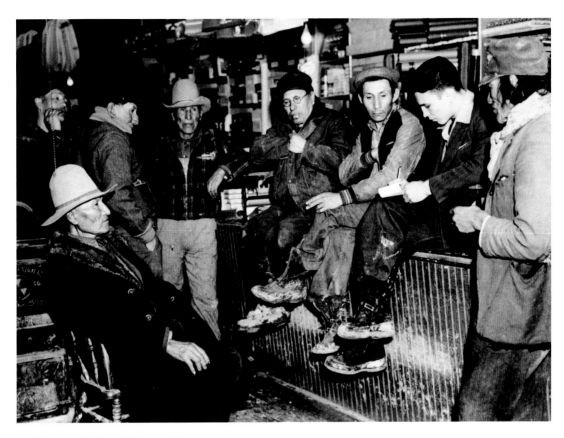

**57.** Meeting in Pine Ridge trading store.

at the ballot box, their hands and voting slips poised above it (fig. 21). She also took a number of shots of the Flathead tribal council, both in formal meetings, with some members taking notes, and more casually. Less conventionally, she made a photograph of a Pine Ridge scene that, as we have seen, Peter Modley recalled as a "tribal council [meeting] in overalls, all sitting on the counter of the trading post."[7]

The generally poor physical health of Native peoples, after more than fifty years of reservation life, provided one of the catalysts for the IRA and was also a (mainly implicit) focus of it. Collier's foreword to the Leightons' *The Navaho Door* duly endorsed their approach to health education for Native peoples as consistent with IRA aims. The Leightons actually turned a whole chapter of their book into "A

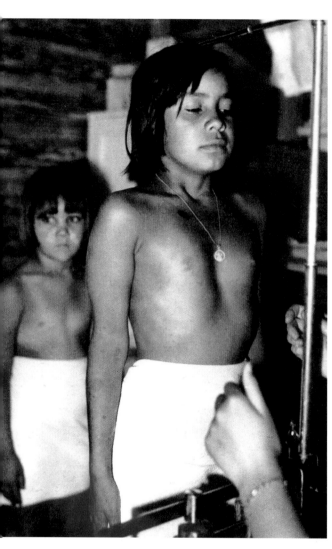

**58.** Flathead girl being weighed during medical checkup; a page from *As Long as the Grass Shall Grow*.

Speech on Health": a living verbatim sample of the kind of talk that could be used to instruct Indian Service medical professionals. And, inevitably, they credited an improvement in Native health to the IRA.[8]

Unsurprisingly, *As Long as the Grass Shall Grow* also touches on medical provision, stressing the IRA's new emphasis on public health and disease prevention. Two of Post's photographs, literally printed back-to-back in the book (61–62), encapsulate the improving trend. First, a boy lies in a hospital bed, his eyes closed, sheets and blankets drawn up to his chin, a noticeable shadow falling across his cheeks. Then, when we turn the page, we find a robust girl being weighed, a smaller, similarly vigorous-looking child behind her. The vantage point is low down, so that we—placed in the position of the nurse who works the scales (and whose hands are visible)—have to look up to the first girl, registering her vigor. She is, literally, a picture of health.

This positive visualization of post-IRA health initiatives was the case in most, if not all, of Post's medical pictures. It is especially true of a graphic sequence she made at the Indian tuberculosis sanatorium at Winslow, Arizona. In one we have seen deployed in the Leightons' *The Navaho Door, Health Education in the Field*, we viewers, like the group of Navajos who surround the nurse to hear her explanation of the large X-ray, look up to her

and, like them, we can see the different shades of light as it penetrates the image she holds aloft (fig. 22). It is almost as if we are able to hear the nurse speaking—as in fact she does in the Leightons' book: "See, here are some X-rays. This one is from a boy who has good lungs. . . . Here is the X-ray of this patient. It looks like he has a hole in his chest."[9]

## BIA Personnel

The IRA's emphasis on Native self-determination was echoed in the way in which the BIA began to favor, for the first time in its history, the recruitment of Indian personnel for more senior positions within its own ranks—and Post duly photographed some of them. One such was Ben Reifel, a Lakota of mixed heritage, born and named Lone Feather on the Rosebud Sioux Reservation. In her best photograph of him, Post presented Reifel in a dapper straw hat, tie, and striped shirt, tellingly holding a piece of paper. He's outdoors—at the Pine Ridge Fair—but he's an official, at ease with paperwork. In his youth Reifel had posed for the camera of John Alvin Anderson, an accomplished independent photographer who went on to sponsor his education. Reifel was an early convert to the IRA and campaigned for a vote in favor of reorganization on the Pine Ridge Reservation. When encountered by Post in 1941, he was the superintendent who ran the BIA office in Aberdeen, South Dakota, and was charged with what proved to be—given factors we will consider later—the near-impossible task of persuading the Oglala people to implement even more of the IRA's provisions.[10]

Ben Reifel's portrait did not get reproduced in *As Long as the Grass Shall Grow*, but Post's astute assessment of his notability was borne out by his later achievements. During the 1950s, when another swing of the national political pendulum produced the destructive decision to try to "terminate" the federal government's treaty responsibilities, including all funding, for specific tribal groups (a BIA policy that ran counter to the IRA and certainly to the true interests of his people), Reifel—from within the bureau—worked and advised against its implementation. When he retired from the BIA in 1960, he ran for office as a representative for the First Congressional District of South Dakota, serving five terms, for much of the time as the only Native member of the House. Under President Gerald Ford, he served briefly as commissioner of Indian affairs.[11]

Another Native BIA official portrayed by Post was the Crow superintendent on the Crow reservation, Robert Yellowtail. His likeness appears several times in *As Long as the Grass Shall Grow*: in full regalia (8), as the leader of a mounted group at Crow Fair (108), and in his office (109). In the office portrait he sits behind a table strewn with papers and

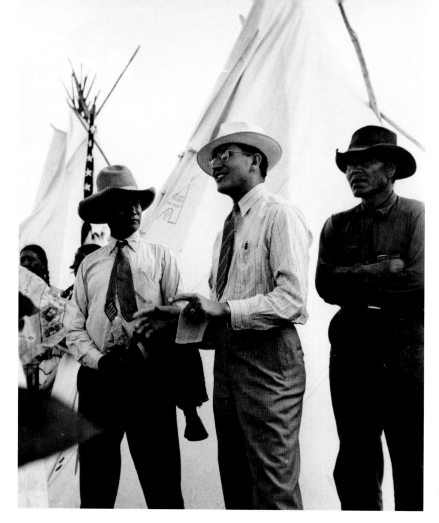

**59.** *Superintendent Ben Reifel.*

bric-a-brac—his hands spread apart as if to indicate the troubling size of whatever issue is under discussion—and appears at ease with his authority; the man to the left of him, with traditionally long hair, stands and pays attention. Robert Yellowtail was someone who had earned respect and deserved attention.

Educated at the Sherman Institute in Southern California, he made his own way in the world, first by the quality of his advice to such forceful traditional Crow leaders as Chief Plenty Coups, then through his own prowess as an advocate of Crow tribal rights. Yellowtail was pleased but amazed in 1934 when Collier made him superintendent, especially as he had mixed feelings about the IRA—indeed, it was no surprise to him when the Crows voted against adopting its provisions. In his eleven years in charge, he helped expand the Crows' grazing lands, took advantage of such New

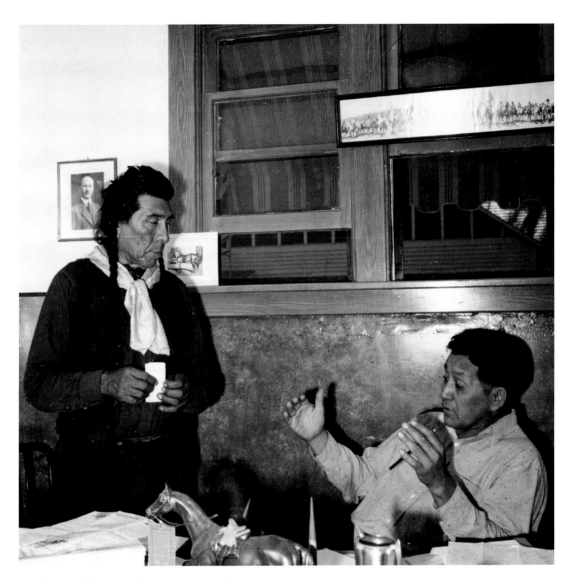

**60.** Robert Yellowtail, Crow superintendent.

Deal initiatives as the Works Progress Administration, oversaw the construction of the first hospital on the reservation, reestablished a buffalo herd on Crow territory, and, by rescheduling the Crow Fair from the harvest period to August, turned it into a major tourist attraction for whites as well as a venue for Indians to meet.[12] Along with the portraits of Robert Yellowtail himself, Post took and archived pictures of members of his family, his home, horses, and more, and she specifically documented his achievements for the tribe—obviously the Crow Fair (114–19, 129) but also the buffalo herd (4–5)—in *As Long as the Grass Shall Grow*.

The provisions of the IRA that were most conducive to photographic representation were probably those that encouraged tribal business initiatives, often by the allocation of seed funds or advice on the establishment of cooperatives. While La Farge's text relates the stories of the enterprises undertaken by the Flatheads, the Jicarillas, and others, Post's pictures illustrate the results: we actually *witness* "the Flathead construction workers, the Jicarilla cooperators, the Mescalero cattlemen and Crow farmers" (121). The Indian School at Pine Ridge—the institution attended by the fictional Louie Hollow Horn—showed great enterprise in purchasing, for breeding purposes, a famous thoroughbred Morgan horse, Sir Linsley, that Post photographed numerous times.[13] And

we have already looked at a view of the Jicarilla cooperative store that works effectively to show how well this busy operation was doing (fig. 45).

For virtually the first time in its history, the BIA recognized that it needed truly to respect cultural differences, both between Native America and the mainstream U.S. populace and among the enormous variety of indigenous peoples—if only to manage reservations better. It funded or partly funded a number of major ethnographies, including *Warriors without Weapons* (1946), a study of the Pine Ridge Oglala by Gordon Macgregor. On both long- and short-term contracts, it actually employed anthropologists, including the Leightons of *Navaho Door* fame. Edward T. Hall, who would later write *The Silent Language* (1959), a best-selling guide to intercultural understanding, recalled in his memoir, *West of the Thirties*, that Collier had himself, in person, recruited him. Similarly, at Collier's urging the young William N. Fenton, who would produce several studies of Eastern Woodland peoples, was appointed director of the Tonawanda Community House Project—where Post, as we have seen, photographed Seneca crafts.[14] *Indians at Work*, the BIA magazine, frequently printed short articles by such well-known advocates of anthropology as Ruth Benedict and Margaret Mead.

## Native Arts and Other Federal Projects

The IRA promoted indigenous cultural initiatives. After decades of suppression of Native languages, reservation schools began to teach them and to conduct classes *in* them. The BIA itself undertook, for the first time, publication of bilingual works—and not just instructional manuals but traditional stories and fiction about contemporary Indian concerns: hence Post's illustrative work for the novel by Ann Clark and the potential folk-story collection by Eugene Wounded Horse and the employment of such Native artists as Ma Pe Wi and Andrew Tsihnahjinnie (Navajo) to illustrate a stream of other BIA-sponsored books, including ones in which Ann Clark retold the folk tales of their peoples.[15] These publications were rapidly added to such libraries as the one looked after by Johnson Holy Rock (fig. 48).

Another federal body, the Indian Arts and Crafts Board—created by Congress in 1935 to promote and hallmark indigenous production—affirmed the new governmental respect for Native American traditions that permeated the IRA. At the level of the individual reservation, many Native peoples founded Arts and Crafts Guilds (or the like) to mesh with the board's national-level work. The Leightons, in their *The Navajo Door*, reported on the success of the Navajo venture.[16] The text of *As Long as the Grass Shall Grow* cites both economic and aesthetic reasons for lauding the Indian Arts and Crafts Board (80), and several of its pictures present craftspeople at work: Blackfeet women—the mainstay of the Blackfeet Arts and Crafts Cooperative—both string beads (18) and engage in beadwork itself (24). Post titled an image not included in the book *Sioux Arts and Crafts—A Flourishing Home Industry*. In it two boys, standing in front of display cases of craftwork, seem interested in buying an Indian doll. Post's other craft pictures include portraits of an arrow maker with his finely honed wares to sell, a woman demonstrating the specialist technique for weaving belts, and a man deftly handling porcupine quills.

In terms of specific peoples, Post gave most attention to the arts and crafts of Navajos. In a likeness to be discussed later, she took a long look at Aschi Mike spinning (fig. 79), and she made portraits of two other Navajo artists who, at the time, had already achieved a measure of fame: Tom Burnsides, silversmith (79), and Andrew Tsihnahjinnie, painter and graphic artist (125). Burnsides—who was only twenty-nine years old when his image appeared in *As Long as the Grass Shall Grow*—was already so well regarded as a craftsperson that John Adair, the anthropologist who wrote what has come to be recognized as the definitive ethnography of Southwest silver work, *The Navajo*

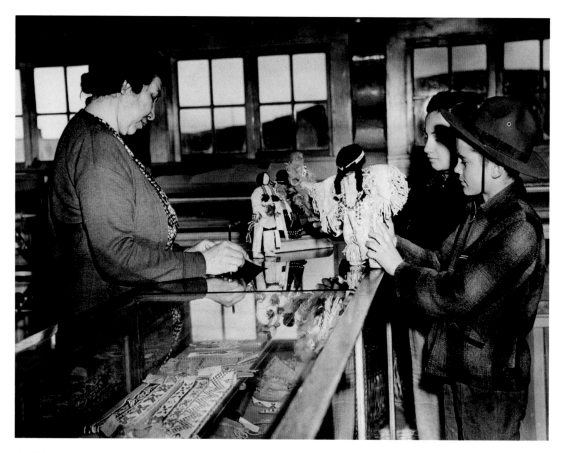

**61.** Pine Ridge crafts store.

*and Pueblo Silversmiths* (1944), spent weeks of the summer of 1938 watching him work at his home-built smithy at Pine Springs. In fact, Adair referred to Burnsides and his family as his "principal interpreters and informants on Navajo silver."[17]

Post, too, spent much time in Pine Springs, where she photographed Burnsides's home,

his corn patch, his five children, and his wife, Mabel, outdoors at her weaving frame (fig. 78). Post's main portrait of Tom himself, taken close up, does more than simply show him posed above his small anvil: his hands come together, between his knees, at just the point to which he obviously directs his steady gaze. Post, through both education and expe-

rience, really understood craftsmanship. This photograph is a concentrated study of the craftsperson, with a sure touch, *at work*. Post was evidently pleased with it: a little later she had it reproduced as a postcard to advertise both her own services as a photographer and a Washington DC store, The Last Fair Deal Trading Co.[18]

The young Andrew Tsihnahjinnie (he was born in 1918)—unnamed, listed only as "Navajo Indian artist" in *As Long as the Grass Shall Grow*—was teaching at the Phoenix Indian School when Post made several portraits of him, including the one she published, in which two young people, presumably pupils at the school, stand behind him to watch him at work (125). He had studied with Dorothy Dunn at the pioneering Indian Painting School in Santa Fe—Dunn later wrote that "in many respects [he] had no equals at the studio"—and worked for the Works Progress Administration. He was on the cusp of public prominence. At the time of his encounter with Post, he was starting on the murals for the Navajo sanatorium at Winslow, where, as we have seen, Post also worked, but she could equally well have met him through either Ann Nolan Clark, whose work he had illustrated, or, more likely, Milton Snow, who had taken him on as a photographic assistant. After military service in World War II, Tsihnahjinnie would devote himself totally to his art, working in every pos-

sible medium, often depicting scenes of Navajo life.[19] The least formal of Post's portraits of Tsihnahjinnie catches him at a moment of distraction, his pencil lifted away from the stencil and paper on the drawing board, allowing the viewer to see him full face, the beginnings of a smile about his lips. He seems—and was made to seem—approachable and likeable.

Just as important as the artists and craftspeople portrayed in *As Long as the Grass Shall Grow* is the work itself. Items of arts and crafts—whether *A Crow Indian's Saddle* (71), the painting by Zia artist Ma Pe Wi (78), or the Navajo cradle board (fig. 28)—are displayed throughout the book. These works illustrate, with little need for words, the vigor of indigenous creativity. The quality of this creativity was culturally acknowledged at the national level in 1941, when, as we have seen, the Museum of Modern Art, with the Indian Arts and Crafts Board, mounted an exhibition of Native artistic production. Announced by a lofty and colorfully carved Northwest coast "totem" pole erected in the street outside the museum, *Indian Art of the United States* occupied the whole space of the MOMA's newly constructed modernist building. It embraced "prehistoric art," "historic art or the living traditions," and "Indian art for modern living." It was in this last section that works by such figures as Nellie Star Boy Menard, Burnsides, Tsihnahjinnie, and Ma Pe Wi appeared. La

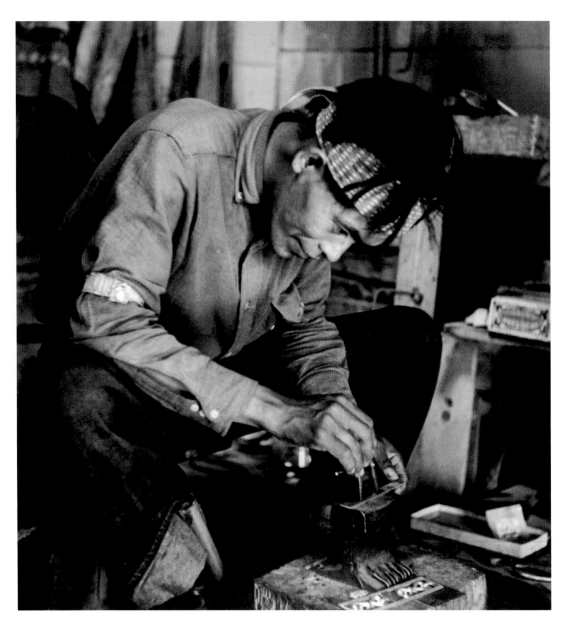

**62.** *Tom Burnsides, Silversmith.*

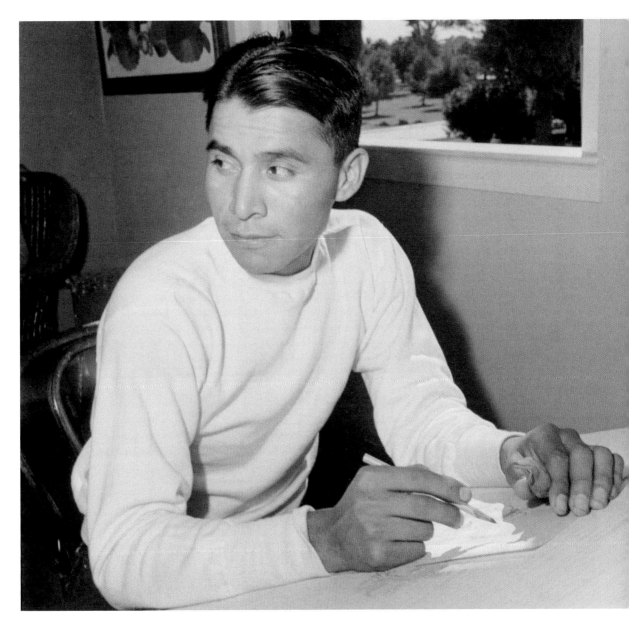

**63.** Artist Andrew Tsihnahjinnie.

Farge boosted the show in several laudatory reviews, including one in the *New York Times* illustrated by some of Post's photographs.[20]

*As Long as the Grass Shall Grow*, as noted, concludes with a portrait of a Navajo man (fig. 53). According to the "List of Photographs," he was employed by the Civilian Conservation Corps (CCC), the New Deal agency established in 1933 to offer work relief to young, mostly unmarried, men. Living communally in camps, with most of their small wages set aside for sending home to their families, they were put to work on public lands throughout the nation, building roads and trails, planting trees, clearing streams, and making general improvements. The first director of the CCC Indian Division (ID) was a devout Collier disciple, anthropologist Jay B. Nash, the man who had coordinated *The New Day for the Indians*, the first survey of the implementation and working of the IRA.

Unlike the main CCC, the ID—which concentrated on securing reservation lands and building schools, clinics, and other infrastructure—often allowed enrollees, if married, to live at home and also offered training beyond basic manual work. ID members became carpenters, truck drivers, mechanics, radio operators, surveyors, and electricians able to fix power lines. Indeed, the activities depicted in the final images of *As Long as the Grass Shall Grow*—such as hooking up a

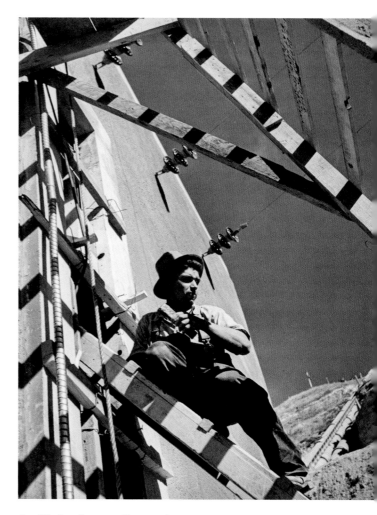

**64.** Flathead power-line worker.

reaper (134), running a dragline shovel (135), or making precise measurements at the drawing board (139)—all feature CCC-ID men. Similarly, improved facilities feature in others of the book's photographs—*Flathead Indians in New Home Built with Government Help* (88), for instance, or *Indians Using Community Laundry in Navajo Day School* (105)—are also the result of CCC projects.[21]

The fact that *As Long as the Grass Shall Grow* concludes with that large smiling face of the CCC-ID man could be interpreted as an affirmation not just of the continual endurance of Native peoples but of the resounding success of recent government initiatives. It is not surprising that when a selection of Post's images was to be shown near the heart of government in Washington DC as part of the publicity effort for *As Long as the Grass Shall Grow*, Rosskam was confident that Commissioner Collier would endorse their efforts by opening the exhibition—and he did.[22]

## IRA Failings at Pine Ridge

But the Indian New Deal, especially when viewed from the perspectives of the Native peoples who went through it, was not always a success. On a number of reservations, including ones where Post spent considerable time, its very existence exacerbated—and sometimes created—divisions in the community. At Pine Ridge, where she worked for months on the

pictures for *Brave against the Enemy*, the Oglala leadership, as historian Akim Reinhardt has detailed, split acrimoniously into "New Dealers" and "Old Dealers." The New Dealer camp consisted mainly of "mixed-bloods" rather than "full-bloods" (in the sociological rather than biological sense of these terms). The reservation did vote, by a small margin (1,169 to 1,095), to adopt the IRA, but since more than 44 percent of those eligible to vote opted not to do so—this in a culture where staying away (in the nineteenth century from treaty meetings) traditionally indicated disapproval—it was obvious to all that managing the act's implementation would not be easy.[23]

What actually happened was that the newly established, IRA-sanctioned Oglala Sioux Tribal Council (OSTC), although representative in composition, with a fair quota of "full-blood" members, quickly became dominated by Frank G. Wilson, its "mixed-blood" chair who, with the vociferous support of other "mixed-bloods," took hold of executive power until his eventual impeachment for misrule some years later. Yet the OSTC *did* very little, and the Pine Ridge "full-bloods," a disproportionate number of whom lived in dilapidated housing and who suffered relatively more from a range of acute and chronic illnesses, rapidly came to feel that major issues critically affecting them were not being addressed. And while the OSTC was frequently threatened with bankruptcy, financial

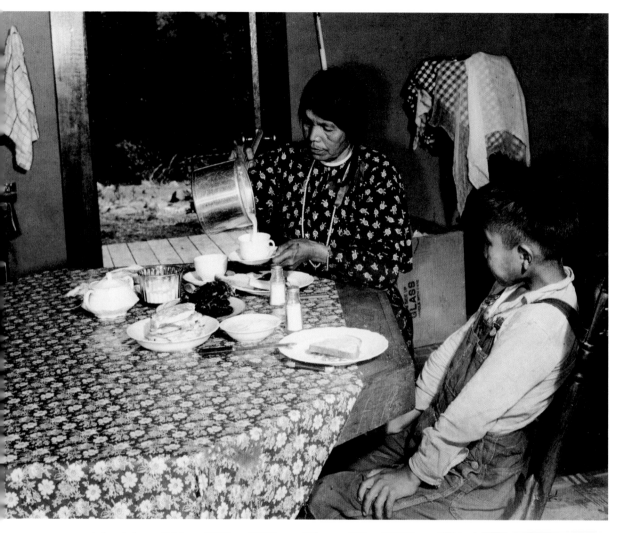

**65.** Mrs. Adams and her grandson in their government-built home, Flathead reservation.

power remained with Superintendent W. O. Roberts of the BIA, who in fact had access to *increased* federal money, including budgets for such New Deal initiatives as the CCC-ID. It was the Indian Office, not the OSTC, that initiated and supported the Red Shirt Table Cooperative, a successful farming venture that also fostered all kinds of communal activities.

On Pine Ridge, despite the IRA and the existence of the OSTC, the BIA, as Reinhardt has demonstrated, retained crucial legal authority—even in such semiprivate matters as the right to grant permission to sell land or horses and certainly with regard to larger contentious issues, including trespass and the potentially illicit use of reservation land for grazing by nonreservation white ranchers. Eager to flaunt its credentials as "progressive," the OSTC did, though, choose to exercise control in religious matters and "traditional" affairs. It tried to suppress the peyote religion, which was gaining ever more followers on the reservation—despite the IRA's ostensible support for indigenous religious practices and the active opposition of Superintendent Roberts. And, mainly for symbolic rather than economic reasons, it attempted to rid the reservation of old-time buffalo by restocking the reservation's communal pastures with beef cattle. The OSTC was also keen to regulate traditional healers, or "medicine men," and here the language of its

ruling reveals the sense of embarrassment at its root: "We protest, object and demand prohibition of pre-inca, stone-age or other North American uncivilized practices of Oglala Sioux now exhibited for show and amusement purposes off the Pine Ridge reservation."[24]

While at Pine Ridge, Post necessarily concentrated on her work for *Brave against the Enemy,* but when she ventured beyond it, she appears to have mildly favored the BIA stance taken by Roberts while steering clear of direct involvement in any of the ongoing controversies. At the Pine Ridge Fair, she mounted a display of the educational series of her images, including the "Health Set," which she had put together for the BIA. She photographed the superintendent dancing with Lucy Knife, a grandmother wearing traditional dress to a fund-raising Parent-Teacher Association event, and, although many Oglalas apparently found Roberts rather aloof, in Post's portrayal any discomfort he felt is not too evident.[25] She also documented the Red Shirt Table Cooperative's horse herd, capturing the healthy liveliness of the horses in the midst of the fertility of their range.

On the other side, so to speak, Post honored the OSTC by troubling to make a formal group portrait of all its members, including Frank Wilson. She got the men to stand outside a large log building, most likely their meeting

**66.** *Red Shirt Table Cooperative Herd.*

place, and arranged them—according to a common convention for group photographs of such size—in two lines, one behind the other, with a third seated line in front, at ground level, each figure clearly visible.[26] But when she photographed healer Thomas Henry Sitting Eagle—in a composition that grants him full respect (fig. 42)—she flew in the face of the OSTC's hostility toward the "show" of such "uncivilized practices." To non-Lakota eyes, Sitting Eagle's performance in this picture may be unfamiliar, even exotic, but the picture itself is reverential.

## Blackfeet Issues

Farther north, in Montana, on one of the reservations Post visited early in her western travels, the Blackfeet, too, were factionalized, largely over post-IRA proposals to revitalize irrigation schemes to make possible the growth of winter feed. The Two Medicine Irrigation Project was planned both to give a new lease of life to failing Blackfeet beef production and, by thus alleviating absolute poverty, to clear the slums that had developed near Browning at Moccasin Flats. But, despite financial investment in it, the mechanics of

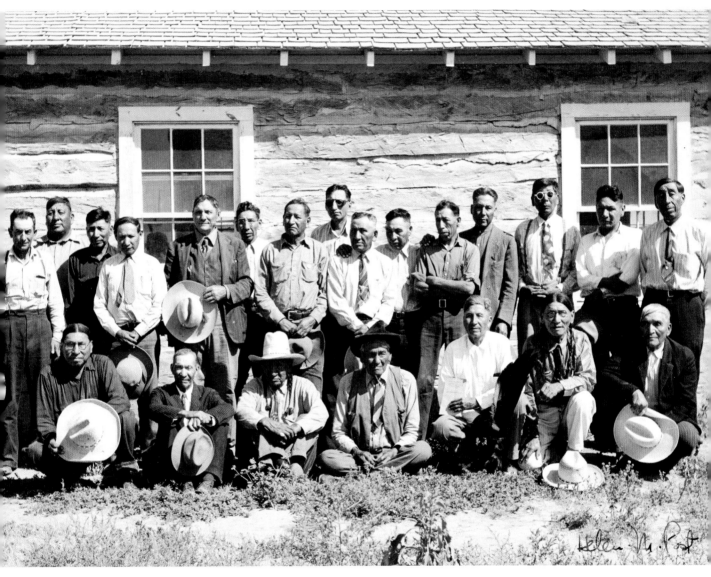

**67.** Oglala Sioux Tribal Council. The man third from the right in the front row holding an eagle-wing fan clasps in his other hand what may be a copy of the council's constitution. Frank Wilson, longtime controversial chair of the osтc, is standing in the center, right of the tall figure in sunglasses. The figure in jacket and waistcoat standing fifth from the left is Peter Dillon, who served for a time as acting chair.

the irrigation scheme didn't work well, and its benefits were very unevenly distributed. The slums persisted.[27]

La Farge's text about the Blackfeet in *As Long as the Grass Shall Grow* gives a brief graphic description of the problems they faced, including "division within the tribe" (85–86), and several of Post's photographs draw visual attention to them. In one picture Yellow Kidney finds that the irrigation channel onto his land is locked and cannot be opened (87). In others—including that described as "The end so clearly to be seen" (fig. 29) and the one of the unnamed "hungry" young woman (fig. 52)—poverty stares the viewer in the face (32, 33, 43, 53, 89).

On the other hand, among the most forceful of Post's Blackfeet images are some she chose not to use in *As Long as the Grass Shall Grow*: usually titled to indicate they were made at the "slums of Moccasin Flats," they include documentation of the lines for distribution of sparse rations, dilapidated shacks with their roof slats half blown away, rough-hewn log houses, children struggling to wash clothes at an outdoor water pump, discarded bedframes littered around tiny cabins, and a tipi erected amid makeshift homes.[28] In one the very blankness of the cloudless sky seems to press down on the depressing tableau, while a girl, surprisingly smartly dressed, her arms folded in resignation

or defiance, stares out at the viewer. The automobile to the right of the frame emphasizes that we are witnesses to a present-day scene. Post was clearly impelled to bear witness to the deprivation she encountered, but her loyalty to the reforming BIA hindered her circulation of images that the mainstream public might have found *too* disturbing.

Similarly, she also suppressed a striking portrait of two Blackfeet elders, *Mr. and Mrs. Yellow Kidney*, seated cross-legged on the ground, the wife, Insima, with a pipe in her mouth. Insima, whose Anglo name was Cecile, was renowned in her own right as a midwife, herbalist, and accomplished quill and beadworker. As was made very clear to a trainee anthropologist, Sue Sommers, in the late 1930s, Insima loved to mimic men for fun and viewed herself as the equal of any man. She had previously been married to another prominent keeper of Blackfeet ways, Yellow Wolf, and she regularly gave advice to women on how to deal with "bad" husbands. In Post's picture she and Yellow Kidney, two leading traditionalists among the divided Blackfeet, exhibit much character. This image did not appear in *As Long as the Grass Shall Grow*, probably because, in the context of the IRA, it would have been considered insufficiently "progressive." The Yellow Kidneys, in this joint portrait, are, perhaps, too assured in their old ways.[29]

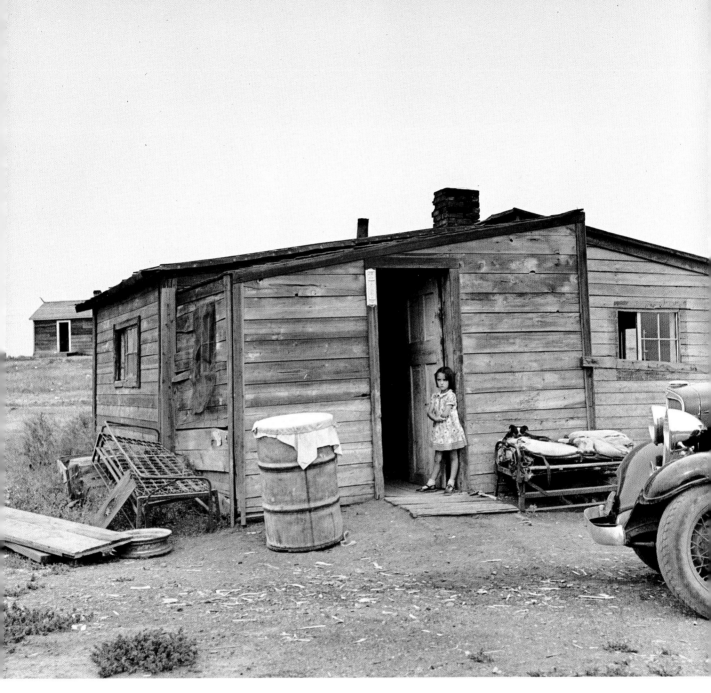

**68.** Blackfeet house and girl, Browning, Montana.

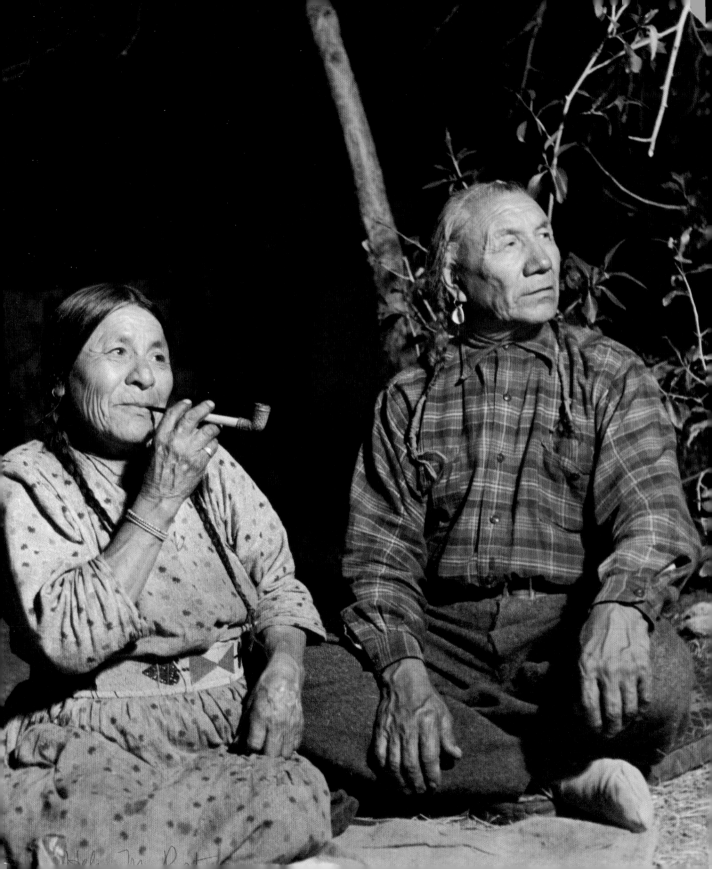

## Navajo Stock Reduction

Perhaps the worst failure to result from Collier's program of reform occurred in Navajo lands. Federal agencies—not just the Indian Office but also the Soil Conservation Service—were convinced that the scrubbiness and aridity of vast tracts of the often-eroded reservation land had been caused by overgrazing. The fact that so many Navajo sheep and goats were scrawny and incapable of commanding a good price at market or sufficiently nutritious meat for the table was because there were far too many of them. The BIA proposed a number of measures, including enlargement of the reservation to take in better land, long-distance irrigation projects, the digging of wells, and some diversification of the Navajo people's predominantly pastoral economy, but the BIA's primary plan, started ahead of the IRA and executed over many years, was stock reduction. Thousands of sheep, goats, and horses were to be corralled and killed. This policy, together with the manner of its execution, led to the Navajos rejecting the IRA; resulted in outbreaks of violence, such as the Shiprock Uprising in 1940, where several individuals refused to surrender their animals; contributed to the impoverishment of many families; and generally caused much misery. For several

**69.** *Mr. and Mrs. Yellow Kidney, Browning, Montana.*

communities it was traumatic, and still today Navajos recall the New Deal period—its "John Collie" reforms—with great bitterness.[30]

Stock reduction had its Navajo supporters, including Chee Dodge and his son, Thomas, who had for a while succeeded his father as chair of the Navajo Tribal Council, but, as time passed, increasing numbers of the people—including, eventually, the Dodges—came to feel that the policy had been *inflicted* on them. Fundamentally, the enactment of livestock reduction revealed a deep lack of understanding and respect for Navajo culture. In 1941 *Indians at Work*, the in-house BIA magazine, carried a brief but revealing notice about Rudi Modley, Post's husband. Describing him as "President of Pictograph Corporation of New York and consultant to the Education Division of the Office of Indian Affairs," it informed readers that Modley had "designed a series of posters for the Education Division which showed the Navajo how to look after their homes, gardens, lands and livestock."[31] Clearly, however "reforming" the BIA, it remained paternalistic, insisting that the Navajos, as a people, were deficient and could not be trusted even to look after their own basic needs.

At the time some non-Navajo commentators acknowledged Navajo suffering. The anthropologists Clyde Kluckhohn and Dorothea Leighton, for example—despite the fact that their researches in Navajo territory were

partly funded by the BIA—concluded in their major study *The Navaho* (1946) that, at best, the livestock reduction program had been a "partial failure" economically and definitely the cause of profound political and emotional distress.[32] *As Long as the Grass Shall Grow*, by contrast, while admitting that the Navajos generally opposed BIA initiatives, mentions stock reduction only in passing and generally supports the official BIA view (97–108). As we have noted, land erosion recurs in the book, both as a subject and as a motif, often with immediate reference to Navajo territory.

In fact, *Navajo Sheep on Overgrazed Land* (101) is probably Post's most graphic representation of erosion. Its composition—with the mountains in the background, numerous sheep among scrub forming a kind of thin strip in the middle ground—accentuates the bareness of the foreground, where just two sheep seem to be struggling to find their way back to the herd up cliff-like walls of earth already forbiddingly in shadow. Given its context, the photograph could be said to affirm the need for sheep to be culled. The existence of this image, together with a number of others like it, might well have led some Navajo people to view Post as on a par with the generality of meddling BIA officials, even as the commissioner's camera eye.

Post must have been aware of Navajo distress. Throughout her time on the reservation, she was out and about, observing, looking for

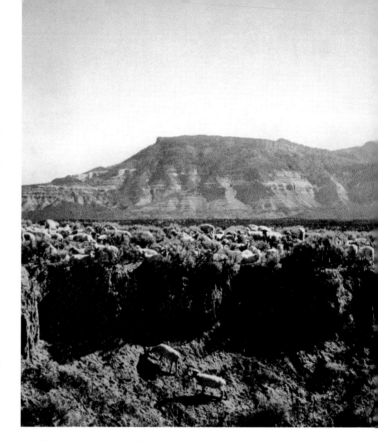

**70.** Navajo sheep, an illustration from *As Long as the Grass Shall Grow.*

pictures or actually photographing, meeting people and talking to them, especially woman to woman. She spent time with her subjects. In one picture she captured Howard Gorman explaining to some elders how the grazing of their sheep, goats, and horses had, as her caption put it, "limited the carrying capacity of their land." Gorman, here in white shirt and dark tie, was both a leading member of the Tribal Council—for a time its vice-chair—and during the New Deal period frequently interpreted for Superintendent E. Reeseman

Fryer as he traveled the reservation insisting on the need for stock reduction. Partly swayed by the involvement of the Soil Conservation Service alongside the Indian Office, Gorman initially supported the policy but became disillusioned by the way it was enforced. In an oral history recording, he described the shooting of animals in front of their owners, concluding, "such incidents broke a lot of hearts of the Navajo people and left them mourning for years. They didn't like it that their sheep were killed; it was a total waste." "Livestock," he added, was "sacred." "They think of livestock as their mother."[33]

Gorman's words give some indication of the status—the *meaning*—the animals had for Navajo families. When anthropologists Sol Worth and John Adair approached Navajo elder Sam Yazzie about his willingness to participate in the shooting of a film, his first question was whether making the film would do his *sheep* any "harm." When assured that it wouldn't, he asked whether it would do them any "good," because if it wouldn't, what was the point? Sheep, horses, and goats constituted not just the basics of a subsistence economy: they were created by the deities Changing Woman and Mirage Man; they helped form the territory that the Navajos recognized as distinctly Navajoland, spread between its four sacred mountains; and they ordained a pastoral way of life. The animals—sheep especially—

were *constitutive* of the people's very identity as Navajo. Except for those few Navajos who ran huge commercial herds, such as Chee Dodge, people lived close to their animals, often sharing their hogans with vulnerable ones in winter. Sheep, disproportionately owned and tended by women in the Navajo's matrilineal culture, loomed large in their lives. The historian Marsha Weisiger recorded many instances of women speaking about the way sheep even inhabited their dreams.[34]

While such thoughts were totally alien to Collier and other gung ho stock reductionists, it is likely that Post—the sheer number of whose Navajo photographs testifies to the extended time she spent among Navajo people, especially women—did gain some insight into Navajo-livestock relationships and their importance in the culture. On the back of one print of her Gorman picture, she marveled at the length of the meeting and noted how, for long after its formal ending, "the leaders . . . would continue [to talk] . . . [and then] very interesting points would finally come out." For a sequence of views that now forms a part of the collections of the U.S. National Archives, she visited a government-demonstration area and was obviously concerned to take pictures that documented the best practice on display: the ideal drinking trough, the "improved lambs," and the like. But the very mundanity of others in the sequence—whether sheep

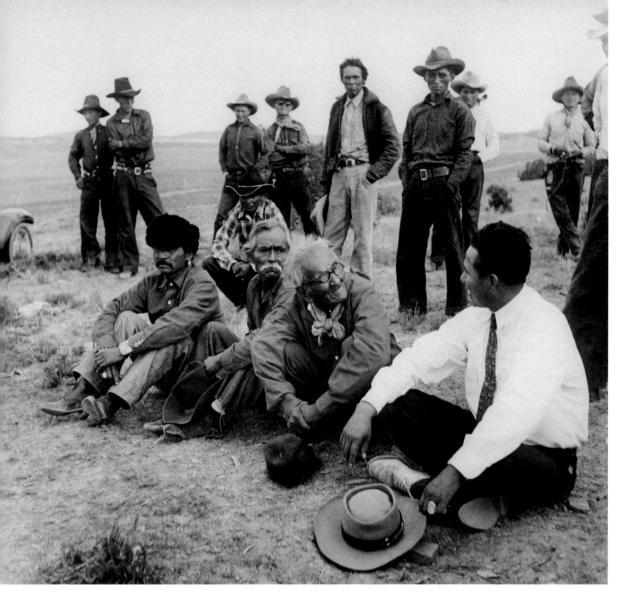

**71.** Howard Gorman talks to Navajo elders about stock reduction.

roaming free, sheep stockaded, sheep marked and unmarked, or a close-up of a young lamb feeding at the teats of its mother—aligns them with the hundred or so other sheep pictures Post made in many different parts of the reservation. The totality of her extensive sheep coverage suggests intimate knowledge.[35] The pictures are *themselves* a record of familiarity with sheep—and what they meant to their owners.

# Conclusion

## Dialogic Power

In 1829 newspapers carried accounts of a speech attributed to the Muskogee leader Speckled Snake in response to President Andrew Jackson's proposals to remove the Muskogee people from their ancestral lands in the Southeast to Indian Territory west of the Mississippi. It was an oration full of irony, irony that deliberately undercut Speckled Snake's apparent acknowledgment of Jackson's promise to leave his people in peace, once settled in the West, for as long as "the grass grows and the rivers run."[1] Oliver La Farge, as noted earlier, presented Euro-Americans as the creative originators of such expressions: "When our forefathers made their treaties with the Indians, they sought for language which should convince a people utterly innocent of our legalities that these promises were binding and eternal"—hence, "as long as the rivers shall run and the grass shall grow" (1).

From the earliest formal encounters between European (then Euro-American) leaders and Native leaders, white observers—most famously Thomas Jefferson—have remarked on the rhetorical power and grace of indigenous speakers. True, onlookers inherently hostile to Indians often considered such eloquence mere glibness, but even some of them noted, in particular, the effective deployment by Native orators of powerful metaphors taken from nature. One informed commentator, writing in the *North American Review* soon after Jackson's speech, observed that the president had in fact used these "figures [of speech] . . . in strict accordance with *Indian* usage." La Farge was therefore most likely wrong in denying to any Native speech maker the creative agency behind his title expression. But despite his oftentimes paternalistic attitudes—attitudes his biographer, D'Arcy McNickle, Native himself, sometimes found oppressive—La Farge was perceptive enough to see the expression as a trope and then to use it in *As Long as the Grass Shall Grow.*[2]

Some of the phrase's force comes from its seemingly organic aptness, some from its elevated formality, some from the associations it gathers by variation and repetition, and some from the sense that it is, indeed, eminently borrowable, in fact *in dialogue* with other discourse. William M. Clements has shown that—like such formulations as "the path" (for the way of life to be adopted), "the Great White Father" (and "his Indian children"), "burying the hatchet," and so forth— the perennial growth of "the grass" is a figure of speech that, because of its reiteration and variation, reverberates with dialogic energy.[3] Even if recorded by white writers, it has a dynamism imparted and reinvigorated by *Native* speakers. I suggest that Native agency was also at work in the books to which Helen Post contributed and, especially, in Post's pictures.

*As Long as the Grass Shall Grow*, as we have seen, emphasizes its evidential character. Its format is "read-and-see." Its author asserts his firsthand knowledge of the book's subject matter. And, of course, its photographs are presented as direct and truthful testimony. In these ways, and more, the book takes its place as an example of what William Stott, in his pioneering study, called the "documentary expression" of the American 1930s.[4] In particular, as a photographic documentary book, it may be compared with such better-known

contemporary works as Erskine Caldwell and Margaret Bourke-White's *You Have Seen Their Faces* (1937) or Dorothea Lange and Paul Schuster Taylor's *American Exodus: A Record of Human Erosion* (1939), both of which, in words and photographs, treated impoverished tenant farmers and, in the case of the latter book, their frequent dispossession and migration westward.

As noted earlier, James Agee and Walker Evans—so open in their phototext *Let Us Now Praise Famous Men* (1941) about their own ambivalence in endeavoring to represent others—despised the stance of Caldwell and Bourke-White: they believed *You Have Seen Their Faces* had deliberately opted "to cheapen [the book's subjects and] . . . to exploit them— who had already been so exploited." Stott pointed out that Bourke-White overemotionalized her portraits of the sharecroppers, *making* them seem abject, and that she and her novelist coauthor—in their caption quotations that purported to emanate from the sharecroppers themselves—attributed to them not just extremes of misery but thorough ignorance of their own state. As he puts it, the worst accompanying legends "say . . . 'Look at me, my life is so wretched I don't even know it.'" Unlike the subjects of the portraits in *American Exodus*, to which Lange and Taylor scrupulously attached captions consisting of the

verbatim sayings of the particular person in the photograph, Caldwell and Bourke-White's people positively *lack* consciousness.[5]

Nothing like such criticism can be leveled against Post—or La Farge—in *As Long as the Grass Shall Grow*. La Farge may have been paternalistic, but he was well aware of prejudices against Indians rampant in the dominant culture and of his own responsibility to get things in proper perspective: "one must look further, behind Congress and government, for they only reflect the attitudes of the people at large. The slow massacre of maladministration, the misery of the children, lie at the doors of you who read and of me who writes these words" (58–59). Post never expressed any parallel opinion, even privately. She took no pictures that overtly point up white prejudice against Native people in the manner of her sister's photograph, taken in 1941, of *Signs behind the Bar in Birney, Montana*. Her work evidences no interest at all in *whatever* whites thought. But she aimed, at least, to bridge any gap there might be between herself and her Native subjects. She was concerned about them as people, and her photographs quietly affirm their humanity. In these concluding remarks, I wish both to continue to stress this view and to show how her images, like the treaty speeches, are dialogic: as such, while they document numerous aspects of reservation life

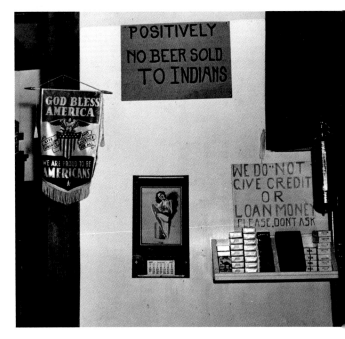

**72.** *Signs behind the Bar in Birney, Montana.* Photograph by Marion Post Wolcott.

at the time, they also affirm Native presence, input, and consciousness.

But first, we must face questions raised by the relationship between text and pictures in *As Long as the Grass Shall Grow*—a relationship, as already hinted, that can be troubling. The text refers to the pictures as able to "speak" (42, 81, 133), and several times it implies that the photographs' human subjects themselves do so address us. This seems especially the case in the picture sequence that begins with

the words, "He [the U.S. president] is not our father," and ends on, "Nothing to do but wait" (36–39)—and when we turn the page an untitled and undescribed photograph shows a man and woman riding away, as if they have, indeed, tired of waiting (fig. 50). The printed legends above or below many of the photographs only *appear* to be words spoken by their subjects; for example, "You must not listen to the old men" (17). Or, as in the case of the Jicarilla store transaction picture (fig. 45), to register the satisfying situation they face: "Their store shows a steady profit" (99).

The clearest example of all is that final sequence supposedly representing "The desire of the Indian people speaking" (133), which begins with the picture of a Crow worker hooking up a reaper that carries the legend, "We shall learn all these devices the white man has, we shall handle his tools for ourselves" (134). The following image, captioned, "We shall master his machinery," shows another Crow man, this time running a dragline shovel (135), the next a Flathead worker seen from below, operating high up on power lines (fig. 64), with the words, "His inventions" (136). These are followed by a laborer threading pipe ("His skills," 36), a Navajo nurse ("His medicine," 138), someone at the drawing board ("His planning," 139), and, finally, the smiling CCC-ID worker ("And . . . still . . . be . . . Indians," 140). Leaving aside what most people today would

recognize as the inherent racism here—there is nothing essentially "white" about medical knowledge or skill with tools or anything essentially "Indian" about their absence—such phrases actually belong, of course, *not* to their "speakers" but to La Farge. In fact, the final words of *As Long as the Grass Shall Grow*, as McNickle has pointed out, very specifically belonged to La Farge, in that they were lifted almost word for word from Myron Begay, the protagonist of the writer's then recent Navajo novel, *The Enemy Gods*: "We have to learn to use the white man's knowledge, his weapons, his machines—and still be Indians."[6]

The Native subjects of the photographs in *As Long as the Grass Shall Grow* are, themselves, silent. They are silent whether they gaze into the distance, gather over a bed in the boarding school dormitory, or meet at the powwow or rodeo. Given that photography, by nature, only ever offers what William Henry Fox Talbot, one of its nineteenth-century inventors, termed "mute testimony," they are silent even when apparently speaking.[7] Even when we witness Stabs Down by Mistake addressing his Blackfeet Tribal Council, we do not know *what* he said. When we see Robert Yellowtail seemingly enlarging on some issue or other, we cannot ascertain what it was. But speech is not the only sign of agency. As Fox Talbot recognized and demonstrated, the encompassing frame of the photograph and its capacity to

present intense detail as well as a broad, luminous picture grant authority to its "testimony."

## Symbolic Documentary

The history of photography—especially during the early twentieth century—witnessed a disturbing tendency to depict Native people alongside signs of modernity as if the conjunctions were anomalous and amusing: several Blackfeet leaders in feathered headdresses looking out, not from the crest of a hill but from atop a skyscraper; top-hatted Geronimo at the wheel of an automobile; a long-haired Coastal Salish elder with a newfangled telephone to his ear, a bemused grin on his face; three Assiniboine men seemingly puzzled by the camera itself in a picture made by Sumner Matteson at Fort Belknap, Montana.[8] By contrast, Post's commitment to documentary—especially the emphasis on post-IRA "Indians Today" in *As Long as the Grass Shall Grow*—means that faithful photographic representation of obvious modernity was integral to her project: images of telephone poles, power lines, microphones, tractors, formidable lumber-mill machinery, and the like.

In this respect, a starring role was taken by the Kerr Dam at Polson, western Montana, on the Flathead reservation. Owned by the Montana Power Company, begun in 1930, stalled by the Great Depression, and restarted only after President Roosevelt himself authorized federal funding, the dam—greater in height than Niagara Falls—had just been completed when Post included several images relating to it in *As Long as the Grass Shall Grow* (92–94, 136). In one photograph the massive pipe leads the eye down toward the water, and the positions of the construction workers, especially that of the statuesque figure in the upper right, make us acutely aware of both the dam's vertiginous height and the workers' ease with it. The accompanying text emphasizes Native involvement—"New enterprises . . . / . . . built by Indian labor" (92, 93)—and the dramatic images themselves stress the dam's monumentality and modernity.[9]

Brian W. Dippie—a scholar who has successfully done more than most to relate the visual imagery of Indians to the dominant ideology of the culture that produced it—labeled such pictures as the one by Sumner Matteson and the others described earlier as "photographic allegories." "A visual allegory should express a complete idea in a single image," he wrote. "The more explanation or elaboration is required, the more its impact is diffused. . . . Of course, allegory cannot be *too* cryptic or it fails its purpose, falling into a twilight zone where it is neither documentary nor coherently symbolic." Dippie was perceptive in presenting photographs of Native people apparently discomforted or displaced by modern technology as "allegories," as propaganda, in effect,

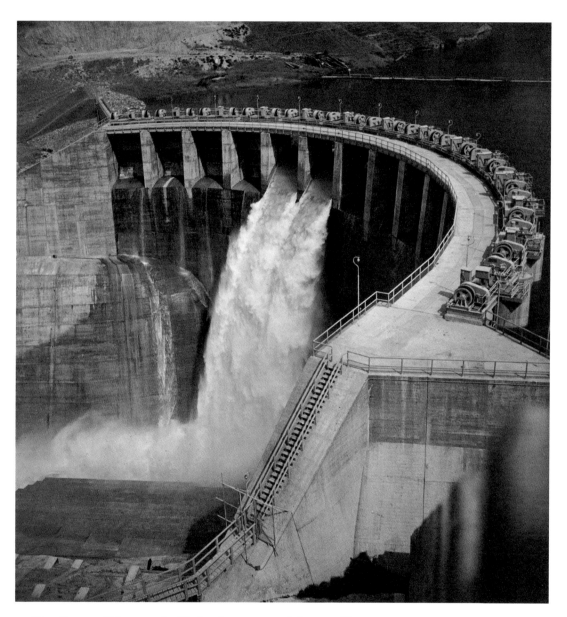

**73.** Kerr Dam, at Polson on the Flathead reservation, Montana. This photograph was used in the two-page spread illustrated as figure 26.

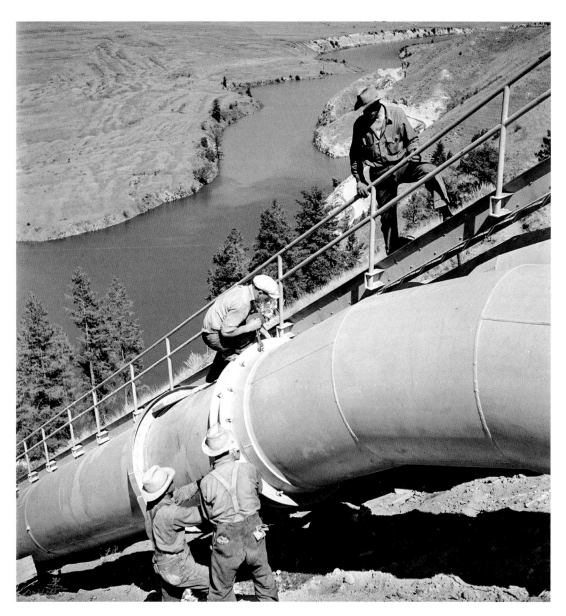

**74.** Kerr Dam, with workers tending the pipes for the dam's irrigation scheme.

for the widespread assumption that Indians had no place in the modern world and were destined to die out, to "vanish." However, he then went on to write, "Probably no-one would regard Helen M. Post's 1930s photograph of an ordinary Indian farmer [with his tractor] as allegorical." For Dippie, "documentary," the category to which this Post tractor picture belongs, could not, by nature, be "coherently symbolic."[10] But, clearly, it could. The import of many of Post's pictures, including those made at Kerr Dam, was tantamount to an inversion—or, better, replacement—of those earlier "allegories" by ones that indicate an ease, even an assurance, with modernity. Joe Medicine Crow takes notes for his dissertation not by hand but on a typewriter (fig. 38).

Post, as I have reiterated, was committed to documentary photography and what she called, in her "how-to" article, its "democratic language, understood and appreciated by a widely diversified audience." In some instances she overtly created images that depend for their power on a symbolic reading. Her previously unpublished photograph titled *Letter from Government Agency*—most likely made while she was at work on the illustrations for *Brave against the Enemy*—shows a man, probably Lakota, preoccupied by the letter he holds; he even ignores his wife sitting beside him and lets the horses stand and the reins loose. Whatever the letter says, the picture—given its

title—is about how the "Government" reaches in to touch the lives of individual Native citizens. Even though a photograph cannot itself tell a story, as such, it can gesture toward one, and there is a palpable sense of pathos here. The picture invites viewers to imagine the thoughts of its subjects. It asks us to consider, as if from their perspective, the import of the letter. It asks us to reckon with, as if from a Native viewpoint, the *effect* of government policies such as those outlined in the previous chapter.

This *Letter* photograph, like so many others that Post made, fits the standards of documentary set by Stryker for the FSA: "The newspicture is dramatic, all subject and action. Ours shows what's in back of the action. It is a broader statement—frequently a mood, an accent, but more frequently a sketch and not infrequently a story." The portrait of a Jicarilla man in a dark, wide-brimmed hat sitting on the counter of the cooperative store in Dulce, New Mexico, surrounded by the store's provisions, brings us very close—almost uncomfortably so—to its human subject. The legend printed below the picture in *As Long as the Grass Shall Grow*, "A very Indian, strong, competent people" (48), tends to conflate this smiling individual with his tribe, even with his entire ethnic group. The camera's vantage point and the man's positioning give a potent sense of his very specific and physical pres-

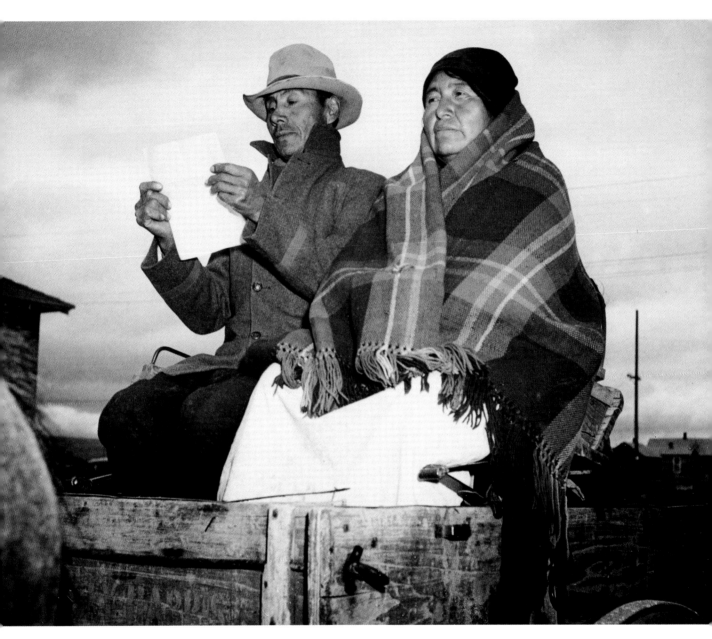

**75.** Man and woman in a cart, the man reading.

ence, but—reinforced by the caption—they also coerce us into seeing him as a figure *representative* of Native strength and competence. Given Post's Popular Front heritage and her commitment—expressed in her "how-to" article—to "the interpretation of the democratic way of life ahead of us," this man can be seen as asserting his human rights.[11]

## Post's Achievement

Helen Post was not a major artist in the photographic medium. Her pictures do not exhibit an indelible and almost immediately recognizable style in the manner of Walker Evans, Dorothea Lange, or Edward Weston. Rather, while certainly not bland, their principal effects are functional. They grant, in a characteristic manner of their own, privileged and interesting access to the ways of life—the worlds—of their otherwise often ignored subjects. At least some of the time, Native people take the initiative. In a handwritten reminiscence, probably written as much as twenty years after the events it described, Post related her first encounter, on the Oglala Pine Ridge Reservation, with Mattie Last Horse:

> Once on a photographic assignment to cover the dedication of a new school building [I] met an Indian woman through a rather curious circumstance. In the building known as the school canning kitchen where the noon meal for probably 500–800 persons [was prepared] the cook declined to be photographed. My presence at the meeting had been explained from the speaker's platform but she was too busy to have heard it. However, as I do not believe a photographer has any business to photograph people who request not to be photographed, I was not insistent . . . but as I worked along through the day, I noticed I was being rather carefully observed by . . . the cook. Finally, late in the afternoon, she approached me with an interpreter and explained that she was not aware of the purpose of my work when she objected to being photographed, and that any time I would like to come to her house she would be pleased to have me take any pictures which I might need.

Post went on to recall how she managed to find someone who knew where Mattie lived, and they "drove through some very wild and lovely country to find her." After enduring "the formalities of making conversation through an interpreter," Mattie, as Post put it, "finally managed to bring herself to speak with me directly in English." "She used the language haltingly," Post wrote, "but in a beautiful tone of voice which possessed both carrying quality and dignity although very quietly spoken. She wanted to tell me about that school. She was very earnest. She told me her own age and her husband's. They were both over sixty." Then,

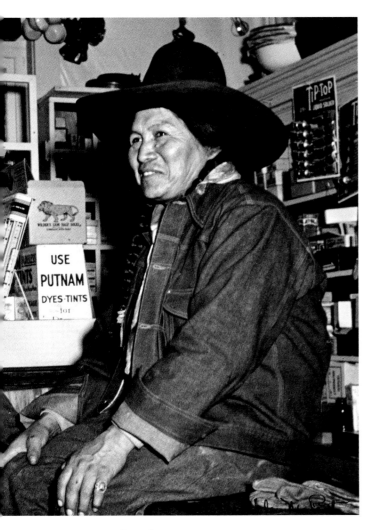

**76.** Jicarilla man.

after Mattie explained that her children were all grown up and that there were no school-age children in the family, she got across what was special about "that particular school": In it "there was a place . . . for everyone, from babies still in their mothers [*sic*] arms to the old people like herself and her husband and the old gentleman, Thomas Henry Sitting Eagle, who had been at the school meeting."[12]

Doubtless Post learned worthwhile things about the school—she recorded what Mattie had to tell her about the school nurse and about the school's special "cottage," where "big girls" learned practical nursery skills, "not out of books" but by "taking care of real babies"—but the most important outcome of the encounter was the series of portraits Post made of Mattie herself. And in these, just as in their initial meeting, Mattie—wearing traditional clothing, in particular a dress of the "darkest blue wool" onto which had been sewn lines of glistening elk teeth—took the lead. She posed herself against the log walls of her house, against the sky, and in the nearby woods. On another day, at either the Pine Ridge or Rosebud Fair, she appeared in the same frame with Thomas Henry Sitting Eagle. In some pictures she stands tall, while others are close-ups. Perhaps the images that most fit with Post's approach are those in which Mattie sits, at ease, on a level with Post's camera, dis-

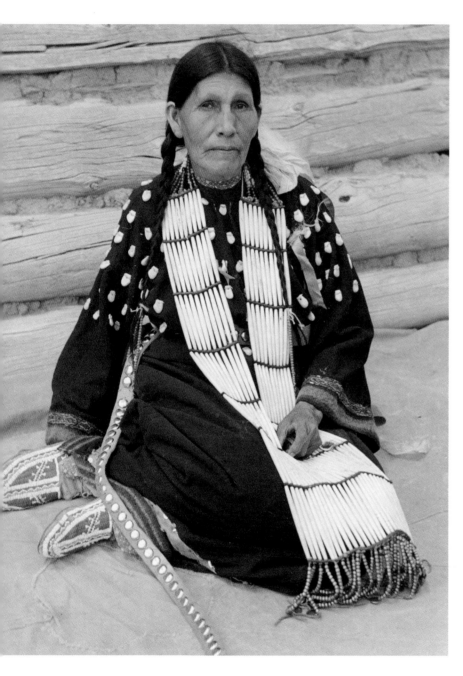

**77.** *Mattie Last Horse at Home*, Pine Ridge Reservation.

playing both herself and her elaborate costume with quiet dignity.

As well as being a cook, Mattie was a craftsperson and worked sporadically for the Indian Arts and Crafts Board. Post clearly had a rapport with craftspeople. Though at first glance her portrait of Mabel Burnsides weaving at her loom in a shady spot outside seems reminiscent of classic images of Navajo women weavers by Curtis, Gilpin, and others, a closer examination reveals something else. Post's photograph may be atmospheric, but it lacks that idyllic look of the classics, in that the sharpest focus is on the woven fabric itself. We see the pattern emerging in the weave. Post, as frequently noted here, was preoccupied with education. The perspective in this image is an instructional one, and there's a performative aspect to Mabel Burnsides's position: she's at work. The photograph constitutes a tableau in which she plays a conscious role. She is enacting, not just reenacting, both a large part of her own life and a significant feature of Navajo culture.

The photograph of Annie Bordeaux measuring Post's feet for moccasins (fig. 1) was thought by Peter Modley to have been made by Post using a hidden timer. But seen in the context of other images probably taken on the same day, in which Annie Bordeaux and Nellie Star Boy Menard usually feature closely together, whether in their craft store, out and about, or relaxing, it is more likely that this close-up and very personal image of Helen Post was in fact shot not by Post herself but by Nellie. A note on the verso of the print of it reads, "Private property of Nellie Menard." Whoever pressed the button, this image—as much as the scene in the Jicarilla store—depicts a transaction. The cultural historian Alan Trachtenberg ventured a definition of such works: "The photograph is a visual record of a transaction across a divide, a cross-cultural dialogical event in which the depicted person is as much an agent as the photographer."[13]

There is a marked sense of ease in Post's portrait of a Navajo woman spinning. As in the portraits of Mattie Last Horse, Peter Pichette (fig. 39), the Yellow Kidneys (fig. 69), and others, the vantage point is characteristically on a level with the subject. In her handwriting on the matte of an archived print, Post identified the spinner as "my friend Mrs. Aschi Mike of Two Grey Hills," and it is evident that the two women must have spent a good deal of time together. Post exhaustively photographed Mike's hogan, her fruit trees, tomato plants, lettuces, sheep, and even a plow left in her family's field. And, as well as portraying her spinning, she presented Mike doing a host of other things, such as sewing or enjoying the Window Rock Fair, and she made a group portrait of her with her husband and daughter that became the cover image for *As Long as the Grass Shall Grow* (fig. 2).

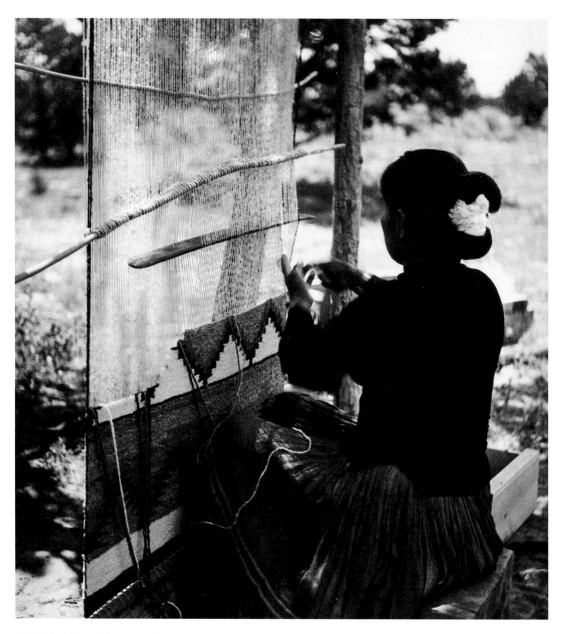

**78.** Mabel Burnsides, weaving.

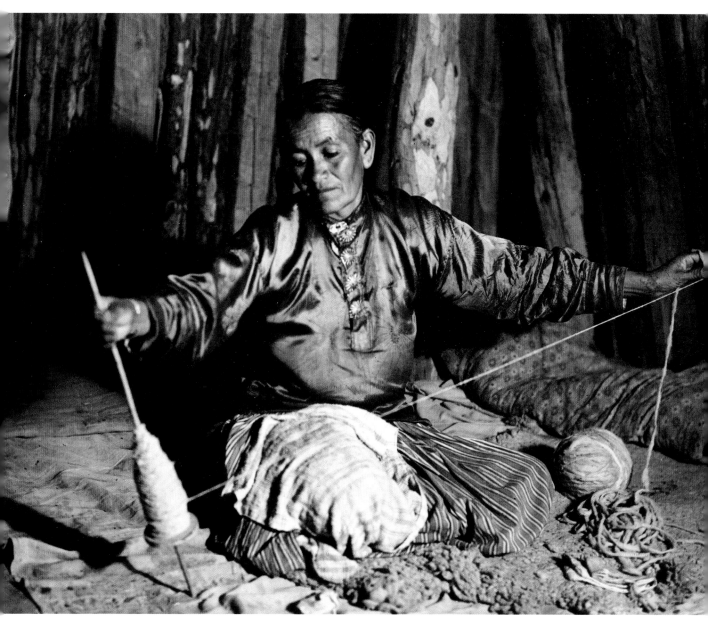

**79.** *Mrs. Aschi Mike Spinning.*

In the spinning image Mike concentrates on her work. But, at the same time as she watches the gathering spool, turning it to take any slack from the thread she feeds from her outstretched other hand, her pose makes her expansively open to us, the silky sheen of her blouse a further soft draw for our gaze. While the shadow she casts indicates glare from a flashbulb, she herself is unfazed, lost in the circle of her work. As Edward T. Hall and others have shown, it is not possible fully to read "body language" in cross-cultural encounters, so here in this image, as in so many others of Post's pictures, something is offered, and something is legitimately withheld. Aware as we are of the firm timber walls of the hogan lit up behind Mike by the flash, we are in an enclosed, private space that—though we visually share it—she controls.[14]

In the case of some of the images here evoked, we are granted an intimation, at least, of worlds as they might be seen by the subjects of the pictures—Mike's assurance in her spinning, the Jicarilla man's pride in the success of the cooperative store, the Flathead couple's ease in their situation, even the San Carlos child's possible awareness of the isolation of her family's farm. Something similar happens in connection with an illustration used in *As Long as the Grass Shall Grow* with the description, "The dwellings they decorated so lovingly" (9). It depicts two Crow tipis, their whiteness eating all the light among trees, some of their lodge poles trailing thin pennants, and their brightness showing up two horse tails attached to the nearer one. A bent cottonwood tree in the foreground neatly separates the protruding lodge poles of the two dwellings, as if it had been planted there for the purpose. This is a temporary encampment; the picture was taken during the Crow Fair in Montana (we see other tipis behind them on the left and the hood of a Ford automobile on the right). The scene is tightly framed, and everything looks *right*. One of the tipis belonged to someone Post knew and whom she named in a caption as "Amy," most probably Amy Yellowtail, Chief Yellowtail's daughter, wife to John White Man Runs Him. Post's photograph of Amy's tipi not only alludes to the naturalness of old-time Crow ways but also allows access to an impression of how Crow people traditionally liked to establish camp, to a sense of Crow aesthetics.

Whether we look at Aschi Mike spinning; Buster Yellow Kidney gazing up to his grandfather; Joe Medicine Crow powwow dancing; Johnson Holy Rock taking pride in the Pine Ridge agency library; or many of the other photographs discussed here, we have to acknowledge Post's artistry. And we must recognize, too, Native agency, a fullness of humanity, as surely as we register it in the treaty speeches. The grass shall grow.

**80.** *Crow Tipis.*

# *Notes*

Abbreviations

*ALATGSG*   Oliver La Farge, *As Long as the Grass Shall Grow*, photographs by Helen M. Post (New York: Alliance, 1940)

HPBF   Helen Post Biography File, Amon Carter Museum of American Art, Fort Worth, Texas

HPMDP   Helen Post Modley Documentary Photographs, Amon Carter Museum of American Art, Fort Worth, Texas

HPP   Helen Post Papers, Amon Carter Museum of American Art, Fort Worth, Texas

HPPC   Helen M. Post Photography Collection, Amon Carter Museum of American Art, Fort Worth, Texas

HRC   Oliver La Farge Papers, Harry Ransom Center, University of Texas, Austin, Texas

Prologue

1. Page numbers for *ALATGSG* appear in parentheses in the text. The book also carries the imprimatur of Longmans, Green of New York and Toronto, a company headquartered in London.

2. An extensive bibliographical survey is Martin Parr and Gerry Badger, *The Photobook: A History*, 2 vols. (London: Phaidon, 2004, 2006); volume 1 has a section on 1930s documentaries, but *ALATGSG* does not feature. Caroline Blinder provides commentary on a range of photobooks from the period—not including *ALATGSG*—in *The American Photo-Text, 1930–1960* (Edinburgh: Edinburgh University Press, 2019).

3. Ann Clark, *Brave against the Enemy*, photographic illustrations by Helen Post, translated by Emil Afraid of Hawk (Washington DC: Education Division of U.S. Indian Service, 1944).

4. I am grateful to the Tribal Historical Preservation officers and unofficial memory keepers on the reservations where Post worked for responding to my letters and pictures and for their efforts on behalf of this book.

1. Introducing Helen Post

1. The epigraph is from "Memorandum to Mr. Helander" (subagent at the Zuni reservation), enclosed with a letter to Helen Post from S. D. Aberle, September 16, 1939, folder 2, box 1, HPP. When Peter Modley, Post's son, donated her photographs and papers to the Amon Carter, he also deposited "A Short Interpretive Biography of Helen Post, Photographer," a typescript to be found in HPBF, on which I have relied. Since the first phase of Helen's life was interwoven with that of her better-known sister, Marion Post Wolcott, some of the information on Marion's earlier life in chapter 1 of F. Jack Hurley, *Marion Post Wolcott: A Photographic Journey* (Albuquerque: University of New Mexico Press, 1989); and scattered through Paul Hendrickson, *Looking for the Light: The Hidden Life and Art of Marion Post Wolcott* (New York: Knopf, 1992), is relevant.

2. The receipt for a "used Linhof" is in folder 7, box 2, HPP. I am grateful to Marion Schling, Post's daughter, for information on Post's Linhof camera (email message to author, June 24, 2018).

3. For Fleischmann, see Naomi Rosenblum, *A History of Women Photographers*, exp. ed. (New York: Abbeville, 2000), 120–21, 322; and, for more detail, Anna Auer, "Trude Fleischmann: Vienna in the Thirties," in *Shadow and Substance: Essays on the History of Photography in Honor of Heinz K. Henisch*, ed. Kathleen Collins (Bloomfield Hills MI: Amorphous Institute Press, 1990), 339–44; and Lisa Silverman, "Trude Fleischmann," *Jewish Women: A Comprehensive Historical Encyclopedia*, Jewish Women's Archive, March 1, 2009, http://jwa.org/encyclopedia/article/fleischmann-trude. Anton Holzer and Frauke Kreutler, eds., *Trude Fleischmann: A Self-Assured Eye* (Vienna: Wien Museum and Cantz, 2011), is a bilingual selection of her Viennese photographs.

4. For an evocation of Vienna at this time, see Helmut Gruber, *Red Vienna: Experiment in Working-Class Culture, 1919–1934* (New York:

Oxford University Press, 1991); for a graphic near-firsthand account of the political strife, see the Austrian chapters of John Gunther, *Inside Europe* (1936; repr., New York: Harper, 1940).

5. For Tudor-Hart, see Duncan Forbes, *In the Shadow of Tyranny* (Edinburgh: National Museums of Scotland, 2013); and, for speculation on how she communicated her political allegiance, see Mick Gidley, "Can You See the Politics?," *Source* 75 (2013): 62–63.

6. Such photographs, usually in appropriately labeled folders, may be found in folders 3, 4, 9, 21, 22, box 6, HPP.

7. Sequences of Post's photographs of educational institutions may be found in folders 8 and 9, box 2, and folders 9–15, box 5, with the Black Mountain College coverage in folders 17–19, box 2, all in HPP. Various of her Black Mountain College images, both of famous teachers and of students farming, appear in publications on the history of Black Mountain College, such as Mary Emma Harris, *The Arts at Black Mountain College* (Cambridge MA: MIT Press, 1987), 21, 20, 49.

8. A sound history of the FSA photographic unit is F. Jack Hurley, *Portrait of a Decade: Roy Stryker and the Development of Documentary Photography in the Thirties* (Baton Rouge: Louisiana State University Press, 1972); more analytic treatment may be found in Lawrence W. Levine, "The Historian and the Icon: Photography and the History of the American People in the 1930s and 1940s," and Alan Trachtenberg, "From Image to Story: Reading the File," both in *Documenting America, 1935–1943*, ed. Carl Fleis-

chauer and Beverly W. Brannan (Berkeley: University of California Press, 1988), 15–42, 43–73. The Stryker quotation is taken from Melissa A. McEuen, *Seeing America: Women Photographers between the Wars* (Lexington: University Press of Kentucky, 2000), 104.

9. Post published a photograph in the *New York Times* of April 16, 1939, D8, the caption of which promised "Now the West Virginians will return the call." The West Virginia images are in folder 7, box 7, HPP. Post Wolcott recalled her first FSA job in her interview with Richard Doud: "Oral History Interview with Marion Post Wolcott, 1965 January 18," *Archives of American Art*, Smithsonian, accessed March 8, 2017, www.aaa.si.edu/download_pdf_transcript/ajax?aaa_id=213979&record_id=edanmdm-AAADCD_oh_213979.

10. For brief biographical information on Modley, who went on to have a distinguished career as a proponent of the international standardization of graphic symbols through both writing and business consultation, see "Rudolf Modley Dies; Industry Consultant," *New York Times*, September 30, 1976, www.nytimes.com/1976/09/30/archives/rudolf-modley-dies-industry-consultant-author-and-conservationist.html?_r=0; and Wikipedia, s.v. "Rudolf Modley," last modified October 27, 2018, 14:39, https://en.wikipedia.org/wiki/Rudolf_Modley. Two of his books of the time are *How to Use Pictorial Symbols* (New York: Harper, 1937) and *The United States: A Graphic History*, with text by Louis Hacker (New York: Modern Age Books, ca. 1937). An indication of Modley's work with

Mead is Margaret Mead and Rudolf Modley, "Communication among All People, Everywhere," *Natural History* 77, no. 7 (1968): 56–63.

11. As is clear from the contents of folders 7–15, box 3, HPP, Charles W. Collier—together with his wife and children—frequently sat for portraits by Post. I am grateful to his daughter, Lucy Collier, for information on Charles and his career; brief comments on his role in the SCS may be found in Douglas Helms, "Hugh Hammond Bennett and the Creation of the Soil Erosion Service," United States Department of Agriculture, accessed April 3, 2018, www.nrcs.usda.gov/wps/portal/nrcs/detail/national/about/history/?cid=nrcs143_021384. Helms does not mention that, as an employee of SCS, Collier routinely took photographs of SCS projects, many of which survive in the Still Picture Division, U.S. National Archives and Records Administration, College Park, Maryland. An account on the internet of the early stages of John Collier's cooperation with the SCS in Navajo territory is Lilian Makeda, "Utopian Vision: The Navajo, the New Deal, and the Soil Conservation Service," Office of the New Mexico State Historian, accessed March 13, 2018, http://newmexicohistory.org/people/utopian-vision-the-navajo-the-new-deal-and-the-soil-conservation-service (site discontinued).

12. James C. Faris, *Navajo and Photography: A Critical History of the Representation of an American People* (Albuquerque: University of New Mexico Press, 1996), 191, 194–203; there is also scattered commentary on Snow in Katherine G. Morrissey and Kirsten M. Jensen, eds., *Pic-*

*turing Arizona: The Photographic Record of the 1930s* (Tucson: University of Arizona Press, 2005). Snow provided photographs for a book by George I. Sanchez, *The People: A Study of the Navajos* (Washington DC: Bureau of Indian Affairs, 1948); and, later, his pictures were used by Robert W. Young in his *A Political History of the Navajo Tribe* (Tsaile AZ: Navajo Community College Press, 1978). Snow wrote briefly about his experiences in "Photographing the Indians of the Southwest," in *1001 Ways to Improve Your Photographs*, ed. Willard D. Morgan (1943; repr., New York: National Educational Alliance, 1947), 79–86; and the Navajo Nation Museum at Window Rock, Arizona, has an extensive archive of his photographs. The HPPC contains a number of Snow images that Post presumably acquired from him, including P1985.50.1479 to P1985.50.1482.

13. Details on Post's approach to reservation work are taken from the transcript of a radio interview for Alma Kitchell's *Brief Case*, February 17, 1941, folder 1, box 1, HPP. Typical newspaper publicity is the *New York Times'* Books and Authors column, April 21, 1940, 88. The Post images at the Still Picture Division, U.S. National Archives and Records Administration, include these among about twenty other Indian pictures made in New York State.

14. Typical reviews are R. L. Duffus, "The Indian in American Life," *New York Times*, May 5, 1940, 97; and Louise Long, "As Long as the Grass Shall Grow," *Southwest Review* 25, no. 4 (1940): 489–92. Plans for a new edition—later abandoned—are outlined in a letter to La Farge

from Günther Koppell, CEO at the Alliance Book Corporation, June 16, 1942, folder 8, box 20, HRC. For Snow's quotation, see Jack Snow to Helen Post, May 28, 1940, folder 4, box 1, HPP. Bourke-White's comments appeared in Margaret Bourke-White and Erskine Caldwell, "The American Indian: 1940," *Saturday Review of Literature*, May 11, 1940, 11. It seems that Caldwell, famous as a novelist at the time, wrote the comments on La Farge's text, while Bourke-White contributed the remarks on Post's work. The review was accompanied by the Fleischmann photograph of Post and La Farge together that appears here as figure 9. Bourke-White's huge fame during this period is evoked in her autobiography, *Portrait of Myself* (1963; repr., London: Collins, 1964), especially chaps. 11 and 12.

15. Bourke-White and Caldwell, "American Indian," 11.

16. Information on the exhibition is taken from correspondence between various figures at the Association on American Indian Affairs (AAIA) and the Alliance Book Corporation in HRC, such as Cole Friedman of Alliance to Ruth Martin of AAIA, April 17 and April 20, 1940; Hazel Christiansen, Big Horn County Library, Hardin, Montana, to Ruth V. Robinson, AAIA, October 16, 1940; many notes by Ruth Martin, especially one to Miss Anne Mumford of the LA County Museum, March 23, 1940; and Oliver La Farge to Günther Koppell, October 19, 1940, all in folder 8, box 20, HRC; and Post Exhibition file, San Francisco Museum of Art, San Francisco Museum of Modern Art Archives. For

an account of Curtis and his project, see Mick Gidley, *Edward S. Curtis and the North American Indian, Incorporated* (New York: Cambridge University Press, 1998).

17. Laura Gilpin, *The Pueblos: A Camera Chronicle* (New York: Hastings House, 1941). John Collier Jr., the photographer and anthropologist, described Gilpin's approach to Indians in this book as "through archaeology rather than sociology"; he is quoted in Martha A. Sandweiss, *Laura Gilpin: An Enduring Grace* (Fort Worth: Amon Carter Museum, 1986), 69.

18. For the Day family's work for Curtis, see Gidley, *Edward S. Curtis*, 85–87; and, for a much more critical view, Faris, *Navajo and Photography*, 108–15. The White Man Runs Him picture is discussed later.

19. Most of the issues of *Indians at Work*, which was produced in typescript, have been digitized by the Smithsonian Institution; see *Indians at Work*, Smithsonian Libraries, accessed June 19, 2018, https://library.si.edu/digital-library/book/indians-work. Tonawanda images by Post appear in several issues, and a typical Post issue is that for March–April 1944, which has one of her portraits of an Indian girl on the cover and several shots of powwow scenes inside. For Post's Indian Affairs appointment, see letters to her from Willard Beatty, Director of Education, Office of Indian Affairs, December 16, 1940; and Paul L. Fickinger, Assistant Director, February 21, 1941, both in folder 4, box 1, HPP.

20. See Frederic H. Douglas and Rene d'Harnoncourt, *Indian Art of the United States* (New York: Museum of Modern Art, 1941), exhibition cat-

alog. Post's pictures appear throughout and are listed in credits on page 219. In HPPC there are numerous images that Post made of items in the show, including P1985.50.1390 to P1985.50.1457.

21. The HPPC print of the photograph (P1985 .50.1287) incorrectly identifies Shorty as "Young Hopi artist" and Elsie Bonser as "Elsie Bouser," and Nellie Star Boy Menard appears without her last name. There is informative commentary on the MOMA show, especially its development as an Indian Arts and Craft Board initiative, in Robert Schrader, *The Indian Arts and Craft Board: An Aspect of New Deal Indian Policy* (Albuquerque: University of New Mexico Press, 1983), 200–245. More nuanced accounts may be found in W. Jackson Rushing, *Native American Art and the New York Avant-Garde: A History of Cultural Primitivism* (Austin: University of Texas Press, 1995), 96–120; and Jennifer McLerran, *A New Deal for Native Art: Indian Arts and Federal Policy, 1933–1943* (Tucson: University of Arizona Press, 2009), 142–58.

22. There is much information on Kabotie in Fred Kabotie, *Hopi Indian Artist: An Autobiography Told with Bill Belknap* (Flagstaff: Museum of Northern Arizona/Northland, 1977)—quotations taken from 70–72—and in Dorothy Dunn, *American Indian Painting of the Southwest and Plains* (Albuquerque: University of New Mexico Press, 1968), particularly 208–9.

23. For Dooley D. Shorty, see William H. Honan, "Dooley D. Shorty, 88, Navajo Code Talker in War," *New York Times*, June 12, 2000, www .nytimes.com/2000/06/12/us/dooley-d-shorty -88-navajo-code-talker-in-war.html. For Elsie

Bonser, who claimed *she* showed Roosevelt round the exhibition, see her *Rapid City Journal* obituary, July 5, 2005, https://rapidcityjournal .com/news/local/obituaries/obituaries-for-july /article_57b84dbc-d84e-5f06-9a9b-072f12804a1 .html (site discontinued). For Nellie Star Boy, see the account of an oral history of her in Susan Labry Meyn, *More Than Curiosities: A Grassroots History of the Indian Arts and Crafts Board and Its Precursors, 1920–1942* (Lanham MD: Lexington Books, 2001), 213–15. Eleanor Roosevelt, *My Day*, quoted in Schrader, *Indian Arts*, 193.

24. Peter Modley, in an email of November 2, 2017, recalled how, during his childhood, Post and her family would visit Rosebud during summer vacations, and in 1969 Nellie Star Boy Menard gave him and his wife, Phyllis, one of her quilts as a wedding present. For a brief summary of Menard's later years, see "Nellie Star Boy Menard: Bio," *NEA National Heritage Fellowships*, National Endowment for the Arts, accessed November 6, 2017, www.arts .gov/honors/heritage/fellows/nellie-star-boy -menard.

25. Post maintained a friendship with Kallir, photographing him at his gallery as late as 1972; photograph reproduced, credited to Helen Post Modley, in Renée Price, ed., *Egon Schiele: The Ronald S. Lauder and Serge Sabarsky Collections* (Munich: Prestel, 2005), 63. *New York Times* clipping for February 2, 1941, folder 1, box 1, HPP. Typescripts of Clark's *Brave against the Enemy*, with other data, are to be found in folders 9 and 10, box 1, HPP. Ann (Nolan) Clark was also an Indian Service employee, initially a teacher; as

part of her job she produced numerous "Indian Life Readers," many bilingual, for the Sioux, Pueblo, and Navajo series. She went on to write successful children's books for a general readership and in 1953 was awarded a Newbery Medal; see Evelyn Wenzel, "Newbery Medal Winner," *Elementary English* 30, no. 6 (1953): 327–32. Information on Emil Afraid of Hawk is from Jeffrey Ostler, *The Lakotas and the Black Hills* (New York: Viking Penguin, 2010), 141.

26. Information on Marion Post Wolcott's assignments is from Hurley, *Marion Post Wolcott*, 109–14; and Hendrickson, *Looking for the Light*, 193–99. For her work in Montana, see Mary Murphy, *Hope in Hard Times: New Deal Photographs of Montana, 1936–1942* (Helena MT: Montana Historical Society Press, 2003), 140–59. Folder 11, box 1, HPP, contains typescripts of stories by Eugene Wounded Horse, and the HPPC has at least one Post photograph (P1985.50.83) of his school bus.

27. Allan G. Harper, John Collier, and Joseph C. McCaskill, *Los indios de los Estados Unidos* (Washington DC: National Indian Institute, 1942); Joseph C. McCaskill and D'Arcy McNickle, *La política de los Estados Unidos sobre gobiernos tribales y las empresas comunales de los indios* (Washington DC: National Indian Institute, 1942). Both of these rare items, unlike the remainder of the series, are available electronically from the Hathi Trust Digital Library: *Los indios de los Estados Unidos*, accessed May 23, 2018, https://babel.hathitrust.org/cgi/pt?id=uiug.30112113388562;view=1up;seq=1; and *La política de los Estados Unidos*, accessed May 23,

2018, https://babel.hathitrust.org/cgi/pt?id=uiug.30112004698038;view=1up;seq=1.

28. Flora Dee Goforth, *Weave It Yourself*, ed. Willard Beatty, with photographs by Helen Post (Lawrence KS: Haskell Institute, 1947). This work is mentioned in the Association on American Indian Affairs (AAIA) records at the Seeley G. Mudd Manuscript Library, Princeton University, NJ. There is a PDF of this now rare item: accessed May 4, 2018, www2.cs.arizona.edu/patterns/weaving/books/gfd_weav.pdf. HPPC holds several Post portraits of Goforth, one of which (P1985.50.541) misidentifies her as Post herself. Alexander H. Leighton and Dorothea C. Leighton, *The Navaho Door: An Introduction to Navaho Life* (Cambridge MA: Harvard University Press, 1944).

29. Leighton and Leighton, *Navaho Door*: the quotation is from John Collier's foreword, xv. Post's X-ray picture was first printed in *Indians at Work* in the issue of January 1940.

30. See Helen Post, "Children in Action," in Morgan, *1001 Ways*, 366–72.

31. Modley, "Short Interpretive Biography, HPBF, 5. For Gőssenberg pictures, see folder 1, box 5, HPP; for the local exhibition, see *Waterbury Republican* clipping of May 29, 1975, 41; and for Dover, see Howard Cirker, President, to Helen Post, April 22, 1975, folders 15 and 4, respectively, box 1, HPP. For the information on Post's final illness, see Carlyle Schmollinger, "Envisioning the American Indian: The Extraordinary Gift of Photographer Helen Post," typescript, 2012, HPBF; Schmollinger relied on a phone interview with Peter Modley on February 24, 2012.

32. Rosenblum, *History*, 115; Lucy R. Lippard, ed., *Partial Recall: With Essays on Photographs of Native North Americans* (New York: New Press, 1992), 183; Barbara A. Babcock and Nancy J. Parezo, *Daughters of the Desert: Women Anthropologists and the Native American Southwest, 1880–1980* (Albuquerque: University of New Mexico Press, 1988); Post's photograph of Navajo people being shown an X-ray, credited to "Helen N. Post," appeared on page 120.

33. William E. Farr, *The Reservation Blackfeet, 1882–1945: A Photographic History of Cultural Survival* (Seattle: University of Washington Press, 1984), 137; Faris, *Navajo and Photography*, 218, 46.

34. Wallace Stegner, *One Nation* (Boston: Houghton-Mifflin, 1945), includes Post images of Indian health facilities and of Flathead construction workers at Kerr Dam, Polson, Montana. After their association ended, La Farge continued to use Post's pictures in various of his publications; see, for example, "The Enduring Indian," *Scientific American* 202, no. 2 (1960): 37–45. There is some current academic interest in Post: in 2016 Carlyle Delia Schmollinger successfully submitted a master's thesis, "Vestiges of Vulnerability: Helen Post's Photographs of Twentieth-Century Navajo," to Brigham Young University: accessed January 23, 2017, http://scholarsarchive.byu.edu/cgi/viewcontent.cgi?article=7076&context=etd.

## 2. Creating a Read-and-See Book

1. The epigraph is from *ALATGSG*, 81. Rosskam and his wife, Louise, also a photographer, gave an account of his career in an interview with Richard Doud; see "Oral History Interview with Edwin and Louise Rosskam, 1965 August 3," *Archives of American Art*, Smithsonian, accessed June 18, 2015, www.aaa.si.edu /collections/interviews/oral-history-interview -edwin-and-louise-rosskam-13112. He is briefly evoked in Michael Lesy's *Long Time Coming: A Photographic Portrait of America, 1935–1943* (New York: Norton, 2002), 319–22. For Rosskam's African American work, as both photographer and caption writer, see Nicholas Natanson, *The Black Image in the New Deal: The Politics of FSA Photography* (Knoxville: University of Tennessee Press, 1992), 144–77. On *In the Image of America*, see John Raeburn, *A Staggering Revolution: A Cultural History of Thirties Photography* (Urbana: University of Illinois Press, 2006), 189–93; and Natanson, *Black Image*, 222–26; panels from the exhibition are in the FSA files, USF34-014701 to USF34-014719, at the Prints and Photographs Division of the Library of Congress, Washington DC, and two are reproduced in Raeburn, *Staggering Revolution*, in the picture selection between pages 302 and 303.

2. The Rothstein Mescalero images may be found in the files, and on the internet, as lot 619 of the FSA holdings in the Library of Congress: accessed May 4, 2018, www.loc.gov/pictures /search/?q=%22Lot%20619%22; Lee's berry-picking ones are in lot 1136: accessed May 4, 2018, www.loc.gov/pictures/search/?q=%22Lot %201136%22; John Collier Jr., quoted in Nancy Wood, *Heartland: New Mexico; Photographs from the Farm Security Administration, 1935–1943* (Albuquerque: University of New Mexico

Press, 1989), 7; see also similar comments based on 1940s correspondence between Stryker and Collier, in Fleischauer and Brannan, *Documenting America*, 294–95.

3. For succinct commentary on *Migrant Mother*, see David Campany, "The Migrant Mother," in the exhibition catalog *Dorothea Lange: Politics of Seeing*, ed. Alona Pardo with Jilke Golbach (Munich: Prestel, 2018), 21–25; for detail on the picture's iconicity, see Robert Harriman and John Louis Lucaites, *No Caption Needed: Iconic Photographs, Public Culture, and Liberal Democracy* (Chicago: University of Chicago Press, 2007), 53–67. Edwin Locke, "Indian Land and Resettlement," *Indians at Work*, May 1, 1936, 30–32; Arthur Rothstein's pictures in *Indians at Work*, August 15, 1936, frontispiece, 18. After 1940 Stryker sometimes loaned out Rothstein to the BIA, and later still, after Rothstein joined *Look* magazine, he contributed independently to *Indians at Work*.

4. Edwin Rosskam, *San Francisco: West Coast Metropolis* (New York: Alliance, 1939); Rosskam, *Washington: Nerve Center*, with Ruby A. Black (New York: Alliance, 1939), quotation on 7.

5. Rosskam, *San Francisco*, ix.

6. These books are Sherwood Anderson, *Home Town* (New York: Alliance, 1940); and, when a better agreement than the one with Alliance came along, Richard Wright, *12 Million Black Voices: A Folk History of the Negro in the United States* (New York: Viking, 1941).

7. In *ALATGSG*'s list of illustrations, Ma Pe Wi is wrongly stated to be from the San Ildefonso Pueblo.

8. This motif image has a similar function—and visually resembles—Edward Weston's opening photograph in his Limited Editions Club publication of Whitman's *Leaves of Grass*, which was published a little later: Walt Whitman, *Leaves of Grass* (New York: Limited Editions Club, 1942).

9. The photograph of "buckskin-and-beadwork magnificence" is not by Post; *ALATGSG*'s "List of Photographs" cites it as "Blackfeet performing pipe ceremony" and credits it to the U.S. Indian Service.

10. This photograph (of Phillip Wells, a noted traditionalist among the Blackfeet) as reproduced in *ALATGSG* (133) is a reverse of its original in the HPPC, PI985.47.548, presumably because in its original format the photograph would not have pointed the right way.

11. Rosskam, *Washington*, 7. For commentary, see William Stott, *Documentary Expression and Thirties America* (1973; repr., Chicago: University of Chicago Press, 1986), 231–33; Raeburn, *Staggering Revolution*, 149, 192; Natanson, *Black Image*, 247–54; and Colleen McDannell, *Picturing Faith: Photography and the Great Depression* (New Haven: Yale University Press, 2004), 202–4.

12. "Mr Rosskam's Paste Up of Contact Prints for Layout," folder 2, box 2, HRC.

13. Oliver La Farge to Christopher La Farge, quoted in D'Arcy McNickle, *Indian Man: A Biography of Oliver La Farge* (Bloomington: Indiana University Press, 1971), 119. When discussing a possible reprint of *ALATGSG* with Alliance, La Farge urged the use of a Plains figure on the cover, instead of Post's thoughtful Navajos in "modern" dress; according to La

Farge, in his letter to Koppell, January 13, 1941, folder 8, box 20, HRC, these Navajo faces looked too "sad."

14. Oliver La Farge, *Laughing Boy* (1929; repr., Boston: Houghton Mifflin, 2004); Leslie A. Fiedler, *The Return of the Vanishing American* (1968; repr., London: Paladin, 1972), 170. For a similar but more recent verdict, this time by a Native American commentator, see Jace Weaver, *That the People Might Live: Native American Literatures and Native American Community* (New York: Oxford University Press, 1997), 98. Leighton and Leighton, on the other hand, included *Laughing Boy* in the bibliography to *Navaho Door* as if it *were* an authoritative text. Oliver La Farge, *Raw Material: The Autobiographical Examination of an Artist's Journey into Maturity* (1945; repr., London: Gollancz, 1946), 140. The London edition lacks the U.S. edition's subtitle. In *Raw Material*, written mostly just after ALATGSG but not published until La Farge's war service had ended, he also says "I *still* don't 'know Indians,' [even if] I know a good deal *about* them" (150; my emphases).

15. For the exhibition, see Oliver La Farge and John Sloan, *Introduction to American Indian Art Selected Entirely with Consideration of Esthetic Value* (1931; repr., Glorieta NM: Rio Grande, 1971), exhibition catalog. I leave aside the issue of the rights and wrongs of viewing indigenous artifacts in this way; for an in-depth historical account, see Rushing, *Native American Art*; and for discussion of the ethical problem, see James Clifford, "Histories of the Tribal and the Modern," in his *The Predicament of Culture* (Cam-

bridge MA: Harvard University Press, 1988), 189–214.

16. Two biographies of La Farge concentrate on his role in indigenous matters: *Indian Man*, by Kootenai Salish writer and fellow activist in Indian affairs D'Arcy McNickle, stresses La Farge's professional abilities as an anthropologist, in Indian linguistics and with historical manuscripts; Robert A. Hecht's *Oliver La Farge and the American Indian: A Biography* (Metuchen NJ: Scarecrow, 1991) emphasizes his role as a campaigner. The relevant correspondence is indexed under "Alliance Book Corporation" in HRC.

17. *The New Day for the Indians: A Survey of the Working of the Indian Reorganization Act of 1934* (New York: Academy, 1938). The most anticipatory sections are "Rebirth at Mescalero," "Power at Flathead," and "Cooperation at Jicarilla."

18. For Cushing—who had himself painted by Thomas Eakins in Zuni dress—see his magazine article "My Adventures in Zuni" (1882–83), reprinted in Jesse Green, ed., *Zuni: Selected Writings of Frank Hamilton Cushing* (Lincoln: University of Nebraska Press, 1979), 46–134. For commentary, see David Murray, *Forked Tongues: Speech, Writing and Representation in North American Indian Texts* (London: Pinter, 1991), 133–43. For Curtis's claims to authority based on his role in ceremonies, see Gidley, *Edward S. Curtis*, 227.

### 3. Peopling Post's Pictures

1. The epigraph is from Order No. 1418, quoted by Snow in "Photographing the Indians," in Mor-

gan, *1001 Ways*, 83. The John Collier quotations are from his editorial for *Indians at Work* 8, no. 11 (1941); the same words appear in Collier to unidentified recipient, n.d., folder 2, box 1, HPP. Correspondence about the planned "unusually complete manuscript and documentation of *ALATGSG*" that was to be offered for sale was found in Oliver La Farge to Günther Koppell, February 21, 1940; and Robert Spiers of Alliance to La Farge, May 2, 1940, both in folder 8, box 20, HRC. For clippings and notes, see folders 12–14, box 1, and folders 1 and 3, box 2, HPP. The phrase "patriot chiefs" is taken from Alvin M. Josephy, who first used it in a book title in 1961.

2. The well-informed librarian at the Big Horn County Library, Hardin, Montana, for example, was aware that "Miss Post spent considerable time on the Crow Indian Reservation." Hazel Christiansen to Ruth V. Robinson of the AAIA, October 16, 1940, folder 4, box 27, HRC. Peter Modley recounted the vacation visits in an email to the author, November 2, 2017.

3. Post, "Children in Action," in Morgan, *1001 Ways*, 372.

4. On the verso of prints portraying her in HPPC, such as PI985.50.396, Marie is identified as Fannie Makes Shines, who had a ranch very close to Wounded Knee on the Pine Ridge Reservation.

5. Post described work on the profile in "Children in Action," in Morgan, *1001 Ways*, 372. Data on Eddie Little Sky may be found in works on Indians in Hollywood, such as Michael Hilger, *From Savage to Nobleman: Images of Native Americans in Film* (Metuchen NJ: Scarecrow, 1995), 117, 181; and *Proposed Wounded Knee Park and Memorial: Hear-*

*ing before the Select Committee on Indian Affairs, United States Senate, One Hundred Second Congress, First Session . . . April 30, 1991, Pine Ridge Indian Reservation, SD* (Washington DC: Government Printing Office, 1991), 47–50. Later still Little Sky became an American Indian Movement activist. The fullest illustrated treatment of the Wounded Knee massacre is Richard E. Jensen, R. Eli Paul, and John E. Carter, *Eyewitness at Wounded Knee* (Lincoln: University of Nebraska Press, 1991); for concentration on its photographs, see Mick Gidley, "Visible and Invisible Scars of Wounded Knee," in *Picturing Atrocity: Photography in Crisis*, ed. Geoffrey Batchen et al. (London: Reaktion, 2012), 24–38, 294–95.

6. Post identified Black Buffalo as Paul Standing Soldier and his "son," Joe Hollow Horn, as Andrew Knife on the versos of relevant prints. Peter Modley contrasted his mother's methods with those of the more effusive Fleischmann in his email, November 2, 2017. Post's claim that she routinely sought permission was found in Kitchell's *Brief Case* interview transcript, HPP.

7. Leighton and Leighton, *Navaho Door*, 95–133. For Yellow Kidney as a subject for Curtis, see A. C. Haddon's firsthand account in Mick Gidley, *Edward S. Curtis and the North American Indian Project in the Field* (Lincoln NE: University of Nebraska Press, 2003), 70–81, especially 77–80; and the commentary in Shamoon Zamir, *The Gift of the Face: Portraiture and Time in Edward S. Curtis's "The North American Indian"* (Chapel Hill: University of North Carolina Press, 2014), chaps. 4 and 5. In folder 1, box 1, HPP, a manuscript note mistakenly names the young man as

Robert Howe, the manager of the ranch owned by Crow leader Robert Yellowtail. Robert Howe later became, in his own right, a prominent figure in the Crow community; there are several other images of Howe, including P1985.47.666 and P1985.50.31, in HPPC. Post correctly identified this subject as Joseph Medicine Crow on several prints, including P1985.47.45, in HPPC.

8. Information on Joe Medicine Crow is taken from Joseph Medicine Crow, *Counting Coup: Becoming a Crow Chief on the Reservation and Beyond*, with Herman Viola (Washington DC: National Geographic, 2006); Mike McPhate, "Joseph Medicine Crow, Tribal War Chief and Historian, Dies at 102," *New York Times*, April 4, 2016, www.nytimes.com/2016/04/05/us/joseph-medicine-crow-tribal-war-chief-and-historian-dies-at-102.html; the finding aid for his papers at the Little Big Horn College Library, Crow Agency, Montana, accessed May 30, 2017, http://lib.lbhc.edu/index.php?q=node/53; and scattered notes in Frederick E. Hoxie, *Parading through History: The Making of the Crow Nation in America, 1805–1935* (Cambridge: Cambridge University Press, 1995).

9. Post's claim that she dressed to please her Indian hosts was made in Kitchell's *Brief Case* radio interview transcript, HPP. The letter from Peter Pichette, dated August 9, 1939, with response from La Farge of November 3, 1939, are in folder 6, box 253, of the AAIA Papers, Mudd Library, Princeton University, Princeton NJ. I am grateful to Princeton archivist Christa Cleeton for sending me copies.

10. A draft of the message to Collier appears on the verso of an unnumbered picture of Post's Galerie St. Etienne show, folder 26, box 6, HPP. Modley, "Short Interpretive Biography," HPBF, 3.

11. The pipe ceremony images appear in the unnumbered sequence of HPMDP.

12. In HPPC this image is P1985.50.88; folder 24, box 6, HPP, contains a sequence of contact prints of the Pine Ridge Fair display. A full description of the Hunkalawanpi ceremony may be found in Edward S. Curtis, *The North American Indian*, vol. 3 (Cambridge MA: Cambridge University Press, 1908), 71–87.

13. The fire-rite image reproduced in *ALATGSG* (and in Leighton and Leighton, *Navaho Door*, where it is printed in reverse), when seen in the light of the whole sequence of fire-rite pictures scattered through the file of HPMDP, including one showing the lighting set up, is instructive. Post also made portraits of Chee Dodge, in one of which (P1985.47.242, HPPC), he walks. James C. Faris's important work, *The Nightway: A History and a History of Documentation* (Albuquerque: University of New Mexico Press, 1990), does not mention either Post's photographs or Pete Price, who also served on the Navajo Tribal Council, but does often refer to Chee Dodge, as both interpreter and Navajo leader.

14. For the Horse Dance, Black Elk, and the Rabbit Dance, see *The Sixth Grandfather: Black Elk's Teachings Given to John G. Neihardt*, ed. Raymond J. DeMallie (Lincoln: University of Nebraska Press, 1984), 214–26, 38–39. For Snow's advice, see his "Photographing the Indians" in Morgan, *1001 Ways*, 85.

15. For a succinct account of the relevant history, see the exhibition catalog: Rupert Martin, ed.,

*Floods of Light: Flash Photography, 1851–1981* (London: Photographers' Gallery, 1982). A fuller and nuanced treatment is Kate Flint, *Flash! Photography, Writing, and Surprising Illumination* (Oxford: Oxford University Press, 2017). Jacob A. Riis, quoted in Alexander Alland, *Jacob A. Riis: Photographer and Citizen* (London: Fraser, 1975), 11. A photographically excellent reprint edition of *How the Other Half Lives* is that edited by David Leviatin (1890; repr., Boston: Bedford Books of St. Martin's Press, 1996). See also Robert Bremner, *From the Depths: The Discovery of Poverty in the United States* (New York: New York University Press, 1956), especially 68–70.

16. The Dorothea Lange comment on Lee is quoted in Hank O'Neal, *A Vision Shared: A Classic Portrait of America and Its People* (New York: St Martin's Press, 1976), 183. For Agee's and Evans's reactions to Bourke-White and for Stott's own discussion, see Stott, *Documentary Expression*, 215–23, 270 (Stott quotation: 270). Faris's critique of Gilpin, "The Endearing Navajo," forms a chapter of his *Navajo and Photography*, 235–53 (one of Gilpin's admittedly rare flash images is reproduced on 239). He also describes the Navajo legal case against the Gilpin estate over her alleged "invasion of privacy" and "unlawful disclosure and misappropriation of likeness" (235).

17. The HPPC holds several similar pictures of [John] White Man Runs Him; the one reproduced here (P1985.50.747) is also in the Still Picture Division, U.S. National Archives and Records Administration, as 75-N-CR-TI.

18. Flint, *Flash!*

19. See the brief coverage of Johnson Holy Rock, including the transcript of an oral interview with him, in Akim Reinhardt, ed., *Welcome to the Oglala Nation: A Documentary Reader in Oglala Lakota Political History* (Lincoln: University of Nebraska Press, 2015), 172, 141–44. For more on Holy Rock's later life, see his 2012 obituaries: "Johnson Holy Rock Passes on at Age of 93," *Native Sun News*, January 27, 2012, www.indianz.com/News/2012/004385.asp; and "Lakota Language Loses Fluent Speaker," *Indian Country Today*, January 31, 2012, https://newsmaven.io/indiancountrytoday/archive/lakota-language-loses-fluent-speaker-CvIgKkF6JEeUSbPaEGAIuA/. Roundabout the time Post took Holy Rock's portrait, she also photographed Dick Wilson as a child with his toys: P1985.51.66, HPPC.

20. John Adair, *The Navajo and Pueblo Silversmiths* (Norman: University of Oklahoma Press, 1944), 99.

21. Commentary on Curtis, Dixon, and the visual vanishment trope may be found in Gidley, *Edward S. Curtis*, especially 12 and 288n16; and Mick Gidley, "The Repeated Return of the Vanishing Indian," in *American Studies: Essays in Honour of Marcus Cunliffe*, ed. Brian Holden Reid and John White (London: Macmillan, 1991), 189–209. The quotation from Curtis is taken from the caption to his photograph *The Vanishing Race*. The other Post pictures of the Flathead couple include P1985.47.717, P1985.47.718, P1985.47.732, P1985.47.733, P1985.50.1362, and P1985.50.1364, HPPC.

22. There is much information on Yellow Kidney, including sizeable extracts from Schaeffer's work, in Adolf Hungry Wolf, ed., *The Blackfoot Papers*, 4 vols. (Skookumchuck, BC: Good Medicine Cultural Foundation, 2006), especially vol. 4, 1472–79. For the information on Buster, I am very grateful to Theda New Breast of the Two Medicine community, conveyed in an email, January 19, 2017. Buster's Field Museum success is recorded in Clark Wissler, Alice Beck Kehoe, and Stewart E. Miller, *Amskapi Pikuni: The Blackfeet People* (Albany: State University of New York Press, 2012), 173.

23. Rosalyn R. LaPier, *Invisible Reality: Storytellers, Storytakers and the Supernatural World of the Blackfeet* (Lincoln: University of Nebraska Press, 2017), 77–78. Joppy Holds the Gun—or Japy Takes the Gun on Top—gave much information to Clark Wissler, the twentieth century's preeminent authority on Plains cultures, through David Duvall, his "son-in-law" (actually his stepson). Duvall's father, Charlie Duvall, was French Canadian and his Blackfeet mother, Yellow Bird, married Joppy after Charlie's death.

### 4. Photographing a New Deal for the Indians

1. The epigraph is taken from Post, "Children in Action," in Morgan, *1001 Ways*, 366. Folder 1, box 1, HPP, includes several letters of introduction from Collier and other BIA officials.

2. La Farge, *Raw Material*, 145; John Collier to Oliver La Farge, telegram, October 26, 1936, folder 2, box 21, HRC; Collier, *From Every Zenith* (Denver: Swallow Sage Books, 1963), 218.

3. In HPPC, the desk image (P1985.50.1484) is mistakenly credited to Post herself. La Farge, *Raw Material*, 142. The preparatory typescript of *ALATGSG*, where the desk photograph was to be inserted, has a typed editorial note in red: "Symbol of government: Commr's desk?"; see folder 10, box 1, HRC.

4. *ALATGSG* itself contains a summary of the IRA and associated activity on pages 68–81, and the IRA implicitly features in the discussion thereafter. Richard Lowitt, in "Whither the American Indian?," a chapter of his *The New Deal and the West* (Bloomington: Indiana University Press, 1984), provides a neutral survey, 122–37. Fuller studies include Kenneth R. Philp, *John Collier's Crusade for Indian Reform, 1920–1954* (Tucson: University of Arizona Press, 1977); Graham D. Taylor, *The New Deal and American Indian Tribalism: The Administration of the Indian Reorganization Act, 1934–1945* (Lincoln: University of Nebraska Press, 1980); and, in brief (with comments on La Farge), Wilcomb Washburn, "A Fifty-Year Perspective on the IRA," *American Anthropologist*, n.s., 86, no. 2 (1984): 279–89. A publication of the time, a set of symposium papers edited by La Farge (with a foreword by Collier) as *The Changing Indian* (Norman: University of Oklahoma Press for the American Association on Indian Affairs, 1942) amounts to an interim assessment of the IRA. La Farge's campaign role in connection with the IRA is treated in Hecht, *Oliver La Farge*, chap. 4. A typical neocolonialist reading of the IRA may be found in Akim D. Reinhardt, *Ruling Pine Ridge: Oglala Lakota Politics from the IRA to Wounded Knee* (Lubbock: Texas Tech University Press, 2007). Reinhardt

quotes Collier's own words, taken from Collier's memoir, *From Every Zenith*, to indict him.

5. The historiography of the IRA is one of contestation; for Native perspectives, see Frederick E. Hoxie, *This Indian Country: American Indian Activists and the Place They Made* (New York: Penguin, 2012), 296–320; and, for more general consideration, the "Indian New Deal" chapter in the various editions of *Major Problems in American Indian History*, ed. Albert L. Hurtado et al. (Lexington MA: Heath, 1994), 442–82 (see also the 2001 and 2015 editions).

6. Farr, *Reservation Blackfeet*, 89, includes a Sun Dance photograph of Stabs Down. Adolf Hungry Wolf, who was born in Germany, married into a Blackfeet family and—through his Good Medicine Cultural Foundation, Skookumchuck, British Columbia, publisher of *The Blackfoot Papers*—celebrates and reinforces traditional Blackfeet culture. Reed's photographs appear in Ernest R. Lawrence, *Alone with the Past: The Life and Photographic Art of Roland W. Reed* (Afton MN: Afton Historical Society Press, 2012). Post's annotation is in "Helen Post's 'List of Photographs' for *As Long as the Grass Shall Grow*," folder 8, box 25, HRC.

7. The photograph of the Crow voting by raising hands is P1985.50.803, and the one of the Pine Ridge Lakota in the voting booth is P1985.50.661. Representative Flathead Tribal Council pictures are P1985.50.1377, P1985.47.151, and P1985.47.744, all in HPPC. According to annotation on the verso of a print of the image of the men in overalls (P1985.50.418, HPPC) they were not in fact a tribal council; rather, the peo-

ple were there to meet someone trying to "locate descendants of Sitting Bull."

8. Leighton and Leighton, *Navaho Door*, 84–94, and, for the comment on Native health improvement, see 136.

9. The quotation is from Leighton and Leighton, *Navaho Door*, 67. It is understandable that this image, one of a series on the tuberculosis hospital and not used in *ALATGSG*, was an apt choice of illustration for Robert A. Trennert in his positive assessment of the IRA period in *White Man's Medicine: The Navajo and Government Doctors, 1863–1955* (Albuquerque: University of New Mexico Press, 1998), 150.

10. Another HPPC Reifel image is P1885.47.302. For John Alvin Anderson and Reifel, see Henry W. Hamilton and Jean Tyree, *The Sioux of the Rosebud: A History in Pictures* (Norman: University of Oklahoma Press, 1971); for brief comments on Reifel's role in the IRA and thereafter, see Reinhardt, *Ruling Pine Ridge*, especially 34, 38, 96; there is a 1967 interview with Reifel by Joseph H. Cash covering similar ground in *The Plains Indians of the Twentieth Century*, ed. Peter Iverson (Norman: University of Oklahoma Press, 1985), 108–20.

11. For Reifel in the 1950s, see Hecht, *Oliver La Farge*, 271–72; and for his House career, see the *Biographical Directory of the United States Congress*, accessed January 15, 2017 http://bioguide.congress .gov/scripts/biodisplay.pl?index=R000152. Reifel also contributed memories to Kenneth R. Philp, ed., *Indian Self-Rule: First-Hand Accounts of Indian-White Relations from Roosevelt to Reagan* (Logan: Utah State University Press, 1995).

12. For a fuller account of Yellowtail, see Hoxie, *This Indian Country*, 302–5, 314–16; and the biography by Hoxie and Tim Bernardis, in *The New Warriors: Native American Leaders since 1900*, ed. R. David Edmunds (Lincoln: University of Nebraska Press, 2001), 55–77.

13. A photograph of Sir Linsley—with woven blanket—was used as the frontispiece in Flora Goforth's *Weave It Yourself*.

14. Gordon Macgregor, *Warriors without Weapons* (Chicago: University of Chicago Press, 1946); Edward T. Hall, *West of the Thirties: Discoveries among the Navajo and Hopi* (New York: Doubleday, 1994), especially 4. For Fenton, see McLerran, *New Deal*, 86.

15. For discussion of the complexities of Indian education after the IRA, see chapters 4 and 5 of Margaret Connell Szasz, *Education and the American Indian: The Road to Self Determination from 1928*, 3rd. ed. (Albuquerque: University of New Mexico Press, 1999). Typical Ann (Nolan) Clark books are *In My Mother's House*, with illustrations by Ma Pe Wi (as Velino Herrera) (New York: Viking, 1941); and *Who Wants to Be a Prairie Dog?*, with illustrations by Andy Tsihnahjinnie (Washington DC: BIA Office of Education, 1940).

16. Leighton and Leighton, *Navaho Door*, 51.

17. Adair, *Navajo and Pueblo Silversmiths*, ix. His long account of Burnsides occupies pages 55–77.

18. The Burnsides postcard, n.d., is in box 6, folder 16, HPP.

19. Tsihnahjinnie's name has been spelled, by him as well as others, in half a dozen ways, and sometimes he has been "Rudy," "Andy," and "Van" Tsihnajinnie. The Dunn quotation is from *American Indian Painting*, 302, where she offers accounts of him. J. J. Brody stresses the typicality of Tsihnahjinnie's career as a mid-twentieth-century Native artist in his *Indian Painters and White Patrons* (Albuquerque: University of New Mexico Press, 1971), 140–46. He was the father of the important conceptual photographer Hulleah Tsinhnahjinnie.

20. Oliver La Farge, "The Indian Artist: The Indian as Artist," *New York Times*, January 26, 1941, SM8. Rushing, *Native American Art*, 114–18, gives a detailed account of the show's reception and La Farge's role in that reception.

21. McLerran, *New Deal*, 200–215, is a succinct account of the CCC-ID. In HPPC, prints of the image of the Flathead home newly built with government help, including P1985.50.1373 (fig. 65), are titled *Mrs. Adams and Grandson*.

22. Edwin Rosskam to Ruth Martin of AAIA, April 25, 1940, folder 4, box 27, HRC.

23. The contemporary ethnography of Pine Ridge by Macgregor, *Warriors without Weapons*, stresses how these divisions marked every aspect of the reservation's public life. Details in this and the following paragraphs are taken from the opening chapters of Reinhardt, *Ruling Pine Ridge*, especially 33, 87–93.

24. Quoted from Oglala Sioux Tribal Council Resolution No. 26, June 21, 1938, in Reinhardt, *Ruling Pine Ridge*, 93.

25. Post's "Health Set" letter: Paul Fickinger to G. Warren Spaulding, Superintendent, Haskell Institute, October 10, 1940, folder 4, box

1, HPP; Post's picture of Roberts dancing is P1985.50.449, HPPC.

26. Tawa Ducheneaux, Archivist, Woksape Tipi Library and Archives, Oglala Lakota College, Kyle SD, kindly identified Frank Wilson.

27. The Two Medicine Irrigation Project, along with other developments, is treated in Paul Rosier, *Rebirth of the Blackfeet Nation, 1912–1954* (Lincoln: University of Nebraska Press, 2001), especially 148–56. See also the chapter titled "Intratribal Diversity," in Malcolm McFee, *Modern Blackfeet: Montanans on a Reservation* (New York: Holt, Rinehart and Winston, 1972).

28. Typical Post Blackfeet slum pictures are P1985.47.611, P1985.47.608, and P1985.47.622, all in HPPC.

29. For reasons unknown, Insima was named "Ansimaki" in P1985.50.699, P1985.47.518, and other prints in the HPPC file. For further information on Insima, as relayed to Sommers, see Alice Beck Kehoe, "Transcribing Insima, a Blackfoot 'Old Lady,'" in *Reading beyond Words: Contexts for Native History*, ed. Jennifer S. H. Brown and Elizabeth Vibert, 2nd ed. (Peterborough, Ontario: Broadview, 2003), 385–406.

30. For detailed accounts, see Donald L. Parman, *The Navajos and the New Deal* (New Haven: Yale University Press, 1976); Peter Iverson, *Diné: A History of the Navajos* (Albuquerque: University of New Mexico Press, 2002), chap. 5; and, especially, Marsha Weisiger, *Dreaming of Sheep in Navajo Country* (Seattle: University of Washington Press, 2009).

31. "Learning through Pictures," notice, in *Indians at Work*, 8, no. 11 (1941): 2.

32. Clyde Kluckhohn and Dorothea Leighton, *The Navaho* (Cambridge MA: Harvard University Press, 1946), 17, 33–35, 40–41.

33. Information on Gorman is from Young, *Political History*, which gives a graphic account of stock reduction on pages 80–119. Gorman's words are quoted in Iverson, *Diné*, 153.

34. Sol Worth and John Adair, *Through Navajo Eyes: An Exploration in Film Communication and Anthropology* (Albuquerque: University of New Mexico Press, 1997), 4; Weisiger, *Dreaming of Sheep*, chap 3, gives a detailed account of the meaning of livestock to Navajos; she uses a particularly graphic quotation about dreaming of sheep as her book's epigraph.

35. The Navajo sheep images in the Still Picture Division, U.S. National Archives and Records Administration, are 75-N-NAV-P1 to 75-N-NAV-P10. One or two of them were reproduced in Leighton and Leighton, *Navaho Door*, opposite 46 and after the (non-Post) image opposite 110. Pictures of sheep form one of the largest groupings and are scattered through the HPPC.

Conclusion

1. Speckled Snake's speech, sometimes as recalled by the Cherokee chief John Ridge, appears in several anthologies and is discussed in William M. Clements, *Oratory in Native North America* (Tucson: University of Arizona Press, 2002), 91–92.

2. See Louis T. Jones, *Aboriginal American Oratory: The Tradition of Eloquence among Indians of the United States* (Los Angeles: Southwest

Museum, 1965). The particular quotation is from "Documents and Proceedings Relating to the Formation and Progress of a Board in the City of New York for the Emigration, Preservation and Improvement of the Aboriginals of America, July 29, 1829," *North American Review* 30, no. 66 (1830): 62–121, quotation on 85; my emphasis. McNickle's views of La Farge's paternalism are quoted in Dorothy R. Parker, *Singing an Indian Song: A Biography of D'Arcy McNickle* (Lincoln: University of Nebraska Press, 1992), 203–5, 213–15.

3. For Clements's discussion of tropes, see *Oratory*, especially chap. 3.

4. Stott, *Documentary Expression*; Stott mentioned, but didn't analyze, *As Long as the Grass Shall Grow* (235).

5. For quotations from Agee and Evans and for Stott's own discussion, see Stott, *Documentary Expression*, 215–23, quotation on 223; for *American Exodus*, see pages 225–31.

6. McNickle, *Indian Man*, 119.

7. William Henry Fox Talbot, *The Pencil of Nature* (1844), quoted in David Bate, "The Nature of Facts," *Source* 95 (Autumn 2018): 44–49, quotation on 48.

8. Most of the instances of pointed apparent incongruity between modern technology and "primitive" Indians are reproduced and discussed in Brian W. Dippie, "Photographic Allegories and Indian Destiny," *Montana: The Magazine of Western History* 42, no. 3 (1992): 40–57.

9. By nice coincidence, during my writing of this book it was announced that at the end of 2015 the Kerr Dam became the property of, and began to be run by, the peoples on whose lands it stands; see "Clock Ticking Down to Kerr Dam's Historic Takeover," *Montana Standard*, May 4, 2015, http://mtstandard.com/news/local /clock-ticking-down-to-kerr-dam-s-historic -takeover-by/article_4a5f90c6-160f-58d3-bf71- ead779994498.html (site discontinued). Post's stress on the monumentality of the dam may have been influenced by Margaret Bourke-White's famous depiction on the cover of the first issue of *Life* magazine (November 1936) of the Fort Peck Dam in Montana.

10. For Dippie's most important work, see *The Vanishing American: White Attitudes and US Indian Policy* (Middletown CT: Wesleyan University Press, 1982). Quotations here are taken from his "Photographic Allegories," 50.

11. Stryker's words are taken from McEuen, *Seeing America*, 104. Post's expression of belief in the "interpretation" of democratic ideals is from her "Children in Action," in Morgan, *1001 Ways*, 366.

12. Untitled and undated typescript in box 1, folder 2, HPP.

13. Alan Trachtenberg, *Shades of Hiawatha: Staging Indians, Making Americans, 1880–1930* (New York: Hill and Wang, 2004), 210. Modley's observation appears on a print of the image P1985.50.542, HPPC; the proprietorial note is on its back.

14. Edward T. Hall, *The Silent Language* (1959; repr., New York: Premier Books, 1961). This Aschi Mike portrait was also reproduced in Leighton and Leighton, *Navaho Door*, opposite 47.

# Photograph and Figure Credits

All photographs were made by Helen Post (1907–79) unless otherwise indicated. Titles and credits are given as requested by the sources of the pictures.

1. *Mrs. Bordeaux Measuring Helen Post for a Moccasin*, ca. 1937–42. Gelatin silver print, 8⅜ in. x 7½ in. Amon Carter Museum of American Art, Fort Worth, Texas. Gift of Peter Modley. © Amon Carter Museum of American Art.

2. Cover of *As Long as the Grass Shall Grow*, 1940. By Oliver La Farge; photographs by Helen Post. Author's collection.

3. *Anni Fleischmann Albers, Black Mountain College, North Carolina*, ca. late 1930s. Contact prints, each 6½ in. x 6½ in., in notebook, 8 in. x 6 in. Amon Carter Museum of American Art, Fort Worth, Texas. Gift of Peter Modley. © Amon Carter Museum of American Art.

4. *Direct Relief Client*, ca. late 1930s, West Virginia. Gelatin silver print, 7⅞ in. x 9¾ in. Amon Carter Museum of American Art, Fort Worth, Texas. Gift of Peter Modley. © Amon Carter Museum of American Art.

5. Trude Fleischmann (1895–1990). [Helen M. Post with camera], ca. 1940. Gelatin silver print, 2 5/16 in. x 2 3/16 in. Amon Carter Museum of American Art, Fort Worth, Texas. Gift of Peter Modley. © Estate of Trude Fleischmann.

6. *Wastelands—Near San Juan River*, ca. 1936–42. Gelatin silver print, 8 7/8 in. x 7 3/4 in. Amon Carter Museum of American Art, Fort Worth, Texas. Gift of Peter Modley. © Amon Carter Museum of American Art.

7. Milton Snow (1905–86). [Men digging on hillside], ca. 1936–41. Gelatin silver print, 4 9/16 in. x 6 7/16 in. Amon Carter Museum of American Art, Fort Worth, Texas. Gift of Peter Modley. © Estate of Milton Snow.

8. [Tonawanda man carving wooden mask], ca. 1936–42. Gelatin silver print, 9 7/16 in. x 7 15/16 in. Amon Carter Museum of American Art, Fort Worth, Texas. Gift of Peter Modley. © Amon Carter Museum of American Art.

9. Trude Fleischmann (1895–1990), *Helen Post and Oliver La Farge Preparing Photos for "As Long as the Grass Shall Grow,"* ca. 1940. Gelatin silver print, 8 7/16 in. x 7 9/16 in. Amon Carter Museum of American Art, Fort Worth, Texas. Gift of Peter Modley. © Estate of Trude Fleischmann.

10. *Crow Fair*, ca. 1936–40. Gelatin silver print, 10 3/8 in. x 13 5/16 in. Amon Carter Museum of American Art, Fort Worth, Texas. Gift of Peter Modley. © Amon Carter Museum of American Art.

11. *Pictograph That Gave Name to Standing Cow Ruin*, 1938. Gelatin silver print, 9 7/16 in. x 7 1/16 in. Amon Carter Museum of American Art, Fort Worth, Texas. Gift of Peter Modley. © Amon Carter Museum of American Art.

12. *White House Ruins, Canyon de Chelly*, ca. 1937–42. Gelatin silver print, 10 3/8 in. x 11 5/16 in. Amon Carter Museum of American Art, Fort Worth, Texas. Gift of Peter Modley. © Amon Carter Museum of American Art.

13. *Sam Day, Jr.* 1938. Gelatin silver print, 8 5/16 in. x 7 9/16 in. Amon Carter Museum of American Art, Fort Worth, Texas. Gift of Peter Modley. © Amon Carter Museum of American Art.

14. *Ocotillo and Shadow*, ca. 1937–42. Gelatin silver print, 9 11/16 in. x 7 7/8 in. Amon Carter Museum of American Art, Fort Worth, Texas. Gift of Peter Modley. © Amon Carter Museum of American Art.

15. [Navajo rug in Indian art exhibition], 1941. Gelatin silver print, 9 1/2 in. x 7 5/8 in. Amon Carter Museum of American Art, Fort Worth, Texas. Gift of Peter Modley. © Amon Carter Museum of American Art.

16. *Karok Effigy of Albino Deerskin Trimmed with Red Woodpecker Feathers*, 1941, Indian Art Exhibition. Gelatin silver print, 9 5/16 in. x 7 9/16 in. Amon Carter Museum of American Art, Fort Worth, Texas. Gift of Peter Modley. © Amon Carter Museum of American Art.

17. Albert Fenn (1913–95). [Native American artists with Eleanor Roosevelt at Museum of Modern Art opening], 1941.

Gelatin silver print, 9½ in. x 7¾ in. Amon Carter Museum of American Art, Fort Worth, Texas. Gift of Peter Modley. © Estate of Albert Fenn.

18. *Nellie Star Boy (Buffalo Chief)*, ca. 1937–42. Gelatin silver print, 9½ in. x 7 ⁷⁄₁₆ in. Amon Carter Museum of American Art, Fort Worth, Texas. Gift of Peter Modley. © Amon Carter Museum of American Art.

19. [Four contact prints of Post's photographs on show with Indian textiles at Galerie St. Etienne, New York], 1941. Gelatin silver print, 8 in. x 9 ¹⁵⁄₁₆ in. Amon Carter Museum of American Art, Fort Worth, Texas. Gift of Peter Modley. © Amon Carter Museum of American Art.

20. Cover of *Brave against the Enemy*, 1944. By Ann [Nolan] Clark; photographs by Helen Post. Author's collection.

21. [San Carlos woman voting.] Page from *La política de los Estados Unidos sobre gobiernos tribales y las empresas comunales de los indios*, 1942. By Joseph McCaskill and D'Arcy McNickle. Courtesy of University of Illinois Library, Urbana-Champaign.

22. *Nurse from USIS Tuberculosis Hospital Uses X-ray to Persuade Navajo Family of the Need for Hospitalization*, ca. 1937–42. Gelatin silver print, 7 ⁷⁄₁₆ in. x 8 ⁷⁄₁₆ in. Amon Carter Museum of American Art, Fort Worth, Texas. Gift of Peter Modley. © Amon Carter Museum of American Art.

23. [Ned Bia, guide and interpreter at Canyon de Chelly], ca. 1937–42. Gelatin silver print, 13 ⁹⁄₁₆ in. x 10 ¹¹⁄₁₆ in. Amon Carter Museum of American Art, Fort Worth, Texas. Gift of Peter Modley. © Amon Carter Museum of American Art.

24. Marion Post Wolcott (1910–90), *Negro Man Entering a Movie Theatre by the "Colored" Entrance, Belzoni, Mississippi*, 1939. Modern print from a nitrate 35 mm negative. Courtesy of Library of Congress.

25. *Life in Bluegrass Country*, ca. 1940. Acetate negative, 4 in. x 5 in. Amon Carter Museum of American Art, Fort Worth, Texas. Gift of Peter Modley. © Amon Carter Museum of American Art.

26. Two-page spread from *As Long as the Grass Shall Grow*. Author's collection.

27. Page of pictures of Blackfeet people from *As Long as the Grass Shall Grow*: two photographs by Helen Post, the other (of pipe ceremony) by unknown U.S. Indian Service employee. Author's collection.

28. [Infant on cradle board, Navajo reservation, Window Rock, Arizona], 1938. Gelatin silver print, 9 ¹¹⁄₁₆ in. x 7 ¹³⁄₁₆ in. Amon Carter Museum of American Art, Fort Worth, Texas. Gift of Peter Modley. © Amon Carter Museum of American Art.

29. *The End So Clearly to Be Seen, Browning Montana*, ca. 1939–40. Gelatin silver print, 10 ¹³⁄₁₆ in. x 13⅜ in. Amon Carter Museum of American Art, Fort Worth, Texas. Gift of Peter Modley. © Amon Carter Museum of American Art.

30. Illustration (of desert conditions) from *As Long as the Grass Shall Grow*. Author's collection.

31. *Fannie Makes Shines*, 1941. Gelatin silver print, 9⅝ in. x 7 ⁷⁄₁₆ in. Amon Carter Museum of American Art, Fort Worth, Texas. Gift of Peter Modley. © Amon Carter Museum of American Art.

32. [Eddie Little Sky and horse], ca. 1940s. Gelatin silver print, 7 ⁹⁄₁₆ in. x 9⅛ in. Amon Carter Museum of American Art, Fort Worth, Texas. Gift of Peter Modley. © Amon Carter Museum of American Art.

33. [Eddie Little Sky and sick man], ca. 1940s. Gelatin silver print, 8⅜ in. x 7½ in. Amon Carter Museum of American Art, Fort Worth, Texas. Gift of Peter Modley. © Amon Carter Museum of American Art.

34. Illustration ("Louie Hollow Horn" asleep in the barn) from *Brave against the Enemy*. Author's collection.

35. *Andrew Knife and Paul Standing Soldier*, ca. 1940s. Gelatin silver print, 9⅞ in. x 7⅞ in. Amon Carter Museum of American Art, Fort Worth, Texas. Gift of Peter Modley. © Amon Carter Museum of American Art.

36. *Buster and His Grandfather, Yellow Kidney*, as reproduced in a page from *As Long as the Grass Shall Grow*. Author's collection.

37. Page from *As Long as the Grass Shall Grow*, depicting Joseph Medicine Crow (*left*) dancing. Author's collection.

38. *Joseph Medicine Crow, Anthropology Student*, ca. 1937–40. Gelatin silver print, 8 in. x 7 ⁹⁄₁₆ in. Amon Carter Museum of American

Art, Fort Worth, Texas. Gift of Peter Modley. © Amon Carter Museum of American Art.

39. *Peter Pichette, Flathead Reservation (Salish Tribes)*, ca. 1937–40. Gelatin silver print, 13 in. x 10⅝ in. Amon Carter Museum of American Art, Fort Worth, Texas. Gift of Peter Modley. © Amon Carter Museum of American Art.

40. *Use of Photos with Language Handicapped, Bilingual Children, Bilingual Adults*, ca. 1937–42. Gelatin silver print, 7⅝ in. x 9 ³⁄₁₆ in. Amon Carter Museum of American Art, Fort Worth, Texas. Gift of Peter Modley. © Amon Carter Museum of American Art.

41. [Mrs. Foky washing hair with yucca root soap at Kayenta Day School], ca. 1937–40. Gelatin silver print, 9⅞ in. x 7⅞ in. Amon Carter Museum of American Art, Fort Worth, Texas. Gift of Peter Modley. © Amon Carter Museum of American Art.

42. *Oglala Sioux Medicine Man, Thomas Henry Sitting Eagle*, 1941. Gelatin silver print, 12 ¹¹⁄₁₆ in. x 10 ⁵⁄₁₆ in. Amon Carter Museum of American Art, Fort Worth, Texas. Gift of Peter Modley. © Amon Carter Museum of American Art.

43. *Fire Dance, Ye-Be-Chai, a Seven-Day Ceremonial*, 1938. Gelatin silver print, 12⅝ in. x 10¼ in. Amon Carter Museum of American Art, Fort Worth, Texas. Gift of Peter Modley. © Amon Carter Museum of American Art.

44. *John White Man Runs Him*, ca. 1941. Gelatin silver print, 9 ⁷⁄₁₆ in. x 7½ in. Amon Carter Museum of American Art, Fort

Worth, Texas. Gift of Peter Modley. © Amon Carter Museum of American Art.

45. Jicarilla store, an illustration from *As Long as the Grass Shall Grow*. Author's collection.

46. *Apache San Carlos Child at Home*, ca. 1937–42. Acetate negative, 4 in. x 5 in. Amon Carter Museum of American Art, Fort Worth, Texas. Gift of Peter Modley. © Amon Carter Museum of American Art.

47. [Apache San Carlos child at home], ca. 1937–42. Acetate negative, 4 in. x 5 in. Amon Carter Museum of American Art, Fort Worth, Texas. Gift of Peter Modley. © Amon Carter Museum of American Art.

48. *Johnson Holy Rock, High School Assistant, Pine Ridge*, 1941. Gelatin silver print, 8½ in. x 6⅞ in. Amon Carter Museum of American Art, Fort Worth, Texas. Gift of Peter Modley. © Amon Carter Museum of American Art.

49. *Navajo Fence Sitters*, ca. 1937–42. Gelatin silver print, 10 ⁵⁄₁₆ in. x 11 ⁵⁄₁₆ in. Amon Carter Museum of American Art, Fort Worth, Texas. Gift of Peter Modley. © Amon Carter Museum of American Art.

50. *Flathead Reservation Near Arlee, Montana*, ca. 1940. Acetate negative, 4 in. x 5 in. Amon Carter Museum of American Art, Fort Worth, Texas. Gift of Peter Modley. © Amon Carter Museum of American Art.

51. [Flathead couple on horseback], ca. 1940. Acetate negative, 4 in. x 5 in. Amon Carter Museum of American Art, Fort Worth, Texas. Gift of Peter Modley. © Amon Carter Museum of American Art.

52. *Moccasin Flats, Browning, Montana*, ca. 1939–40. Gelatin silver print, 9¾ in. x 7⅝ in. Amon Carter Museum of American Art, Fort Worth, Texas. Gift of Peter Modley. © Amon Carter Museum of American Art.

53. Young Navajo man, an illustration from *As Long as the Grass Shall Grow*. Author's collection.

54. *Joppy Holds the Gun*, ca. 1940. Gelatin silver print, 9 ⁷⁄₁₆ in. x 7 ⁹⁄₁₆ in. Amon Carter Museum of American Art, Fort Worth, Texas. Gift of Peter Modley. © Amon Carter Museum of American Art.

55. Edwin Rosskam (1903–85), attributed to Helen Post, *John Collier's Desk*, ca. 1936–40, Washington DC. Gelatin silver print, 7 ⁵⁄₁₆ in. x 7⅞ in. Amon Carter Museum of American Art, Fort Worth, Texas. Gift of Peter Modley. © Amon Carter Museum of American Art.

56. *Tribal Council Meeting at Browning*, ca. 1940. Gelatin silver print, 9⅜ in. x 7 ⁹⁄₁₆ in. Amon Carter Museum of American Art, Fort Worth, Texas. Gift of Peter Modley. © Amon Carter Museum of American Art.

57. *Sioux Trading Post Visit to Locate Descendants of Sitting Bull Family*, ca. 1937–42. Gelatin silver print, 7½ in. x 9¾ in. Amon Carter Museum of American Art, Fort Worth, Texas. Gift of Peter Modley. © Amon Carter Museum of American Art.

58. Flathead girl being weighed during medical checkup, an illustration from *As Long as the Grass Shall Grow*. Author's collection.

59. *Superintendent Ben Reifel*, 1941. Gelatin silver print, 9¼ in. x 7 ⁷⁄₁₆ in. Amon Carter

Museum of American Art, Fort Worth, Texas. Gift of Peter Modley. © Amon Carter Museum of American Art.

60. *Robert Yellowtail, Superintendent for Crow Tribe*, ca. 1940. Gelatin silver print, 7¾ in. x 7⅞ in. Amon Carter Museum of American Art, Fort Worth, Texas. Gift of Peter Modley. © Amon Carter Museum of American Art.

61. *Sioux Arts and Crafts—A Flourishing Home Industry*, ca. 1937–42. Gelatin silver print, 7 ⁹⁄₁₆ in. x 9⅜ in. Amon Carter Museum of American Art, Fort Worth, Texas. Gift of Peter Modley. © Amon Carter Museum of American Art.

62. *Tom Burnsides, Silversmith*, 1938. Gelatin silver print, 12⅛ in. x 10 ⁷⁄₁₆ in. Amon Carter Museum of American Art, Fort Worth, Texas. Gift of Peter Modley. © Amon Carter Museum of American Art.

63. [Andrew Tsihnahjinnie at Phoenix Indian School], 1938. Gelatin silver print, 7 ¹¹⁄₁₆ in. x 8 ⁷⁄₁₆ in. Amon Carter Museum of American Art, Fort Worth, Texas. Gift of Peter Modley. © Amon Carter Museum of American Art.

64. [Power-line worker, Polson Dam], ca 1942. Acetate negative, 4 in. x 5 in. Amon Carter Museum of American Art, Fort Worth, Texas. Gift of Peter Modley. © Amon Carter Museum of American Art.

65. *Mrs. Adams and Grandson*, ca. 1940. Gelatin silver print, 7 ¹⁄₁₆ in. x 9⅛ in. Amon Carter Museum of American Art, Fort

Worth, Texas. Gift of Peter Modley. © Amon Carter Museum of American Art.

66. *Red Shirt Table Cooperative Herd*, 1941. Gelatin silver print, 7 ⁹⁄₁₆ in. x 9 ⁹⁄₁₆ in. Amon Carter Museum of American Art, Fort Worth, Texas. Gift of Peter Modley. © Amon Carter Museum of American Art.

67. *Tribal Council*, 1941. Gelatin silver print, 7 ¹⁵⁄₁₆ in. x 9⅞ in. Amon Carter Museum of American Art, Fort Worth, Texas. Gift of Peter Modley. © Amon Carter Museum of American Art.

68. [House, Browning, Montana], ca. 1939–42. Acetate negative, 4 in. x 5 in. Amon Carter Museum of American Art, Fort Worth, Texas. Gift of Peter Modley. © Amon Carter Museum of American Art.

69. *Mr. and Mrs. Yellow Kidney, Browning, Montana*, ca. 1940. Gelatin silver print, 9 ⁹⁄₁₆ in. x 7¾ in. Amon Carter Museum of American Art, Fort Worth, Texas, gift of Peter Modley. © Amon Carter Museum of American Art.

70. Navajo sheep, an illustration from *As Long as the Grass Shall Grow*. Author's collection.

71. *Howard Gorman, Interpreter, Interviewing the Elders Whose Sheep, Goats and Horses Had Severely Limited the Carrying Capacity of Their Land*, ca. 1937–42. Gelatin silver print, 7 ¹⁵⁄₁₆ in. x 8¼ in. Amon Carter Museum of American Art, Fort Worth, Texas. Gift of Peter Modley. © Amon Carter Museum of American Art.

72. Marion Post Wolcott (1910–90), *Signs behind the Bar in Birney, Montana*, 1941. From mounted gelatin silver print. Courtesy of Library of Congress.

73. *Polson Dam, Montana*, ca. 1940. Gelatin silver print, 8 $\frac{1}{16}$ in. x 7 $\frac{11}{16}$ in. Amon Carter Museum of American Art, Fort Worth, Texas. Gift of Peter Modley. © Amon Carter Museum of American Art.

74. *Flathead Irrigation System Gets Water from River Which Flows Out of Flathead Lake at Polsen, Montana*, ca. 1940. Acetate negative, 4 in. x 5 in. Amon Carter Museum of American Art, Fort Worth, Texas. Gift of Peter Modley. © Amon Carter Museum of American Art.

75. *Letter from Government Agency*. Gelatin silver print, 7 $\frac{9}{16}$ in. x 9 $\frac{9}{16}$ in. Amon Carter Museum of American Art, Fort Worth, Texas. Gift of Peter Modley. © Amon Carter Museum of American Art.

76. *Jicarilla Apache Trading Post, Coop Store, Dulce, N.M.*, 1938. Gelatin silver print, 13 $\frac{5}{16}$ in. x 10 $\frac{7}{16}$ in. Amon Carter Museum of American Art, Fort Worth, Texas. Gift of Peter Modley. © Amon Carter Museum of American Art.

77. *Mattie Last Horse at Home*. Gelation silver print, 9 $\frac{9}{16}$ in. x 7½ in. Amon Carter Museum of American Art, Fort Worth, Texas. Gift of Peter Modley. © Amon Carter Museum of American Art.

78. *Mrs. Burnsides, Weaver and Silversmith*, 1938. Gelatin silver print, 12 $\frac{9}{16}$ in. x 10⅛ in. Amon Carter Museum of American Art, Fort Worth, Texas. Gift of Peter Modley. © Amon Carter Museum of American Art.

79. *Mrs. Aschi Mike Spinning*, 1938. Gelatin silver print, 7 $\frac{15}{16}$ in. x 9⅞ in. Amon Carter Museum of American Art, Fort Worth, Texas. Gift of Peter Modley. © Amon Carter Museum of American Art.

80. *Crow Tipis*, 1939. Gelatin silver print, 11 $\frac{7}{16}$ in. x 10 $\frac{3}{16}$ in. Amon Carter Museum of American Art, Fort Worth, Texas. Gift of Peter Modley. © Amon Carter Museum of American Art.

# Index

*Page numbers in italics indicate illustrations.*

Aberdeen SD, 89
Aberle, S. D., 5
Adair, John, 76, 93, 109; *The Navajo and Pueblo Silversmiths*, 93–94
Adams, Mrs. (Flathead), *100*
Afraid of Hawk, Emil (Oglala), 3, 27
African Americans, *9*, 35, *37*, 38, 45
Albers, Anni, 7, *8*
Alexie, Sherman (Spokane/Coeur d'Alene), 46
Alliance Book Corporation, 36, 47
Allotment Act of 1887, 48, 84
*American Exodus* (Lange and Taylor), 112–13
American Indians. *See* Native Americans
American Indian Movement, 75, 139n5
Anasazi ruins, 19, *19*
Anderson, Sherwood, *Home Town*, 37–38, 45
Anschluss, 6, 10
anthropologists: Ruth Benedict, 92; Frank Hamilton Cushing, 49, 138n18; David Duvall, 142n23; William N. Fenton, 92; Edward T. Hall, 92, 126; Clyde Kluckhohn, 107; Gordon Macgregor, 92; Margaret Mead, 10, 92; Jay B. Nash, 49, 98; Claude Schaeffer, 81; Sue Sommers,

anthropologists (*cont.*)
    104; Herbert J. Spinden, 46; Sol Worth, 109.
    *See also* Adair, John; Faris, James C.; La Farge,
    Oliver; Leighton, Dorothea
anthropology, 33, 46, 61, 92
Apaches (Southwest), 41, 47, 48, 57. *See also* Jicar-
    illas (Southwest); Mescalero Apaches (South-
    west); San Carlos Apaches (Southwest)
*As Long as the Grass Shall Grow* (La Farge and
    Post): as photobook, 1, 112, 113; illustrations
    from, *2, 40, 42, 51, 60, 61, 72, 81, 88, 108*;
    importance of, 3–4; La Farge's contribution to,
    45–50, 84; mentioned, 19, 34, 37, 64, 68, 80, 81,
    86, 89, 92, 93, 108, 123, 126; Post's contribution
    to, 13–18, 84; structure of, 38–45, 59, 98, 111, 113;
    text quoted from, 35, 39, 41, 48, 49, 50, 71, 77,
    104, 113, 114, 118. *See also* Indian Reorganiza-
    tion Act (IRA); La Farge, Oliver; Post, Helen;
    Rosskam, Edwin
Assiniboines (Plains), 115
Association on American Indian Affairs (AAIA),
    18, 47, 48
Austin, Mary, 46

Bauhaus, 7
Berg, Alban, 6
Bia, Ned (Navajo), 21, 33, 34, *34*
Birney MT, 113, *113*
Bitterroot Mountains (Montana), 47
Black Americans. *See* African Americans
Black Buffalo. *See* Standing Soldier, Paul (Oglala)
Black Elk (Oglala), 68
Blackfeets (Plains), 40–41, 47, 81, 115, 143n6;
    mentioned, 33, 86, 137n10; in photographs, 41,
*42, 44*, 45, 59, 65, 77–78, 80–81, *105, 107*, 114; pipe
    ceremony of, *42*, 65; Sun Dance of, 81, 86
Blackfeet Reservation MT, 29, 102–4; Arts and
    Crafts Cooperative at, 93; Tribal Council of,
    86, 114; Two Medicine Irrigation Project at,
    102–4. *See also* Browning MT
Black Hills SD, 27
Black Mountain College (North Carolina), 7, *8*
Bonser, Elsie (Oglala), 23, *24*, 25
Bordeaux, Annie (Rosebud Sioux), *xx*, 25, 123
Bourke-White, Margaret, 17–18, 39, 70, 112–13,
    146n9. *See also You Have Seen Their Faces*
    (Caldwell and Bourke-White)
*Brave against the Enemy* (Clark and Post), 3, 27, 29, 34,
    53–59, 81, 99, 101, 118; illustrations from, *28, 54–60*
British Empire, 84
Browning MT, 59, 77, 102–4, *105, 107*; Moccasin
    Flats, 102, 104
Buffalo Chief, Nellie Star Boy. *See* Menard, Nel-
    lie Star Boy (Rosebud Sioux)
Bureau of Indian Affairs (BIA), 3, 13, 22, 29, 30, 36,
    83–84, 89, 92, 93, 101, 104, 107–9. *See also* Indian
    Service; U.S. Indian Office
Burnsides, Mabel (Navajo), 123, *124*
Burnsides, Tom (Navajo), 93–95, *96*
Bursum Bill (1922), 48

California (Indian culture area), 22
cameras: Linhof, 6, 21; Rolleiflex, 7, 21; Speed
    Graphic, *11*, 21
Canyon de Chelly (Arizona), *18*, 19, *19*, 21
Cherokees (Southeast), 36, 38
Cheyennes (Plains), 21, 71
Chinle AZ, 21

CIA, 31

Civilian Conservation Corps (CCC), *81*, 98; Indian Division (CCC-ID), 98–99, 114

Clark, Ann (Nolan), 3, 27, 53, 93, 95, 134n25. See also *Brave against the Enemy* (Clark and Post)

Clements, William M., 112

Coastal Salish (Northwest Coast), 115

Collier, Charles W., 10, 132n11

Collier, John, 10, 29, 63, 83, 87, 90, 92, 98, 99, 107, 109; quoted, 52, 84

Communist Party. See Popular Front; Vienna, Austria

Crow Reservation MT, 61, *71*, 89, 90–92; agency at, 71; fair, *17*, 29, 59, 89, 92, 126

Crows (Plains), 21, 47, 59, 61, 86, 90; mentioned, 92; in photographs, 114, 126, *127*

culture area. See California (Indian culture area); Northwest Coast (culture area); Plains (culture area); Plateau (culture area); Southwest (culture area)

Custer, George Armstrong, 21, 61, 71

*Daughters of the Desert* (Babcock and Parezo), 33

Dawes Act. See Allotment Act of 1887

Day, Sam, Jr., 19–20, *20*

d'Harnoncourt, René, 23, 30

Dillon, Peter (Oglala), *103*

Dippie, Brian W., 115–17, 118

documentary. See photography, documentary

Dodge, Chee (Navajo), 68, 107, 109, 140n13

Dodge, Thomas (Navajo), 107

Dover Publications, 33

Dulce NM, 71, 118

Dunn, Dorothy, 95

Dust Bowl, 36. See also erosion of land; Navajo stock reduction; Soil Conservation Service (SCS)

Eastern Association on American Indian Affairs, 47, 48

Erdrich, Louise (Turtle Mountain Ojibwe), 46

erosion of land, *12*, 10, 50, *51*, 107, 108. See also Dust Bowl; Navajo stock reduction; Soil Conservation Service (SCS)

Europeans, 111. See also whites

Evans, Walker, 35, 120. See also *Let Us Now Praise Famous Men* (Agee and Evans)

The Face of America (book series), 1, *2*, 36–38, 46

Faris, James C., 140n13; *Navajo and Photography*, 13, 33–34, 70, 141n16

Farm Security Administration (FSA), 7, 9, 14, 21, 29, 33, 35–36, 38, 70, 118

Farr, William, *The Reservation Blackfeet, 1882–1945*, 33

fascism. See Nazis, Nazism

Fenn, Albert, 25; photograph by, *24*

Fiedler, Leslie, 46

Flathead Reservation MT, *100*, 115, *116*; Tribal Council of, 87

Flatheads (Plateau), 47, 86, 92; mentioned, 41, 92, 99, 114; in photographs, *39*, 63, *63*, 77, *78*, 79–80, *79*, 88, *88*, *98*, *100*, 126

Fleischmann, Trude, 5–6, *8*, 10, 13, 14; photographs by, *11*, *16*

Flint, Kate, *Flash!*, 71

Foky, Nora (Navajo), 65, *66*

Ford, Gerald, 89

Fort Belknap MT, 115

Fort Defiance AZ, 21
Fryer, E. Reeseman, 109

Galerie St. Etienne NY, 25, *42*
Gallup Intertribal Indian Ceremonials, 70
George Washington Bridge (New York), 7
Germany, 35, 61; Third Reich, 6
Geronimo (Chiricahua Apache), 52, 115
Giroux, Grace (Oglala), 31
Glacier National Park (Montana), 29, 40, *42*
Goforth, Flora Dee, 30–31
Gorman, Howard (Navajo), 108–9, *110*
Gőssenberg, Austria, 33
Great Depression, 1, 115. *See also* 1930s
Grey Moustache (Navajo), 76

Hardin MT, 61
Herrera, Velimo Shije. *See* Ma Pe Wi (Zia Pueblo)
Holds the Gun, Joppy (Blackfeet), 81, *82*, 142n23
Hollow Horn (fictional family). *See* Knife, Andrew (Oglala); Little, Edsel Wallace (Oglala); Makes Shines, Fannie (Oglala)
Holy Rock, Johnson (Oglala), 75, *75*, 93, 126
Hopi Reservation AZ, 13, 49; Awatobi Ruins at, 23, 25; Cultural Center, 23
Hopis (Southwest), 83–84, 86; crafts of, 23, 25, *27*; Snake Dance of, 49
Howe, Robert (Crow), 139n7
Hoxie, Frederick, 61
Hungry Wolf, Adolf, 86, 143n6

Ickes, Harold L., 52
Indian Affairs. *See* Bureau of Indian Affairs (BIA); Indian Service; U.S. Indian Office

*Indian Art of the United States* (exhibition), 22–25, *22, 23, 24*, 30, 95–98
Indian Arts and Crafts Board, 22, 23, 25, 93, 98, 123
Indian Defense Association, 83
Indian Painting School (Santa Fe), 47, 95
Indian Reorganization Act (IRA), 3, 4, 41, 48–49, 83, 84–110
Indian Service, 4, 21, 22, 29, 30, 31, *42*, 83, 88. *See also* Bureau of Indian Affairs (BIA); U.S. Indian Office; *specific reservations*
Indians, American. *See* Native Americans
*Indians at Work* (magazine), 22, 36, 92, 107, 133n19
Indian Territory, 111
*In the Image of America* (exhibition), 35–36

Jackson, Andrew, 111
Jefferson, Thomas, 111
Jicarilla Reservation NM, 50, 71
Jicarillas (Southwest), 33, 47, 71, 86, 92; in photographs, 71, *72*, 114, 118–20, *121*, 123, 126

Kabotie, Fred (Hopi), 23–25
Kallir, Otto, 25
Karoks (California), 22, *23*
Kent CT, 31
Kentucky, 5
Kerr Dam (Montana), *40*, 115, *116, 117*, 118
Klamath River (California), 22
Knife, Andrew (Oglala), 53, *58*, 59
Knife, Lucy (Oglala), 101
Koostatah (Flathead), *40*, 80
Koppell, Günther, 47. *See also* Alliance Book Corporation

La Farge, Christopher, 45

La Farge, John, 46

La Farge, Oliver: biographical data, 46–47, 59, 63; contribution to *As Long as the Grass Shall Grow*, 1, 13, *16*, 45–46, 47–50, 52, 61, 111, 113; *The Enemy Gods*, 46, 114; and Hopis, 83–84; and Indian Reorganization Act, 84–85, 92, 104; *Laughing Boy*, 46, 138n14; mentioned, 3, 18, 65, 113; *Raw Material*, 46, 138n14. See also *As Long as the Grass Shall Grow* (La Farge and Post)

Lakotas or Sioux (Plains). *See specific tribes*

Lakota (language), 3, 27, 29, 58

Lamarr, Hedy, 6

Lange, Dorothea, 35, 36, 45, 70, 112–13, 120. See also *American Exodus* (Lange and Taylor)

LaPier, Rosalyn (Blackfeet/Métis), 81

*La política de los Estados Unidos* (McCaskill and McNickle), 29, 30

Last Horse, Mattie (Oglala), 29, 120–23, *122*

Leighton, Dorothea, 33, 107. See also *The Navaho Door* (Leighton and Leighton)

*Let Us Now Praise Famous Men* (Agee and Evans), 70, 112

*Life* (magazine), 17, 25, 146n9

Lincoln High School (New York City), 9

Lippard, Lucy R., *Partial Recall*, 33

Little, Edsel Wallace (Oglala), *28*, *55*, 56–57, *56*, *57*

Little Big Horn: battle of, 21, 71; Battlefield National Park, 61

Little Fork MN, 36

Little Sky, Eddie (Oglala), 57–58, 139n5. *See also* Little, Edsel Wallace (Oglala)

Locke, Edwin, 36

Lone Feather. *See* Reifel, Ben (Rosebud Sioux)

*Look* (magazine), 34, 137n3

*Los indios de los Estados Unidos* (Harper, Collier, McCaskill), 29, 30

Makes Shines, Fannie (Oglala), 53, *54*

*A Man Called Horse* (movie), 57–58

Manuelito (Navajo), 21

Ma Pe Wi (Zia Pueblo), 38, 47, 93, 95

Marshall Field store (Chicago), 18

Mayan (language), 46

McCaskill, Joseph C., 29, 30

McNickle, D'Arcy (Salish Kootenai), 30, 111, 114

Medicine Crow (Crow), 59

Medicine Crow, Joseph "Joe" (Crow), 38, 59–63, *61*, *62*, 118, 126

Menard, Nellie Star Boy (Rosebud Sioux), 3, 23, *24*, 25, *26*, 29, 53, 95, 123

Mescalero Apaches (Southwest), 36, 38, 92

Mike, Aschi (Navajo), 2, 93, 123–26, *125*

Modley, Peter, 31, 33, 53, 65, 87, 123

Modley, Rudolf "Rudi," 10, 13, 31, 33, 107, 131n10

Montana Power Company, 115

Monument Valley (Utah), 30

Museum of Modern Art (MOMA) (New York), 22–25, *22*, 30, 95–98

museums: Field Museum, 81; Los Angeles County Museum, 18; Museum of New Mexico, 23; National Anthropological Archives, 34; Santa Fe Museum of Art, 18; Southwest Museum, 18. *See also* Museum of Modern Art (MOMA) (New York)

Native Americans: arts and crafts of, *15*, *22*, *23*, 41, *43*, 46–47, 93–95; education of, 13, 14, 29, 53, 85, 93, 107, 120–21; governance of, 4, 13, 30, 48–49, 85, 118; health of, 14, 31, 87–89; and industry

Native Americans (*cont.*)
and technology, 39–40, 115–18; oratory of, 39, 50, 111–12, 114; as subject of photography, 1–2, 18, 33, 36, 52, 59, 68, 77, 114–15. *See also* Bureau of Indian Affairs (BIA); *Indian Art of the United States* (exhibition); Indian Arts and Crafts Board; Indian Reorganization Act (IRA); Post, Helen; *specific tribes*
*The Navaho Door* (Leighton and Leighton), 31, 33, 59, 87–88, 92, 93
Navajo Reservation AZ: fair at, *2*, 68, 70; schools, *43*, 66; services at, 13; Tribal Council of, 86, 107
Navajos (Southwest): code talkers, 25; cosmology, 109; crafts, *22*, 41, *43*, 93, 95, *96, 97*, 123, *124, 125*; fire rite *or* Nightway, 68, *69*, 140n13; land, *12*, 13, 31, 50, 107, *108*, 109; Long Walk, 47; in photographs, 33–34, 75–76, *76*, 109. See also *The Navaho Door* (Leighton and Leighton)
Navajo stock reduction, 107–10, *110*; and Shiprock Uprising, 107
Nazis, Nazism, 6, 7, 10, 25, 31
New Deal, 4, 10, 22, 29, 90–92, 98; and short-comings of Indian New Deal, 99–110. *See also* Civilian Conservation Corps (CCC); Indian Reorganization Act (IRA); Works Progress Administration
New York City, 7, 31, 35
*New York Times*, 25–26
1930s, 1–2, 4, 21, 70, 77, 104, 112, 118. *See also* Great Depression
*North American Review* (journal), 111
Northwest Coast (culture area), 95

Obama, Barack, 63
Office of Strategic Services, 31

Oglalas (Plains), 30, 86, 89, 101; Hunkalawanpi (ceremony) of, *67*, 68; Sun Dance of, 57; Horse Dance of, 68; in photographs, *67*. *See also* Oglala Sioux Tribal Council (OSTC); Pine Ridge Reservation SD
Oglala Sioux Tribal Council (OSTC), 99–102, *103*
Okies, 7, 36
Osages (Plains), 38, 47

Phoenix Indian School AZ, 95
photobooks, 1–2, 19, 112–13
photographers: Russell Lee, 7, 36, 70; Jacob A. Riis; Arthur Rothstein, 7, 36, 137n3; William Henry Fox Talbot, 114–15; Edith Tudor-Hart, 6; Edward Weston, 120, 137n8. *See also* Bourke-White, Margaret; Evans, Walker; Fenn, Albert; Fleischmann, Trude; Lange, Dorothea; Rosskam, Edwin; Wolcott, Marion Post
photographers of Native Americans: John Alvin Anderson, 89; John Collier Jr., 36, 133n17; Edward S. Curtis, 18–19, 21, 49, 77, 80; Joseph Kossuth Dixon, 77; Alexander Gardner, 30; Laura Gilpin, 19, 33, 70, 123, 141n16; Sumner Matteson, 115; Timothy O'Sullivan, 19; Roland Reed, 86. *See also* Post, Helen; Snow, Milton "Jack"
photography, documentary, 1, 4, 7, 38–39, 70, 77–78, 112, 115–18; flash, 21, 55, 63, 70–71, 126. *See also* cameras
Pichette, Peter (Flathead), 63, *63*, 123
Pine Ridge Reservation SD, 3, 29, 30, 52, 58, 64, 75, 92, 99–102, 120; Crafts Store, *94*; Fair, *28*, 68, 89, 101, 121; in photographs, *75, 122*; Red Shirt Table Cooperative, 101, *102*; trading store, *87*. See also *Brave against the Enemy* (Clark and Post); Oglala Sioux Tribal Council (OSTC)

Pine Springs AZ, 94

Plains (culture area), 29, 39, 47, 61; stereotype, 46, 137n13. *See also specific tribes*

Plateau (culture area), 47. *See also* Flatheads (Plateau)

Plenty Coups, Chief (Crow), 59, 90

Polson MT. *See* Kerr Dam (Montana)

Popular Front, 10, 120

Post, Helen: early life of, 5; employment, 7, 9, 10–14, 21–23, 52, 83; exhibitions, 18–19, 25–27, *27*, 33; marriage, 10, 31; photographed, *xx*, 10, *11*, 14, *16*; photographic practice of, 1, 3–4, 19–21, 52, 63–68, 70–77, 113, 118, 123; photographic training, 5–7, 13; publication of works by, 1, 29–31; reputation of, 33–34, 120. See also *As Long as the Grass Shall Grow* (La Farge and Post); *Brave against the Enemy* (Clark and Post)

Post family: Nan (mother) and Walter (father), 5; Marion Elisabeth Modley (daughter), 31. *See also* Modley, Peter; Modley, Rudolf "Rudi"; Wolcott, Marion Post

Post, Marion. *See* Wolcott, Marion Post

Price, Pete (Navajo), 68, 140n13

Pueblos, 19, 47, 65

Red Cloud (Oglala), 30, 57

Red Rock, Miss. *See* Bonser, Elsie (Oglala)

Reifel, Ben (Rosebud Sioux), 89, *90*

Reinhardt, Akim, 99, 101

Resettlement Administration. *See* Farm Security Administration (FSA)

Rhoads, Charles, 84

Roanhorse, Kate (Navajo), 21

Roberts, W. O., 101

Rockefeller Center (New York), 7

Roosevelt, Eleanor, 23, *24*, 25, 36

Roosevelt, Franklin D., 4, 10, 115. *See also* New Deal

Rosebud Lakotas or Sioux (Plains): Art and Craft Shop of, 25; Rabbit Dance of, 68; Reservation, *xx*, 21, 29, 89; and Rosebud Fair, 68, 121; and Rosebud Museum, 25. *See also* Menard, Nellie Star Boy (Rosebud Sioux)

Rosenblum, Naomi, *A History of Women Photographers*, 33

Rosskam, Edwin, 1, 3, 14, 35, 36–37, 45, 84, 99; photograph by, *85*; *San Francisco*, 36; *Washington*, 36, 37, 45

Salzburg, Austria, 5

San Carlos Apaches (Southwest), 30, *30*, 47, 71–75, *116*, *117*, 126

Sanger, Margaret, 5

San Ildefonso Pueblos (Southwest), 137n7

San Juan River, *12*, 13

Saroyan, William, 36

*Saturday Review of Literature* (magazine), 17

Schwawinsky, Xanti, 7

Senecas (Eastern Woodland), 13, *15*, 22, 92. *See also* Tonawanda Reservation NY

Sharon CT, 31

Sherman Institute (California), 90

Shorty, Dooley D. (Navajo), 23, *24*, 25

Sioux or Lakotas (Plains). *See specific tribes*

Sir Linsley (horse), 92

Sitting Bull (Hunkpapa Sioux), 52, 143n7

Sitting Eagle, Thomas Henry (Oglala), 65–68, *67*, 102, 121

Sloan, John, 46

Snow, Milton "Jack," 13, 17, 70, 95; photograph by, *7*

Soil Conservation Service (SCS), 10, 13, 30, 107, 109
Southwest (culture area), 47, 93. *See specific tribes*
Speckled Snake (Muskogee), 111
Stabs Down by Mistake (Blackfeet), 33, 86, *86*, 114
Standing Soldier, Paul (Oglala), *56*, 58–59, *58*
Stegner, Wallace, *One Nation*, 34
Stott, William, *Documentary Expression and Thir-ties America*, 70, 112
Stryker, Roy E., 7, 35, 118

Tewa Pueblos (Southwest), 49
Thompson, Flora Owens (Cherokee), 36
Tonawanda Reservation NY, 13, *15*, 22; Tonawanda Community House Project at, 92
Trachtenberg, Alan, 123
Tsihnahjinnie, Andrew (Navajo), 93, 95, *97*, 144n19

U.S. Department of Agriculture, 10
U.S. Indian Office, 30, 36, 61, 107, 109. *See also* Bureau of Indian Affairs (BIA); Indian Service
U.S. Marine Corps, 25
U.S. National Archives, 109, 132n11, 132n13, 141n17, 145n35
U.S. National Indian Institute, 29–30
U.S. Senate Committee on Indian Affairs, 58
U.S. Seventh Cavalry, 58

Vienna, Austria, 5–7, 10, 25; "Red Vienna," 6

Wanamaker's store (Philadelphia), 18
Wanblee SD, 29
Washington DC, 31, 33, 51, 84, 95, 99
*Weave It Yourself* (Goforth), 30–31
Weisiger, Marsha, 109
Wells, Phillip (Blackfeet), 137n10
Westenbrook Gallery (Sheffield, Massachusetts), 33

West Virginia, 9, *9*
White House Ruins, *12*, 19
White Man Runs Him (Crow), 21, 61
White Man Runs Him, John (Crow), 21, 61, 71, *71*, 126
whites, 41, 45, 47, 48, 49, 50, 63, 111, 112, 113, 114; mentioned, 27, 39, 53, 57, 61, 101; prejudice against Native people, 113, *113. See also* Europeans
Wiesenthal, Grete, 6
Wild West show, 65
Wilson, Frank G. (Oglala), 99, 101, *103*
Wilson, Richard "Dick" (Oglala), 75, 141n19
Window Rock AZ, 68, 123
Winslow AZ, 88, 95
Wolcott, Marion Post, 5, 6, 9, 14, 29, 33, 36, 37, 113; photographs by, *37*, *113*
Works Progress Administration, 9, 92, 95
World War I, 35
World War II, 1, 14, 31, 75, 95
Wounded Horse, Eugene (Oglala), 29, 93
Wounded Knee SD, 75; massacre at, 58, 139n5
Wright, Richard, *12 Million Black Voices*, 38, 45

x-ray, 31, *32*, 88–89

Yazzie, Sam (Navajo), 109
Yellow Kidney (Blackfeet), 59, 60, 80–81, 104, *107*, 123
Yellow Kidney, Buster (Blackfeet), 59, 60, 80, 81, 126
Yellow Kidney, Insima (Blackfeet), 104, *107*, 123
Yellow Wolf (Blackfeet), 104
Yellowtail, Amy (Crow), 126
Yellowtail, Chief (Crow), 126
Yellowtail, Robert (Crow), 3, 89–92, *91*, 114
*You Have Seen Their Faces* (Caldwell and Bourke-White), 70, 112–13

Zuni (Southwest), 49